Director's Note

1968, following the urgings of Charles Wrightsman,
member of the Metropolitan Museum's Board of
Trustees, I first visited the famed Gold Room of the
Hermitage. It was a dazzling experience. It was also the
beginning of years of delicate, at times frustrating, but
always rewarding negotiations with the Ministry of Culture of the Soviet Union to secure the best of the gold
treasury for this exhibition. Those negotiations, which
my Soviet colleagues looked upon with optimism and
unremitting enthusiasm, were successful. This landmark
exhibition, *From the Lands of the Scythians,* comprising
97 works of art from the ancient civilizations of the
territories that now are part of the Soviet Union, is the
first fruits of what promises to be an extraordinary series
of cultural exchanges between the museums of the Soviet
Union and the Metropolitan. Our part of the first round
of exchanges opens at the Hermitage in May and will
consist of 100 masterpieces of European and American
painting from our collections, one of the finest shows
the Metropolitan has ever mounted.

Why did we choose for the first exhibition these stunning Scythian gold objects, the fabulous carvings and
textiles from the frozen tombs of Siberia? The answer is
simple. They are unique in the world not only in quality
but in type. I have seen literally abundances of gold and
silver and precious objects in museums around the globe,
from ancient Egyptian through Greek and medieval to
the fabled treasures of more modern kings and emperors.
But none are like the contents of the Gold Rooms of the
Hermitage or Kiev State Historical Museum. Nothing

can quite match the beauty, craftsmanship, and power of
these awesome objects assembled by the unknown kings,
princes, and chieftains of the sixth, fifth, and fourth centuries B.C., whose territories were larger by far than all
the lands of the then so-called civilized world. Looking
at the abstract majesty of the great gold panther (color
plate 5) and then at the sublime idealism of the human
figures in the superb comb (color plates 12, 13) one feels
as if one were seeing the archetypes of the two fundamental styles of art: one, the abstract, decorative art of
hieratic symbolism that will wend its way through
time, through Byzantine art, through the mystifyingly
complex animal interlaces of the Book of Kells, and even
to the abstract impulses of our day. The other reflects the
serene, balanced human idealism of the ancient Greek
experience.

Who were these people – the Urarteans, the Scythians,
the tribes of the Altai mountains, the Sarmatians – who
commissioned and collected objects of such exceptional
beauty and sophistication? Little is known. They had no
recorded written language, no coinage. And that is normally the formula for historical oblivion. But we have
their great works of art and some history, too. For the
Scythians we have the Greek historian Herodotus, whose
account is included in this catalogue. Even in his own day
he was called a quaint teller of fanciful tales, but modern
archaeology has proven him uncannily accurate about
Scythian burial customs and techniques of warfare.

Herodotus' portrait of the Scyth is not particularly
complimentary: the Scyth was a nomad, a fierce hunter

and fighter, a tough, indomitable barbarian addicted to strong wine, hashish, and violence, wandering, always wandering, uncivilized and rootless. But one must be cautious. A Greek historian of the fifth century B.C. would look upon any people who did not speak the mother tongue as barbarians, and would judge any group of mankind without cities as beyond the pale. However, as one examines the uniquely beautiful art made by and for the Scyths, one must acknowledge that, stereotyped concepts of civilization aside, these anonymous peoples were connoisseurs of supreme taste. What else is there to say about a people who commissioned the spectacular gold pectoral shown on the cover (surely one of the most breathtaking works of goldsmith's art ever created)?

These remarkable works of art, the vast majority of which have never been outside the Soviet Union, are here because of the work and interest of a number of dedicated individuals: especially the Secretary of State, Henry A. Kissinger, who ensured that the exchange was specifically mentioned in the communiqué of the 1974 summe meeting between President Richard Nixon and Part Secretary Leonid Brezhnev; and Yekaterina Furtseva, la Minister of Culture, whose deep interest in the proje and whose personal intervention in securing the loa from Kiev made the show possible. A very genero grant from the National Endowment for the Humanit was of key importance in producing this exhibitio Finally, I would like to thank Mr. and Mrs. Charl Wrightsman, whose support in every way has been fundamental significance to this exhibition and to t entire round of exchanges.

Thomas Hoving
Director
The Metropolitan Museum of Ar

The Metropolitan Museum of Art Bulletin No. 5, 1973/19
Volume XXXII, Number 5

Published quarterly. Copyright © 1975 by The Metropolitan Museum of Art, Fifth Avenue and 82 Street, New York, N.Y. 1002
Second class postage paid at New York, N.Y. Subscriptions $10.00 a year. Single copies $2.50. Sent free to Museum members. Fo
weeks' notice required for change of address. Back issues available on microfilm from University Microfilms, 313 N. First Stre
Ann Arbor, Michigan. Volumes I-XXXVIII (1905-1942) available as a clothbound reprint set or as individual yearly volumes fr
Arno Press, 330 Madison Avenue, New York, N.Y. 10017, or from the Museum, Box 255, Gracie Station, New York, N.Y. 1002
Editor of the *Bulletin:* Katharine H. B. Stoddert; Associate Editor: Joan K. Holt. Art Director: Stuart Silver.

From the Lands of the Scythians

Organized in cooperation with the Ministry of Culture of the U.S.S.R.,
this loan exhibition has been made possible through the assistance of
the National Endowment for the Humanities and Mr. and Mrs. Charles Wrightsman

The color photographs, especially made for this exhibition, are by
Lee Boltin, with the assistance of Ken Kay. The catalogue was designed
by Irwin Glusker and his associates, Christian von Rosenvinge
and Lilly Hollander. The maps were drawn by Wesley B. McKeown.

From the Lands of the Scythians

Ancient Treasures

from the Museums of the U.S.S.R.

3000 B.C.–100 B.C.

The Metropolitan Museum of Art

The Los Angeles County Museum of Art

Contents

Preface

Cultural exchanges are of profound importance in promoting understanding between two peoples, and we would like to commend the vigorous efforts and initiative of The Metropolitan Museum of Art and the Ministry of Culture of the U.S.S.R. that led to the agreement providing for a major series of exchange exhibitions. The two current shows arranged through this agreement present magnificent works from each country's artistic patrimony: this one presents masterpieces of the most ancient peoples who lived in what is now the territory of the U.S.S.R., lent by four Soviet museums; a concurrent exhibition in Moscow consists of outstanding European and American paintings from the Metropolitan Museum's collection.

Works of art affirm in a universal language the common humanity that underlies different cultural traditions, and we welcome these exchanges as symbolic of the efforts our two nations are making to improve mutual understanding.

John Richardson, Jr.
*Assistant Secretary of State for
Educational and Cultural Affairs*

Acknowledgments

Mr. Hoving and I wish to thank everyone who participated in organizing and presenting this magnificent exhibition. Few other exhibitions have drawn on so many individuals in so many different areas, and in this case the task was especially difficult as the material is, for the most part, unfamiliar to the majority of Americans. Outside scholars gave generously of their time, and amongst them I wish to single out Professors Ann Farkas of Brooklyn College, John F. Haskins of the University of Pittsburgh, and Véronique Schiltz of the University of Besançon. Curators on the staff of the Metropolitan Museum played an indispensable and varied role, writing essays and interpretive comments on many of the pieces for the catalogue entries, and providing other educational information: Prudence Oliver Harper, Ancient Near East; Dietrich von Bothmer, Greek and Roman; Helmut Nickel, Arms and Armor; Jean Mailey, Textile Study Room; and Jean K. Schmitt, Far Eastern Art.

Katharine Stoddert, aided by Joan Holt, coordinated the preparation of the catalogue, a difficult assignment since these are complex fields rife with scholarly disputes. To be recognized in the Education Department are Melanie Snedcof, assisted most ably by Holly Pittman, Marie-Thérèse Brincard, and Tobia Frankel, who prepared educational aspects of the exhibition. Stuart Silver and Clifford La Fontaine designed the show to combine aesthetic impact with vitally needed interpretive material.

The precise negotiations with the Soviets were conducted by Mr. Hoving and myself at the Ministry of Culture in Moscow, at The State Hermitage Museum in Leningrad, and at The Kiev State Historical Museum. Assisting at various stages of the negotiations was James Pilgrim, who should also be commended for his leadership in the area of administration, where the roles of Rosemary Levai, Kay Bearman, Louise Condit, and John Buchanan should be acknowledged; and a special note of personal thanks should go to Vera K. Ostoia, who translated, with enthusiasm and dispatch, catalogue material submitted to us in the Russian language.

We are especially grateful to Dr. Boris Piotrovsky of the Hermitage, who supplied a lengthy essay that was adapted for the catalogue, and to the directors of the institutions in the Soviet Union who lent some of their most precious objects to this show.

To Irina Antonova, Director of the Pushkin Museum in Moscow, go particular thanks for facilitating negotiations concerning *100 Masterpieces of European and American Painting,* being sent by The Metropolitan Museum of Art to the Soviet Union as part of this exchange.

Many of the logistical problems were so complicated that those who resolved them cannot be overlooked in a list of credits: thus our appreciation goes to Victor Sakovich, Cultural Counselor of the Embassy of the Union of the Soviet Socialist Republics in Washington, D.C., and to Nicolai Loginov, Cultural Attaché to the Soviet Mission to the United Nations. On the American side, a deep debt of gratitude is owed to John Richardson, Jr., and Peter Solmssen of the Department of State, Washington, D.C., for their assistance along every step of the way.

Finally, we must thank all the others who helped in the organization and assembly of this great exhibition and who remain unnamed. Their professionalism and interest did not go unnoticed.

Philippe de Montebello
*Vice-Director for Curatorial and
Educational Affairs
The Metropolitan Museum of Art*

7

Introduction

Ann Farkas
Associate Professor
The New School for Liberal Arts
Brooklyn College, C.U.N.Y.

The Scythians were an Iranian-speaking people, one of many groups of nomads who dominated the Eurasian steppes during the first millennium B.C. The Scythian domains were the lands north of the Black Sea, the Pontic steppes, described by the Greek historian Herodotus as "level, well-watered, and abounding in pasture" (IV, 47). Herodotus also recorded very vividly the Scythian way of life, which enabled these nomads to rule so successfully over the various inhabitants of the Pontic steppes: "Having neither cities nor forts, and carrying their dwellings with them wherever they go; accustomed, moreover, one and all of them, to shoot from horseback; and living not by husbandry but on their cattle, their waggons the only houses that they possess, how can they fail of being unconquerable, and unassailable even?" (IV, 46).

Many scholars agree that the Scythians originated somewhere in Siberia and that early in the first millennium B.C. they moved westward, into the Near East, and then into the Pontic steppes in the late seventh century B.C. The reason for their western migration, the dates of their Near Eastern sojourn, and the causes for their move to the Pontic steppes are all uncertain; the available evidence is too fragmentary to allow us to interpret very fully this segment of Scythian history. However, the Scythian presence in the Near East is documented in Assyrian and Urartean royal inscriptions, and Herodotus tells a colorful, if not entirely accurate story of the Scythian expulsion from the Near East by the Medes, whose kingdom the Scythians had usurped.

Most evidence of Scythian material culture comes from the elaborate and splendid graves in which Scythian rulers were buried. The great importance given to their king, in death as in life, is amply described by Herodotus, who mentions that when a Scythian ruler died, he was embalmed, placed on a wagon, and carried around t visit the various tribes over whom he had ruled in life When this ceremony was completed, the king's bod was brought to the grave that had been dug for it. "I the open space around the body of the king they bur one of his concubines, first killing her by strangling, an also his cupbearer, his cook, his groom, his lackey, h messenger, some of his horses, firstlings of all his othe possessions, and some golden cups.... After this the set to work, and raise a vast mound above the grave all of them vying with each other and seeking to mak it as tall as possible" (IV, 71). A year later, the grisl ceremony was continued. Fifty young men were kille along with fifty horses, and the dead horses and ride were mounted around the royal tomb as a final toke of the late king's power over his people.

Archaeology has shown that much of Herodotu writing is correct. In the royal Scythian tombs discovere in the northwest Caucasus and on the Pontic steppe women, servants, grooms, and horses were often interre along with the main burial. While the form of the tom may vary from site to site, the tombs were always larg underground structures of wood or stone, lavishly fur nished with royal possessions, and covered with mound of earth and stone. The Scythians seem to have pai homage to their rulers by providing them in death wit the same extravagant possessions the kings must hav enjoyed while alive. The objects from the royal tomb are always possessions used in life—weapons, clothing jewelry, even cooking pots. But the workmanship o royal possessions was often extremely beautiful; gol was frequently used for weapons and jewelry and cloth ing ornaments and drinking vessels. The king seems t have spared no expense when it came to providing him self with the most luxurious equipment possible, so tha

the tombs represent a rather peculiar blend of barbaric customs and elegant decoration.

The most typical feature of Scythian art is the so-called animal style–the proliferation of animal motifs with which the art is adorned. However, it is also typical of Scythian art that in the earliest royal burials on the Pontic steppes and in the northwest Caucasus there are already admixtures of foreign styles–Near Eastern and Greek–which must reflect the various artisans commissioned to execute Scythian art. Aside from Near Eastern and Greek elements, it is possible to speak of a native Scythian art characterized by single animals naturally rendered in several poses: with dangling legs and head, with rear legs folded forward over the front legs, or curled into a circle. All these poses may perhaps be interpreted as renderings of a dead, passive, or powerless animal, and the Scythians might by this means have intended to destroy or contain the power they believed inherent in the animal images. The same explanation might be applied to another typically Scythian trait–the use of animal parts like heads, beaks, or hooves to symbolize the entire animal.

One of the most common motifs in Scythian art is the stag, very often the reindeer. According to Soviet scholars, the Iranian name for the Scythians, Saka, may be interpreted as antler or stag, and the significance of the stag image might be that of a totem animal. Other common animals are felines, perhaps snow leopards, and real or fantastic birds of prey. While Scythian art when executed by Greek artisans often contains narrative scenes that must reflect a Scythian mythology, native Scythian art relies on the mysterious power of single animals and parts of animals, a power so obvious to the Scythian peoples that it needed no explanation.

The animal style was not confined to Scythian art alone but was shared by all the nomads who lived along the Eurasian steppes as far east as Mongolia; a separate animal style had been developed by earlier inhabitants of the Caucasus (the Koban culture), and it is possible that the roots of this artistic tradition lie somewhere in the Russian north. The nomadic animal style provided a rich artistic source for later nomadic peoples, like the Sarmatians, who dominated the steppes after the Scythians had retreated to their Crimean kingdom in the second century B.C. Much later, vestiges of this remarkable style may linger in the extraordinary wealth of animal imagery in the art of the Migrations period.

Cat. no. 18

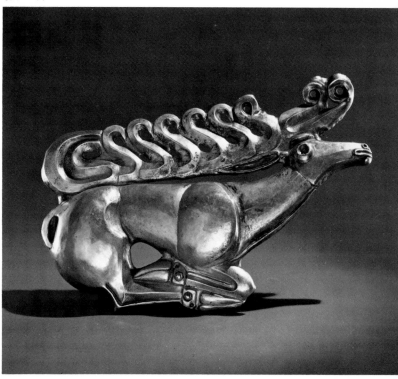

The Scythian World

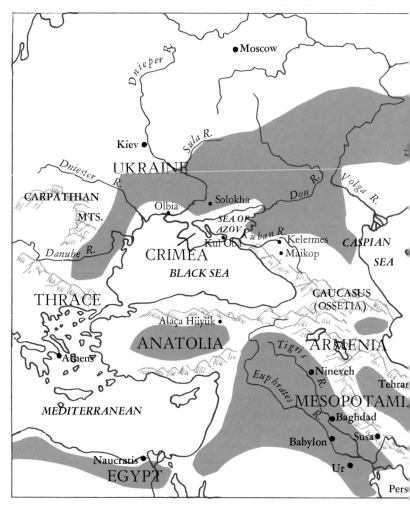

The Early Sites

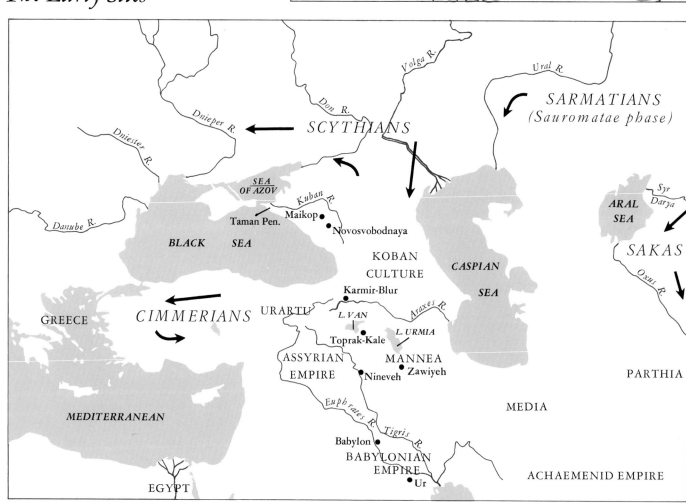

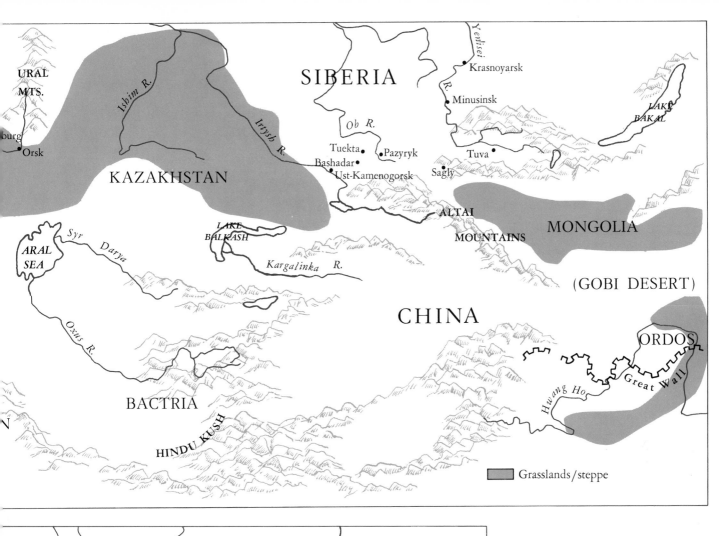

URAL MTS.

SIBERIA

Krasnoyarsk

Minusinsk

burg

Orsk

Ishim R.

Irtysh R.

Yenisei R.

LAKE BAIKAL

KAZAKHSTAN

Ob R.

Tuekta

Pazyryk

Bashadar

Ust-Kamenogorsk

Tuva

Sagly

ARAL SEA

Syr Darya

LAKE BALKASH

ALTAI MOUNTAINS

MONGOLIA

Kargalinka R.

(GOBI DESERT)

N

Oxus R.

CHINA

ORDOS

Hwang Ho

Great Wall

BACTRIA

HINDU KUSH

▮ Grasslands/steppe

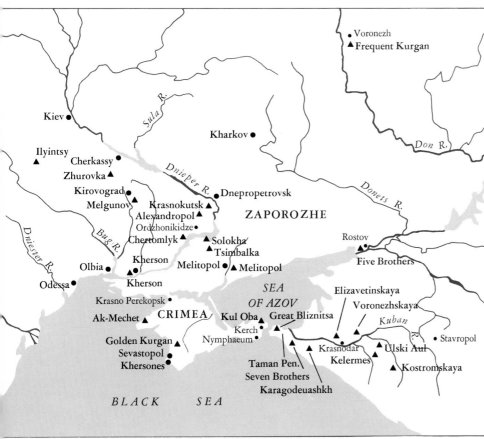

• Voronezh
▲ Frequent Kurgan

Kiev •

Sula R.

Kharkov •

Don R.

Ilyintsy ▲

Cherkassy •

Zhurovka ▲

Dnieper R.

Donets R.

Kirovograd •

Melgunov ▲

Krasnokutsk ▲

Dnepropetrovsk •

Alexandropol ▲

ZAPOROZHE

Ordzhonikidze •

Bug R.

Chertomlyk ▲

Solokha ▲

Rostov

Olbia •

Kherson •

Tsimbalka ▲

Five Brothers ▲

Dniester R.

Melitopol • ▲ Melitopol

Odessa •

Kherson

SEA OF AZOV

Elizavetinskaya ▲

Krasno Perekopsk •

Voronezhskaya ▲

Kuban R.

Ak-Mechet ▲

CRIMEA

Kul Oba ▲ Great Bliznitsa ▲

Golden Kurgan ▲

Kerch

Krasnodar •

Ulski Aul ▲

• Stavropol

Sevastopol •

Nymphaeum •

Kelermes ▲

Khersones •

Taman Pen. ▲

Kostromskaya ▲

Seven Brothers ▲

Karagodeuashkh ▲

BLACK SEA

*The Royal
Scythian Tombs*

11

Early Cultures of the Lands of the Scythians

Adapted from a Russian text by Boris Piotrovsky
The State Hermitage Museum, Leningrad

The Maikop Culture

Late 3rd millennium B.C.
[Catalogue nos. 1-3]

In 1897 a princely tomb was excavated in the town of Maikop in the northern Caucasus. Covered by a mound almost thirty-five feet high was a large burial chamber, over twelve by seventeen feet, with wooden walls and paved with river stones. Wooden partitions divided the tomb into three areas: the principal burial was in the largest, southern part. The skeleton, painted red, was lying on its back with legs drawn up, and great quantities of objects, some of gold and silver, lay on and around it. There were two gold diadems decorated with double rosettes, a necklace of rows of gold, lazurite, turquoise, and carnelian beads, and headdress pendants of massive gold wire. The dead man had been placed under a canopy decorated with numerous gold plaques: thirty-eight were ring-shaped, while sixty-eight represented lions and nineteen represented bulls (color plate 2, cat. no. 1). Four gold and silver poles have been identified as supports for this canopy, and each ended in sculptures of bulls cast in gold or silver (cat. no. 2). Flint arrowheads and flint inlays from a knife lay near the skeleton's knees, and in various parts of the chamber were found a great number of tools and weapons; in the southeastern corner, for instance, were some made of copper: axes, a chisel, and a flat dagger with a curving blade fastened to the hilt with silver pins. There were also many vessels: seventeen stood along the eastern wall–two of gold, one of stone with gold and silver inlay, and the rest of silver. Two of the silver vases had remarkable decoration. Along the rim of one a mountain range was depicted, with a bear standing on its hind legs between two trees; on the

vessel's body were two rivers that flowed into a circl representing a lake or sea; also shown were two bull a horse, a lion with a bird of prey on its back, a wild boa an antelope, and a mountain sheep. On the second vase besides some ornamental motifs, appears a scene o predators attacking a bull and a goat.

The grave's other two rooms contained additiona burials–of a man and a woman–with considerably les rich inventory: gold and carnelian beads, earrings c gold wire, and various clay and copper vessels.

The Maikop burial, combining works of art of hig quality with rather primitive flint and copper tools, i outstanding because it heralds the coming of a new epoc in the history of the Caucasus. This was the tomb of chieftain of a rich tribe of livestock-breeders that ha dealings with the more civilized countries to the soutl Many of the objects found here are doubtlessly of foreig manufacture: the designs on the silver vases and the gol plaques showing lions and bulls bear witness to a connec tion with Near Eastern cultures. The beads are made o exotic materials: the carnelian and turquoise came from Transcaucasia and Iran, the lazurite from Central Asia Tools and weapons with curved blades fastened to th hilt with silver pins have analogies with Achaean objects more specifically Trojan ones. Thus the Maikop buria gives a vivid picture of the interchange between a grou of herdsmen and their more sophisticated neighbors: i exchange for cattle, driven south and southwest, th tribes of the North Caucasus received precious objects

This kurgan characterizes a culture widespread in th North Caucasus during the Copper Age. At first scholar dated the Maikop kurgan anywhere from the late fourtl or early third millennium to the eighth century B.C. now, on the basis of other local finds, it is convincingl dated to the late third millennium B.C.

The Maikop kurgan has analogies in other regions of the Near East: in date, character, and general appearance it can be compared to the famous burial at Alaça Hüyük in Anatolia, which preceded the formation of the Hittite state, and to the large sepulcher at Til-Barsip in northern Syria. There had been rich burials in the more southerly regions of the Near East even earlier, at the beginning of the third millennium B.C., such as the so-called Royal Cemetery excavated in the ancient Sumerian town of Ur.

The Koban Culture

Early 1st millennium B.C.
[Catalogue nos. 4-9]

The Bronze Age in the southern Caucasus-the nineteenth to fourteenth centuries B.C.-is represented by remarkable monuments such as a kurgan in the Trialeti region of Georgia and in Kirovakan in northern Armenia. These were graves of chieftains of prosperous cattle-breeding tribes that maintained relations with the countries of the Near East. The chieftain's ashes were placed on a wooden carriage in the center of a large funerary chamber (like the burial ritual of the Hatti kings). Around the carriage lay skeletons of long-horned and short-horned cattle, as well as painted or polished vessels, sometimes with carved or stamped ornament. The tools and weapons placed in the graves were made of bronze: copper alloyed during smelting with arsenic or, in a newer technique, with tin (which had to be imported from afar). Objects of precious metals testified to the high development of the goldsmiths' art; there were cups and goblets of silver or gold (some with chased or relief decoration), pins, and beads with granulated ornament.

In the Kirovakan kurgan were found silver vessels that are similar in shape and details to the famous gold goblets found at Vaphio in Greece.

In somewhat later burials in Armenia (15th-14th century B.C.), at Lchashen and Artik, foreign objects such as cylindrical Hurrian seals were found. Such seals, associated with the state of Mitanni in Syria, are found throughout a large area from the shores of the Mediterranean to the Caspian Sea, and in the North Caucasus. Analogies for the gold and bronze objects found at Lchashen and Artik can be found in Ras Shamra (Ugarit) and in Mari, along the middle of the Euphrates river. Assyrian and Ugaritic documents describe the routes from the kingdom of the Hatti to Assyria used by merchant caravans bringing tin from the far west; roads to the southern Caucasus branched out from the main caravan routes, and led from the Hatti town of Kanesh into the Assyrian cities of Nineveh and Assur.

At the end of the second and the beginning of the first millennium B.C., important centers of Bronze Age culture appeared in the Caucasus, Iran, and the Near East, all having connections with regions producing metal ores. Along with cattle, metal objects became the main items of barter. Archaeological work in the Caucasus has revealed a number of individual cultures, outstanding in the originality of their artifacts and, despite a general similarity of bronze wares (axes, battle axes, swords, daggers, arrowheads, spearheads), with local differences. The cattle-breeding tribes became only semi-nomadic as they took over mountainous areas, where high-altitude pastureland provided more continuous grazing for their herds; into their hands thus fell ore-bearing locations, so the development of metallurgy occurred among these tribes.

The most famous monument of Bronze Age culture in

the Caucasus is the Koban burial of North Ossetia. Discovered near the village of Verkhnii Koban in 1869, it consisted of numerous stone boxes in which the skeletons lay on their side with legs drawn up, as well as a great quantity of bronze weapons and ornaments. Very characteristic are small bronze axes of elegant shape, often with engraved designs – animals, geometric motifs, and scenes connected with religious beliefs: one of them, for example, shows a man with a bow in his hand, battling seven snakes, which can be interpreted as a scene from an Ossetian epic recounting the struggle of the hero Amran with seven snakes. The handles of these axes are usually wood, but some are bronze.

The burial contained many daggers, of two types: one with a wooden handle, and the other cast in one piece, with handles often decorated with small sculptured animals.

The other bronze objects are numerous and varied: there are belts made of sheet bronze with figural clasps, fibulae (fasteners like safety pins), bracelets for arms and legs, pins, and beads. Of special interest are the bronze amulets–small figures of horses, dogs, stags, rams, and birds (seldom human beings). Many of these statuettes or pendants are remarkable for their elegance and laconic forms; the decorative pendants in the shape of rams' heads with wide horns are especially handsome (cat. no. 9). All these pieces are executed in bronze of high quality; by the late second and early first millennium B.C., the tribes in this area knew of iron, but it was used only for decoration, as in the inlay of the flat belt clasp shown in color plate 2 (cat. no. 8).

Since 1869 other cemeteries similar to the Koban burial have been found. Collecting Caucasian bronze objects became a passion for many archaeologists and amateurs in Russia and western Europe, although the careful study of the Bronze Age in the Caucasus onl began early in the twentieth century. Koban objects, suc as bronze belts and axes, have been found along the nort ern shores of the Black Sea region and up to the Dniep area, and can also be found in burials in the souther Caucasus, where there was another culture very close t that of Koban.

The Culture of Urartu
9th–beginning of the 6th century B.C.
[Catalogue nos. 10-16]

During the first half of the second millennium B.C., th Hurrians (who had come into the Near East from th north early in the third millennium B.C.) dominate most of Syria and northern Mesopotamia under the cor trol of Mitannian overlords. Around 1000 B.C., after th fall of the Mitannian state, a Hurrian tribe, called th Nairi, began to unite in northeastern Anatolia. In th ninth century B.C. these tribes created a new state i the region of Lake Van in present-day Turkey, whic immediately became a competitor of Assyria: Assyria called this state Urartu. In Urartean inscriptions, the ce ter of their territory was called the country of the Biaini a word preserved in the name of Lake Van.

The earliest written information about the Urartea occurs on monuments of the Assyrian king Shalmanes III who, from the first year of his reign, 860 B.C., le uninterrupted wars against his northern neighbors. The campaigns are described in his annals and depicted on th bronze gates of a temple at Balawat near Nineveh: th scenes show Assyrian armies leaving their camp, crossin the mountains, and battling the Urarteans–storming for

esses and returning with loot and prisoners.

Despite this opposition, the Urartean state quickly became powerful, and in the first half of the eighth century B.C. extended its rule over a wide area.

Having entered into an alliance with the small states in northern Syria, the Urarteans took possession of the lands down to the western bend of the Euphrates river, gaining control of a main route to the Mediterranean from the southern Caucasus. Simultaneously they started to subjugate the southern Caucasus itself, including the fertile valley of the middle Araxes river and the mountains of Armenia, rich in copper ore and in cattle. Overcoming the resistance of local chieftains, the Urarteans seized the land around Mount Ararat and Lake Sevan (the largest lake in Transcaucasia, in central Armenia), and established military and administrative centers there. In 782 B.C. the Urartean king Argishti I founded Erebuni, a fortress on the northern edge of the Araxes valley, where he settled 6,600 prisoners; somewhat later he founded Argishtihinili ("built by King Argishti"), a large city on the banks of the Araxes.

Assyria could not stand by indifferently as Urartu expanded and grew more powerful. During the reign of Argishti's son, Sarduri II (764-735), the Assyrians undertook two campaigns against Urartu, in 743 and 735 B.C. In the second, they reached and besieged the Urartean capital of Tushpa. Under Sarduri II Cimmerians are first mentioned as being present in the land of the Mannai, to the south of Lake Urmia in Iran; two groups, Cimmerians and Scythians, seem to be referred to in Urartean and Assyrian texts, but it is not always clear whether the terms indicate two distinct peoples or simply mounted nomads. The Assyrian royal archive, found in their capital of Nineveh, contains some remarkable documents, reports from Assyrian scouts in neigh-

boring countries. The most interesting of these is a dispatch from the crown prince Sennacherib, who reports that Cimmerian nomads were marching against Urartu and had inflicted a defeat on the Urartean forces, listing the names of the Urartean commanders who fell in battle. Sargon, encouraged by this defeat to his archenemy, led an ambitious campaign against Urartu in 714 B.C. It ended in a complete victory for the Assyrians, which is described in a long text on a clay tablet found at Assur, while scenes from the campaign, such as the plundering of the Urartean temple in Musasir, southeast of Lake Van, are represented on the walls of the royal palace at Dur Sharrukin (Khorsabad).

After the Assyrian victory of 714 B.C., the Urartean government was reformed; the old administrative centers were abolished and replaced by new ones. The second rise of Urartu is connected with King Rusas II, who ruled in the first half of the seventh century B.C. The Urartean culture of this period is well known from the excavations of the Teishebaini fortress, on the hill Karmir-Blur near Erivan, which replaced the earlier fortress, Erebuni. Objects from the treasury of Erebuni were transferred to Teishebaini; an inscription describing the founding of the new fortress mentions that the "sacred weapons" were brought in and, indeed, during the excavations objects with the names of the earlier Urartean kings of the eighth century B.C. were found: shields (with inscriptions saying they were made by Argishti I for Erebuni), quivers (cat. no. 12), helmets, bronze cups (cat. nos. 10, 11), and horse trappings.

The excavations at Teishebaini provided a vivid picture of life in a Urartean city of the seventh and early sixth centuries B.C. Agriculture, cattle raising, and crafts were all highly developed; especially important is the wide distribution of iron implements and weapons at

this site. As a result of Urartean influence, iron came into common use in the southern Caucasus in the seventh and sixth centuries B.C.

The Teishebaini excavations also produced good examples of Urartean art, which had previously been known only from accidental finds and from the excavations of the fortress at Toprak-Kale, near Tushpa, the Urartean capital. In the eighties of the past century, some bronze statuettes, originally covered with gold leaf, appeared in the possession of dealers; these proved to be parts of a Urartean ceremonial throne (or two such thrones) that had been found by villagers at Toprak-Kale. The statuettes passed into various museums (The British Museum, the Louvre, the Berlin museum, the Metropolitan Museum, the Brussels museum, the Hermitage); among the four statuettes in the Hermitage, the most outstanding is the small figure of a winged lion with human torso (color plate 2, cat. no. 14): the face is of white stone, with colored stone inlays. These small figures belong to the courtly art of Urartu, similar in style to that of Assyria.

The diverse finds at Teishebaini testify to Urartu's widespread contacts: they include Egyptian amulets, Mediterranean jewelry and ceramics, Assyrian seals and bronzes, and Iranian beads and seals. Of special interest are works indicating the connections between Urartu and the Scythians: these consist of Scythian arrowheads (trihedral and forked), iron *akinakes* (the Scythian short sword), and horse trappings–some of horn, others of bronze in the shape of griffins' or birds' heads, and cheekpieces with an animal head at one end and a hoof at the other, similar to those found as far north as the Dnieper region.

In the seventh century Urartean relations with the Scythians were peaceful. This worried the Assyrian kings Esarhaddon and Assurbanipal, a concern reflected in the questions asked of the oracles and requests in hymns to the gods. At this period the Assyrians were involved in constant struggles with the nomads to the north. The Scyths (called "Ashguzai" and "Ishkuzai" by Esarhaddon) were also in the Mannean region: Esarhaddon mentions an Assyrian defeat in a raid led by the Scythians, and the god Shamash is asked whether the Scythian king, Partatua, will remain friendly if Esarhaddon allows his daughter to become the Scythian's wife, as Partatua had requested.

From archaeological data, from cuneiform tablets and from information supplied by Herodotus, we know the Cimmerians and Scythians remained in the Near East many years, and participated in the destruction of Assyria and other ancient Near Eastern centers. For instance Babylonian chronicles of 616-609 B.C., describing the fall of Assyria, tell that nomadic tribes (referred to as "Umman mánda") joined the Babylonian and Median armies in the siege and capture of Nineveh in 612 B.C. Herodotus, in describing their siege, mentions that a large Scythian army appeared under the walls of Nineveh led by Madyes, son of Protothyes (the Partatua of the cuneiform sources).

Also connected with the Scythians' stay in the Near East are the objects thought to have been found at the end of the Second World War in a fortress at Zawiyeh in Iranian Kurdistan. These pieces fall into three categories: Assyrian works of the eighth century B.C., seized as booty; local objects; and pieces combining ancient Near Eastern and Scythian styles. In the latter, one encounters Near Eastern motifs–such as the adoration of the sacred tree-that had obviously lost their original meaning, since figures that used to form a definite composition are now arbitrarily placed; there are also rep

sentations of Scythian themes, such as panthers or stags
ith broad antlers. Especially characteristic of Zawiyeh
bjects is a strongly stylized tree of life, which is also
ncountered on Urartean bronze belts from Teishebaini
nd from other areas influenced by Urartean culture.
acred trees similar to the Urartean ones are also repre-
nted on some Scythian objects, such as the gold sheaths
or *akinakes* found in the North Caucasus at Kelermes
nd in the Ukraine at the Melgunov kurgan, which are
e most striking examples of Urartean artistic influence
mong the objects found in Scythian tombs.

Thus Urartu was very important in transmitting
ncient Near Eastern elements to Scythian art of the end
the seventh and the beginning of the sixth century
.C. But after the occupation of Tushpa by the Medes
the beginning of the sixth century B.C., the Scythians
ruck a decisive blow against the northern Urartean
nters and destroyed them.

he Scythian Culture

nd of the 7th-4th centuries B.C.
Cat. nos. 17-92]

he origins of the Scythians are murky. Herodotus, who
ved in the fifth century B.C., tells three stories of their
eginnings: that they came from Asia and displaced the
immerians from the area north of the Black Sea; that
ey claimed to be descended from Targitaus, the son of
eus and the daughter of the Borysthenes river (the
nieper); and that their ancestor Scythes was the son of
eracles and a creature—half-woman, half-snake—who
velt in the Scythian woodland. Archaeology seems to
nfirm both ideas, of an Asian origin and a local devel-

opment. In 1902 the archaeologist V. A. Gorodtzov, on
the basis of his excavations, suggested that the most an-
cient peoples of the northern shores of the Black Sea
could be divided into three cultures, according to the
strikingly different ways in which they built their tombs:
the pit-grave culture, the catacomb-grave culture, and the
timber-grave culture. This theory has been supported
and made more precise by later archaeological work. The
tombs of the catacomb culture date from the beginning
and middle of the second millennium B.C.; they be-
longed to a Bronze Age people with a developed bronze
metallurgy, whose economy was based on semi-nomadic
cattle-breeding and agriculture. They had already estab-
lished relations with other cultures.

In the middle of the second millennium B.C., the cata-
comb people were replaced on the north shore of the
Black Sea by the timber-grave people, whose tombs were
built like log cabins. This culture had developed to the
east, in the region around the Volga river and the south-
ern Urals, and had spread over a vast territory, remaining
in existence until the mid-eighth century B.C. Again, its
characteristics were a highly developed bronze metal-
lurgy and semi-nomadic cattle-breeding, but with special
emphasis on horse-breeding. Recent studies have con-
vincingly suggested that the Cimmerians represent tribes
of a late stage of the timber-grave culture; they were
well-armed horsemen who could move easily over long
distances.

The tribes of the Scythian culture developed on the
foundation of the late timber-grave culture of the eighth
century B.C. This could explain the two ancient ideas of
Scythian origins, the one involving migration and the
local one, since the timber-grave culture had been spread
by peoples moving westward into the Black Sea region
from Asia.

The earliest typically Scythian artifacts (primarily horse equipment) have been found over a wide area. They occur as far north as the Kiev area on the Dnieper, in the Kuban region (the northeast shore of the Black Sea), in the northern and southern Caucasus, in central Urartu, and in Iran. Within the same territory, and even further into the Near East, have been found characteristic Scythian bronze arrowheads of the second half of the seventh century B.C.

This archaeological evidence is borne out by historical records that refer to the presence of nomads in the Near East during the eighth and seventh century B.C. (It should be mentioned, however, that Assyrian and Urartean documents call these nomads by several names, and it is not always certain whether the terms really indicate distinct, identifiable groups or are meant to imply "nomads" in general; so this documentary evidence should be interpreted with care.)

As mentioned earlier, beginning in the second half of the eighth century B.C., Assyrian sources refer to nomads identified as the Cimmerians; other Assyrian sources say these people were present in the land of the Mannai (south of Lake Urmia in Iran) and in Cappadocia for a hundred years, and record their advances into Asia Minor and Egypt. The Assyrians used Cimmerians in their army as mercenaries; a legal document of 679 B.C. refers to an Assyrian "commander of the Cimmerian regiment"; but in other Assyrian documents they are called "the seed of runaways who know neither vows to the gods nor oaths."

Scythians are apparently first mentioned at the end of the first half of the seventh century B.C., in the texts of the Assyrian king Esarhaddon (681-668 B.C.); called "Ashguzai" or "Ishkuzai," they are said to be in the land of the Mannai. Scholars explain their advance into the Near East in various ways, suggesting that the climate along the north shore of the Black Sea changed, thus forcing the Scythians to search for new grazing grounds, or that a constant inclination toward pillaging is a specific psychological characteristic of nomadic peoples. Another possible explanation, however, is economic. The Near Eastern kingdoms had, for the most part, switched to an economy based on agriculture with extensive irrigation, and their own cattle-breeding was replaced by the import of livestock. The Scythian tribes of the northern shores of the Black Sea must have possessed a considerable surplus of cattle and, since they moved with great ease, began driving part of their herds south of the Caucasian mountains. In exchange for cattle the Scythians received the merchandise they needed: iron, copper, and tin, as well as textiles and jewelry.

Gradually, these commercial relations may have led to less peaceful ones as barter was replaced by seizure, when the nomads discovered their military superiority over the sedentary farmers who lived on the outskirts of the Near Eastern states. The Scythian invasion may also have been encouraged by the great changes that had taken place in the political life of the ancient Near East in the second half of the eighth century B.C., as the old states grew weaker and new ones started to appear; in this inner struggle the nomads (referred to collectively as "Umman mánda") played an important role.

Herodotus gives the following account of their stay:

A numerous horde of Scyths, under their king Madyes, son of Protothyes, burst into Asia in pursuit of the Cimmerians whom they had driven out of Europe, and entered the Median territory. . . . the Scythians [had] turned out of the straight course, and took the upper route, which is much

longer, keeping the Caucasus upon their right. The Scythians, having thus invaded Media, were opposed by the Medes, who gave them battle, but, being defeated, lost their empire. The Scythians became masters of Asia.

After this they marched forward with the design of invading Egypt. When they had reached Palestine, however, Psammetichus the Egyptian king met them with gifts and prayers, and prevailed upon them to advance no further. On their return, passing through Ascalon, a city of Syria, the greater part of them went their way without doing any damage; but some few who lagged behind pillaged the temple of Celestial Aphrodite. . . .

The dominion of the Scythians over Asia lasted twenty-eight years, during which time their insolence and oppression spread ruin on every side. For besides the regular tribute, they exacted from the several nations additional imposts, which they fixed at pleasure; and further, they scoured the country and plundered every one of whatever they could. At length Cyaxares and the Medes invited the greater part of them to a banquet, and made them drunk with wine, after which they were all massacred. The Medes then recovered their empire, and had the same extent of dominion as before. (Book I, 103-106.)[1]

The Scythians' contact with Near East is reflected in Scythian art of the late seventh to sixth century B.C. (Many of these pieces have traditionally been dated to the sixth century B.C., which increases the discrepancy

[1] From "The Greek Historians," edited by Francis R. B. Godolphin. Copyright 1942 and renewed 1970 by Random House, Inc. Reprinted by permission of the publisher.

between the first written mention of Scythians and actual Scythian objects in this area.) The works said to have come from Zawiyeh, south of Lake Urmia, have already been mentioned; these pieces of the late seventh and early sixth century B.C. combine ancient Near Eastern motifs like the tree of life with Scythian ones, like panthers and reclining stags.

A similar combination of Near Eastern and Scythian motifs occurs on works of art found in two early Scythian kurgans, at Kelermes in the North Caucasus and at the Melgunov kurgan in the Ukraine. At both sites was found an iron *akinakes* (the Scythian short sword) whose hilt and scabbard are covered with sheets of gold. Both are decorated with representations reminiscent of pieces from Zawiyeh. Some motifs seem to have lost their meaning (winged genii who fertilize the sacred tree on Assyrian and Urartean works are separate entities, detached from the tree), suggesting that they were copied from Urartean objects – a theory corroborated by the way the animals' bodies are rendered: as flat designs with minute all-over patterns. But Scythian scabbards, unlike Urartean ones, had a projection at the side by which they were attached to the belt; thus the artist, having no model to copy for this part, decorated this projection with Scythian motifs, a reclining stag and birds' heads, executed in a purely Scythian style, a blocky modeling in relief with no patterning.

We do not appreciate sufficiently the role that the copying of individual elements played in ancient art. A round silver-gilt mirror found at Kelermes is another example of such copying of foreign pieces (color plate 4, cat. no. 25). Its relationship to Ionian art was pointed out long ago, but its technique and composition are very different: the motifs were probably copied from several different works. Still another example is the decoration

on a ceremonial axe covered with gold leaf (color plate 7), also from Kelermes. Various animals are distributed on the axe itself and on its handle, while the sacred tree is shown on a separate panel from the distorted figure of the genius; only the depiction of a reclining stag indicates the Scythian origin of this piece, which is decorated in a manner that at first glance seems rather odd.

These Scythian objects date from the end of the seventh or the beginning of the sixth century B.C., the same date as the pieces from Zawiyeh. It has been suggested that the Scythian style originated in the Near East, but it is important to point out that, on the contrary, the so-called Scythian animal style is found over a wide territory in the steppes even by the seventh century B.C. In the Golden Kurgan in Kazakhstan, far to the east, S. S. Chernikov has discovered remarkable gold plaques in the shape of panthers and reclining stags that had been used to decorate a quiver (color plate 4, cat. no. 29), as well as some bronze arrowheads of the archaic Scythian type of the seventh century B.C. (cat. no. 30). Farther east, at Tuva, M. P. Gryaznov found a bronze in the shape of a curled-up predator, which is analogous to gold "Scytho-Siberian" plaques that are dated even earlier.

By the time Herodotus wrote, in the middle of the fifth century B.C., the Scythians of the Black Sea area were grouped into a large confederation of separate tribes. In its most precise form, the term "Scythians" refers to some tribes who lived on the northern shores of the Black Sea, but the "Scythian culture" was shared by various tribes spread over a large territory, with similar ways of life and close interrelations, promoted by nomadic cattle-breeding. The horse made direct communication possible between people living at great distances from each other, and it is no mere coincidence that horse equipment, specifically, is similar over the whole terri-tory inhabited by tribes of the so-called Scythian culture.

According to Herodotus, in the regions of the lower Bug and Dnieper rivers lived the Callipidae (whom Herodotus calls a "Graeco-Scythian race" since the important Greek trading post of Olbia was nearby) and the Alazonians; both tribes raised corn. Still further north were the "Scythian cultivators," who also grew corn, though not for their own use but for sale. To the east of the Dnieper, stretching eastward along the steppes, were the territories of the nomad Scythians, "who neither plough nor sow." And farther east lived the Royal Scyths, "the largest and bravest of the Scythian tribes." The objects in this exhibition come from kurgans in various regions and must have belonged to different tribes, although they are closely similar.

Herodotus describes the nomad Scythians' way of life, with wagons transporting their belongings as they followed their vast herds of cattle and horses. Although he says Scythians had no fortified towns, this must apply only to nomads along the steppes, since we know of Scythian fortified settlements in other regions. For instance, a large settlement called Kamenskoye, an important trading post, has been unearthed near the Dnieper. The lower Dnieper was probably the religious center for the Scythian tribes; some of the richest kurgans are found in this area, which might explain Herodotus' remark that the burials of the nomad chieftains lay far from their own territories.

The first Greek settlements on the northern shores of the Black Sea appeared in the second half of the seventh century B.C. and soon became flourishing trading cities. From the first, they were in close contact with the local peoples, because Scythia was a rich source of grain, cattle, and fish for mainland Greece and the Greek colonies in Anatolia. One of the most significant of these Greek

cities was Olbia, which Herodotus visited to collect information on the Scythians. In exchange for produce, Greeks provided the Scythians with luxury objects— jewelry, weapons, vessels—many decorated with representations of Scythians. Relations between the Greek colonies and Scythians were not always peaceful: fifth-century Scythian settlements began to be surrounded by ramparts and ditches, and Greek towns were provided with stout defensive walls.

We have little certain information about later Scythian history. Herodotus describes the Persian campaign of the late sixth century B.C., in which Darius attempted to subdue them; the Persians left after a fruitless and embarrassing trek through Scythian territory. There is also a semi-legendary story of the Scythian king Atheas, who led a successful war against the Thracians who lived south of the Danube and whose culture was similar to the Scythians'; Atheas fell in battle in 339 B.C. when the Scyths encountered Philip of Macedon. During the same period, according to ancient writers, one of Alexander's generals led an unsuccessful campaign against the Scythians, and in 329-328 B.C. the Scythians sent an emissary to Macedonia.

The history of the Bosporan kingdom is better known. It was founded in the fifth century B.C. along the eastern and western shores of the Cimmerian Bosporus, the straits connecting the Sea of Azov with the Black Sea. Its main city was Panticapaeum, the present-day Kerch. During the fourth century, trade between Greece and the Bosporan kingdom flourished: grain was supplied to Greece, while Greek works of art were imported in exchange. The famous Kul Oba kurgan, near Kerch, was the burial place of a member of the Bosporan nobility: in his tomb were found many rich objects of Greek workmanship, such as the famous gold bottle decorated

with Scythians (color plates 17, 18, cat. no. 81) and pendants decorated with the head of Athena, inspired by the statue in the Parthenon (color plate 16, cat. no. 78). A fifth-century Attic amphora found in Elizavetinskaya (to the west of Kerch) was a prize at the Panathenaic festival in Athens and may have been brought still containing the expensive olive oil it originally held (cat. no. 84). Magnificent Greek works depicting scenes from Scythian life are also found along the Dnieper. Superb examples include the gold comb from Solokha (color plates 12, 13, cat. no. 71) and the silver-gilt cup from Gaimanova Mogila (color plate 29, cat. no. 172). Scythian kurgans and settlements contain other types of Greek wares (including a great number of ceramics from various regions and colonies of Greece, as well as gold, silver, and copper coins), as well as objects imported from other ancient civilizations such as Achaemenid Iran and Egypt (color plate 10, cat. nos. 67, 62).

Between the fifth and third centuries B.C., the Scythians not only were in contact with the civilizations of Greece, Egypt, and the Near East, but shared a cultural unity with many other tribes living in the steppe region of eastern Europe and Asia. In art, an indication of such unity is the so-called animal style. Powerful, stylized, and decorative, this style is characteristic of a wide territory stretching from Hungary to China. It portrays animals and birds with their most important attribute— horns, paws, hooves, jaws, beaks, ears—exaggerated or accentuated. Predatory beasts and birds were important subjects, and the animals often appear locked in combat or in one of several characteristic poses: lying with legs folded under, curled into a circle, or running. These images probably had religious or magic significance: representations of strong, frightening, or speedy animals on the weapons or armor of a mounted warrior would

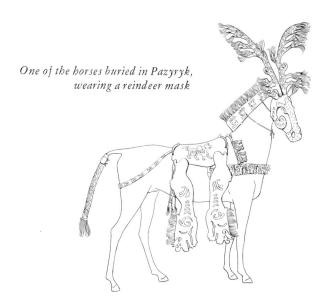

*One of the horses buried in Pazyryk,
wearing a reindeer mask*

be expected to increase his power and protect him from evil. Works in the animal style are often small, useful, and easily portable, and the most widely distributed objects are weapons and horse equipment, as might be expected of nomads' possessions. Spread over the vast expanse of the Eurasian steppes, they testify to the wide intertribal exchanges between Scythians and the other peoples of these lands.

The Culture of the Altai Mountains

6th–4th centuries B.C.
[Catalogue nos. 100-142]

A large group of objects in this exhibition comes from the extraordinary kurgans of the Altai mountains in Siberia. The kurgans, at Tuekta, Bashadar, and Pazyryk, were built between the sixth and fourth centuries B.C. in mountainous regions difficult to reach. Immediately after the burials, water had seeped into the stone mounds and turned to ice; this permafrost has preserved some five thousand objects of wood, textiles, felt, leather, and fur.

The antiquities from the Altai kurgans at the Hermitage are particularly valuable since many are the most ancient examples of those arts and crafts for which time shows no mercy—an embroidered silk textile, a knotted rug, felt appliqués, and leather and wooden parts of horse equipment. All the kurgans had been robbed in antiquity, but the robbers only took objects made of precious metal, leaving the rest of the contents strewn about. The most important material comes from the Pazyryk excavations carried out in 1929 by M. P. Gryaz-

nov and S. I. Rudenko, and between 1947 and 1949 by Rudenko.

Under one mound at Pazyryk was a chamber lined with wooden logs, built in a trench about 164 feet square and from 13 to 23 feet deep. In the chamber was a sarcophagus hewn from a single log, decorated with scenes of animal combat. The body of the dead man had been embalmed, and on the skin of his arms, chest, and legs tattoos of animals and fish can still be seen. The chieftain's wife or concubine had been buried with him, and in the grave had been placed clothing (cat. no 125), ornaments, furniture, objects of everyday life, and musical instruments—everything that had surrounded him while he was alive; there was also a bronze cauldron filled with burnt hemp seeds, corroborating Herodotus' account of a Scythian custom (Book IV, 73-75).

Everything connected with the funerary procession and ritual had been placed in a trench near the outer wall of the chamber. In Pazyryk kurgan 5, near the north wall were found bodies of richly caparisoned horses, a wooden chariot on large wheels, a felt wall hanging (part of the funerary tent) with two pictures of a seated woman holding a branch with a horseman before her, poles from the tent or chariot with felt swans as finials (color plate 25, cat. no. 118), a remarkable woolen rug, and other objects. The horses of the funerary procession were tall and slender, and of a different breed than the small local ones, known from common burials. They wore lavishly decorated saddles and bridles, with straps ornamented by a multitude of wooden plaques (often covered with gold or tin) depicting birds, animals, or mythical creatures, either sculptured or in relief. The saddles were also richly decorated, with ornaments made of varicolored pieces of felt or leather, and sometimes with important Iranian or Chinese textiles. Most of the scenes depict

animal combat, often mythical and close in style to those seen in Scythian art. Two steeds, who probably led the procession, were particularly outstanding: each wore an elaborate mask, one in the shape of a griffin's head, the other in the shape of the head of a reindeer with enormous antlers.

The Altai kurgans belonged to chieftains of rich tribes of herdsmen similar to the Scythians, who roamed over vast territories connecting the Far East with Europe. Their path preceded the later, more famous "silk route," which lay further south. It is no accident that works of art in the Altai kurgans bear witness to these people's

A Pazyryk kurgan

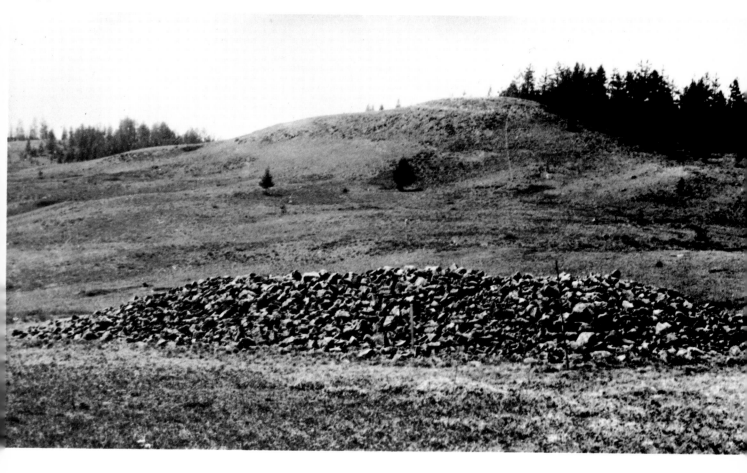

wide cultural connections: with the Far East, Central Asia, the Near East, and with the Scythian world. For instance, from kurgan 5 at Pazyryk comes a magnificent Chinese textile embroidered with birds sitting on branches or fluttering around, which had been made into a saddle blanket (color plate 23, cat. no. 117); fragments of other Chinese textiles have been found in other Pazyryk kurgans. The chariot with big wheels and covered seat is probably also Chinese: Rudenko suggests that it was a wedding chariot, brought by the Chinese bride of an Altai prince as part of her dowry. There is a woolen rug with nap, richly decorated with stylized birds' heads, fallow deer (known as "speckled stags"), floral patterns, and borders of horsemen. Although this rug cannot be positively identified as Iranian, some of the other textiles certainly are; these include fragments of woolen textiles with patterns similar to those on the clothing of Achaemenid warriors depicted on glazed tiles from Susa. Also Iranian are textile fragments with a row of striding lions (cat. no. 116), like those on the frieze of the processional road in Babylon near the Ishtar gate, and with women standing before incense-burning altars.

The Altai artisans were not simply borrowers, but were magnificent craftsmen in their own right: their carvers, for instance, created distinctive works in wood and bone that are remarkable for their realism, decorative quality, variety of compositions, and wealth of imagination. Especially beautiful is the pole top in the shape of a griffin holding a stag's head in its beak (cat. no. 126), and the miniature figure of a stag with spreading antlers is exquisite (cat. no. 127). These rich and interesting finds from the permafrost of the Altai kurgans remind us that excavations usually reveal only those few objects made of materials that can withstand the destructive actions of nature and of time.

The Culture of Siberia

6th–3rd centuries B.C.
[Catalogue nos. 143-161]

Thousands of ancient kurgans surrounded by tall vertical stones are a distinctive feature of the mountainous steppe landscape of the Minusinsk district of Siberia. Most of them were left by contemporaries of the Scythians, the tribes of the Tagar culture, named after the location of excavations on the Tagar lake and island, near Minusinsk.

Archaeological exploration has been going on in the Minusinsk region since the beginning of the eighteenth century. In 1722 D. G. Messerschmidt's expedition, commissioned by Peter I, carried out the earliest excavations of the kurgans on the Yenisei river and sent a number of objects to Peter's *Kunstkammer*. Intensive collection and study has continued; important excavations were conducted in the 1920s.

The Tagar tribes lived during the seventh to third centuries B.C. in the Minusinsk basin on both shores of the Yenisei river, and spread northward to present-day Krasnoyarsk. Their occupations were herding, farming, hunting, and fishing. Favorable geographic conditions allowed their horses and long- and short-horned cattle to graze year-round, and on their territory structures to irrigate the fields and provide water for livestock have been found. The Tagar tribes also possessed a highly developed metallurgy, producing bronze knives, daggers, battle axes, mirrors, finials, horse equipment, and decorations. Their ceramics have a distinctive appearance: there are conical black polished jars, often with wide grooves along the upper edge, and various types of red clay vessels (cat. no. 147).

Characteristic of the Tagar period are tombs in the shape of earthen kurgans, with a four-sided enclosure of vertical slabs at the bottom. Tall stones stand at the corners of the enclosures, and often in the middle of their sides. The dead were buried in a stone box or log sarcophagus. Later in the Tagar period collective burial vaults occur, containing up to two hundred people who were buried over a number of years.

Tagar art is marked by the so-called Scytho-Siberian animal style. Their artists liked to represent horses, birds, mountain goats, wild boars, a feline predator, and stags; most often the animals are shown standing. Such representations appear on knife handles, dagger hilts, finials, battle hammers, clothing ornaments, and horse trappings. This art is monumental, decorative, and characterized by its peculiar, abbreviated stylization, which allows us to distinguish the work of Tagar artists from similar pieces from other regions. Although Scythian traits can be detected in the works of art and the weapons and armor, the Tagar tribes preserved their originality more than any others of the Scythian epoch, partly because they were a settled people, rather than nomadic, and because they lived in the deep Minusinsk basin, isolated from the rest of the world—surrounded on three sides by mountains and on the north by forest. These natural barriers prevented the mass penetration of other tribes into their territory, but did not interfere with their commerce with their neighbors. The peoples who developed the Tagar culture are the last large group of Europoid settlers in Eurasia.

Further east lived peoples of Mongoloid appearance, and in the cultures of these tribes of Transbaikalia and Mongolia there are many traces of so-called Scythian traits, especially evident in the art of the animal style.

The Sarmatian Culture

1st century B.C.–1st century A.D.
[Catalogue nos. 162-165]

Contemporary with the Scythians and, like them, mounted herdsmen, were the Sauromatae, who lived in the steppes around the Ural mountains and the Don and Volga rivers, and who seem to link the Scythian world with that of the Sakas of Central Asia. In the third century B.C. the Sarmatians developed from this ancient culture, and by the second and first centuries B.C. they had conquered much of Scythia as well as the towns along the north shores of the Black Sea. Later, in the third and fourth centuries A.D., the Sarmatians were driven out by other nomadic tribes, such as the Huns.

This exhibition includes several Sarmatian objects from the "Novercherkassk Treasure" (cat. nos. 163-164), which were discovered by accident in the 1860s. These elaborate works are remarkable for their striking decorative effect and complicated compositions involving fantastic animals; many are encrusted with colored stones, glass, and pearls. Also in the show is a bracelet found in 1954 in a kurgan in the Volga region (cat. no. 162), which reflects a complex version of the animal style.

The most important goal of this exhibition is to present magnificent examples of ancient art: the sumptuous masterpieces made by and for the Scythians, and examples of the dramatic art from the ice-bound Altai tombs. The other material illustrates the relationship of these peoples with contemporary cultures and with cultures that preceded and followed them, and shows how the far-ranging contacts between the tribes of the first millennium B.C. carried this handsome, powerful art over the vast expanse of the steppes.

Excavations and Discoveries in Scythian Lands

Adapted from a Russian text by Boris Piotrovsky
The State Hermitage Museum, Leningrad

In 1725, 250 years ago, the Russian Academy of Sciences was founded; its first statute established the study of ancient history. But interest in the country's past had already begun in Russia; as early as the sixteenth century, Russian antiquities were being gathered in the Kremlin's Armory Hall.

The first real museum in Russia was the *Kunstkammer,* founded in 1714 by Peter the Great. From boyhood Peter had collected weapons, then coins and medals, and during his reign he purchased works of art. Fascinated by antiquities, Peter was interested in the discovery of mammoth bones at Kostonka, near Voronezh on the Volga river (where Stone Age settlements are still being investigated). Reflecting his varied interests, Peter's *Kunstkammer* contained zoological, botanical, and mineral collections, curiosities, and antiquities. A year after it was founded, Alexis Demidov, owner of a metallurgical industry with many mines in Siberia, donated twenty ancient gold objects: they had been found in kurgans—the Russian term for burial mounds—in Siberia. The next year, the Governor of Tobolsk, M. P. Gagarin, sent the *Kunstkammer* fifty-six similar gold objects, two of which are included in this exhibition (color plate 22, cat. nos. 97, 99).

In 1718 a special government decree ordered the "collecting from earth and water of old inscriptions, ancient weapons, dishes, and everything old and unusual"; it also recommended making notes and drawings of finds (sound scientific instructions, though often ignored).

During this period, the first half of the eighteenth century, the Academy of Sciences sent scholarly expeditions to Siberia to collect antiquities, in northern Kazakhstan and around the Irtysh, Ob, and Yenisei rivers. The director of the first expedition, D. Messerschmidt, mentioned in his diary for 1721 that digging up gold and silver from ancient graves had become a kind of trade in Siberia. This was confirmed by G. F. Miller, who worked in Siberia from 1733 to 1743 and wrote the first history of this vast land, mentioning the archaeological finds.

Archaeology became firmly established as part of the exploration program of Russian geographers, ethnographers, and historians, who were commissioned by the Academy of Sciences. The *Kunstkammer's* "marvelous and mysterious collection of Siberian antiquities"—as it was still called by Russian archaeologists in the beginning of the twentieth century—was handed over to the Academy of Sciences in 1723; in 1859 it was passed on to the Hermitage, then a court museum.

The antiquities hidden in the kurgans on the steppes of the Caucasus and the northern shores of the Black Sea attracted attention later than the Siberian ones. In 1763 a kurgan near Elizavetgrad (now Kirovograd) in the Ukraine was dug up under the supervision of General A. P. Melgunov. This mound contained a rich burial of the late seventh or early sixth century B.C., including many objects of gold and silver. Special attention was attracted by an iron *akinakes*—the short sword characteristic of the Scythians—in a scabbard covered with gold, on which fantastic animals were depicted. At that time the Scythian culture was unknown, and the find was not fully appreciated. The objects from this burial entered the *Kunstkammer* and later, in 1859, came to the Hermitage. The *akinakes* and its scabbard were separated from the other pieces, and were exhibited with works from Sasanian Iran. No attention was paid to the silver legs from a taboret (cat. no. 17), which have been identified as Urartean, because no one knew of this culture. (Similarly, the first Urartean antiquities to enter the Hermitage, which had been found on the Russian-Persian frontier and were given by the Governor of Erivan,

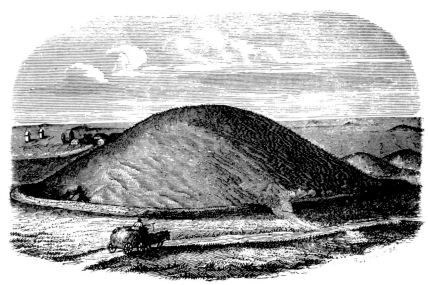

The Alexandropol kurgan

N. P. Koliubakin [color plate 2, cat. no. 13], remained unidentified for a long time and were also exhibited in the Sasanian section.)

By the end of the eighteenth century, travelers in south Russia began to mention in their reports the large ancient kurgans that they encountered on their journeys: the famous Chertomlyk kurgan is mentioned in such an account in 1781, although it was not studied until eighty years later.

In 1794, the scholar P. S. Pallas was commissioned to prepare a description of the Black Sea district annexed by Russia, and during his visit to the Bug river estuary his attention was attracted by the ruins of an ancient town, which he correctly identified as Olbia, a colony settled by Greeks from Miletus. Systematic excavations of Olbia, begun in 1901 and still continuing, have proved the great influence of this town–an outpost of Greek civilization on the frontiers of Scythian territory–on Scythian culture of the north shores of the Black Sea.

The excavations that inaugurated the study of Scythian antiquities took place at the Kul Oba kurgan near Kerch, an important ancient city on the straits connecting the Black Sea with the Sea of Azov to the north. In 1830, in the course of a construction project, a stone burial vault was discovered beneath the kurgan's mound. Connoisseurs of antiquities came to the site and found a rich burial of the fourth century B.C.–the tomb of a Scythian chieftain, along with his wife and a servant. Around his neck the chieftain wore a magnificent gold torque ending in figures of Scythian horsemen (color plate 19, cat. no. 82); nearby were other precious objects, such as an iron sword in a gold sheath and an elaborately embossed libation bowl (color plate 20, cat. no. 83). Like her husband, the chieftain's wife had been buried in luxurious clothes decorated with small gold ornaments,

and near her head were gold pendants representing Athena (color plate 16, cat. no. 78), copied from the famous statue of the goddess by Phidias in the Parthenon. By her feet lay a remarkable vessel depicting Scythians (color plates 17, 18, cat. no. 81). Under the floor of the crypt was a secret hiding place, from which comes the massive gold plaque in the shape of a stag (color plate 15, cat. no. 77) that may have been a shield decoration. The excavators, I. A. Stemikovsky and P. Dubrux, made a schematic drawing of the arrangement of the burial, and took the measurements of the crypt itself. In 1831 the Kul Oba objects were handed over to the Hermitage, becoming the foundation of its famous collection of Scythian antiquities, and the imperial court granted two thousand rubles for further exploration in Kerch.

Between 1853 and 1856 the Alexandropol kurgan was explored; this was one of the largest Scythian mounds in the Dnieper river region, almost seventy feet high. The excavation was undertaken because two bronze pole tops had accidentally been discovered there in 1851–one a rather crude figure of a goddess, the other with an elegant crescent shape crowned by three birds (cat. nos. 89, 90)–but the actual burials, of the fourth and beginning of the third century B.C., had been totally ransacked. The archaeologists did, however, find the burial of fourteen horses with many gold and silver ornaments, as well as another grave containing a single steed wearing a richly decorated bridle and saddle. It had been buried in a posture typical of animal representations in Scythian art: its legs were drawn under the body and its head and neck stretched forward. The burial of horses–a mainstay of the Scythians' economy–is characteristic of Scythian kurgans; often many of them are buried at a single site, a custom described by Herodotus (Book IV, 71-72).

Intensive excavations of kurgans both in the Ukraine and in the Kuban region of the North Caucasus were begun in the second half of the nineteenth century. Exhibitions of recently excavated antiquities were presented in the Winter Palace, and the best of them were given to the Hermitage for safekeeping.

In 1863 the Hermitage was enriched by a magnificent collection of objects indicating the connection of the Scythians with Greece and Iran. These came from the extraordinary Chertomlyk kurgan, excavated by I. E. Zabelin, which closely resembled the Alexandropol kurgan in size and construction. By great good fortune, much of this fourth-century burial lay untouched; robbers, indeed, had been at work, but the roof of the burial chamber had collapsed and the skeleton of one of them was found trapped inside their tunnel. Among the finds concealed in secret recesses of the main chamber was an iron sword with a gold hilt with Iranian decoration, and a gold scabbard of Greek workmanship depicting a griffin attacking a stag and a battle between Greeks and Persians (color plate 10, cat. nos. 67, 68).

The Great Bliznitsa kurgan on the Taman peninsula was excavated between 1864 and 1868: this was apparently a family cemetery, since it contained four separate burial crypts. The first of these belonged, it is believed, to a priestess of Demeter, because a picture of the goddess was found on the ceiling; amidst the gold jewelry it contained were plaques depicting dancers (color plate 9, cat. no. 65). No less interesting were some of the finds from the fourth crypt, which included an Iranian seal showing a king wrestling with a lion, and an Egyptian amulet of the god Bes (cat. nos. 62, 63). The amulet might have reached this area via Iran, since many Egyptian amulets depicting Bes were found in the excavations at the Achaemenid capital of Susa. At least ten Iranian

seals have been unearthed along the northern shores of the Black Sea and in the North Caucascus, while even more Egyptian objects have been found. For instance, an Egyptian alabaster vessel with cuneiform and hieroglyphic inscriptions mentioning the name of the Near Eastern king Artaxerxes was discovered in the southern Urals, and many other Egyptian works, particularly amulets, have been discovered in the Caucasus, near the Black Sea, and in the steppes around the Don and Volga rivers. Until the sixth century B.C. they reached these areas by way of the Near East, more specifically through Urartean centers, while from the sixth century B.C. on, when Miletan colonies such as Olbia developed in the Black Sea area, they were sent north from the large Miletan colony at Naucratis in Egypt, on the Nile delta. Beautiful examples of scarab amulets from Naucratis have been discovered in the archaic necropolis of Olbia, while a number have been found in burials along the slopes of the southern Caucasus mountains.

A hundred years ago, in 1875, V. Tiesenhausen began his successful excavations of seven kurgans near the mouth of the Kuban river. Known as the "Seven Brothers," they date from the fifth and early fourth centuries B.C. Important finds from the fourth kurgan included a silver Achaemenid rhyton and some triangular gold plaques that also showed strong Iranian influence in their decoration (color plate 11, cat. nos. 48, 49), together with Greek pottery, and a bridle plaque that is purely Scythian in style (cat. no. 50).

The late nineteenth and early twentieth centuries were marked not only by continued exploration of Scythian sites, but also by important finds of pre-Scythian and early Siberian cultures of the North Caucasus, especially in the Kuban region.

In 1897 N. I. Veselovsky excavated the large kurgan

n the town of Maikop discussed earlier. The combina-
ion of flint and copper tools and precious objects of an-
ient Near Eastern origin opened a new, little-understood
vorld, and arguments raged over the age of this tomb,
vith scholars suggesting dates as much as twenty-five
undred years apart. The next year, Veselovsky exam-
ned two kurgans near the village of Novosvobodnaya
formerly Tsarskaya), and found two dolmens of large
tone slabs underneath the mounds; inside these kurgans
vere flint ferrules and copper tools and weapons, as well
s gold and silver objects. It has now been established
hat the Novosvobodnaya kurgans are somewhat later
han the Maikop ones–probably of the late third and
arly second millennium B.C.–but at that time their date
vas a puzzle.

Finds in the Kuban region continued to baffle archae-
·logists. In 1903 a mining technician, D. G. Schulz, dug
p four early kurgans in the village of Kelermes, which
·roduced extraordinarily precious works of art. Among
he treasures were an iron sword with a gold hilt and
cabbard, with representations of Near Eastern type
losely related to those on the scabbard from the Mel-
·unov kurgan, an iron ceremonial axe mounted on a long
·olden handle (color plate 7), a gilded silver mirror
vith unusual designs (color plate 4, cat. no. 25), and
large gold plaque in the shape of a panther, a particu-
·rly magnificent example of Scythian art (color plate 5,
at. no. 28). The archaeologist N. I. Veselovsky was sent
· Kelermes in 1904; the two kurgans he excavated
·roved to have been pillaged, although they provided in-
ormation about the construction of the burial chambers,
·hich were made of wood in the shape of a tent with
pyramidal roof: more than twenty horses were buried
long the sides of one. The Kelermes kurgans were simi-
ar to the Kostromskaya kurgan, which Veselovsky ex-

cavated in 1897, and from which comes the golden stag
(color plate 3, cat. no. 18), no less famous than the
Kelermes panther.

These early monuments of Scythian culture are tradi-
tionally dated to the beginning of the sixth century B.C.,
but there are several reasons why they should probably
be dated to the end of the seventh century B.C. or the
turn of the seventh to sixth centuries. For instance,
objects from these early Scythian kurgans have definite
relations with the remarkable pieces said to come from
Zawiyeh in Iran, which combine ancient Near Eastern
and Scythian decorative motifs. In addition, finds from
Urartean centers such as Teishebaini (Karmir-Blur)
include Scythian arrowheads, cheekpieces, and bridle
plaques similar to those found at Kelermes, ceramic
beads like some found in the Dnieper region and in early
Scythian burials in the Mozdok region, and also objects
similar to Zawiyeh ones.

Important excavations took place in 1898 and 1908-
1909 in Ulski Aul, a town near Kelermes and Kostrom-
skaya. Although all the kurgans had been robbed, the
archaeologists were able to collect several interesting ex-
amples of early Scythian art, such as two handsome
bronze standards (color plates 6 and 8, cat. nos. 31, 33).
Under the forty-six-foot-high mound of the first kurgan
was a grandiose wooden structure with pillars in the cor-
ners, and wooden hitching posts all along the sides.
Lying around the posts were the skeletons of more than
three hundred and sixty horses–eloquent testimony to the
vast herds owned by this nobleman's tribe.

Almost every year there were new discoveries in the
North Caucasus and the Kuban region, but such interest-
ing finds from the Ukraine were rare. It seemed as if all
important kurgans had already been investigated and
only pillaged tombs remained–which meant enormous

Excavating the Solokha kurgan

efforts might produce very modest results.

But the unexpected can happen. Archaeologists had long noticed, on the left bank of the Dnieper river, a large kurgan that local inhabitants called "Solokha." An excavation slated for 1883 did not get underway, and it was not until 1912 that N. I. Veselovsky, who often had good luck, took over this assignment.

The kurgan had clearly been robbed, but the archaeologists were counting not only on the fact that thieves usually left a few things behind, but also on the fact that Scythian kurgans often contained secret compartments where the exceptionally valuable objects were hidden. The archaeologists' calculations proved to be correct.

Only a few finds were made the first year. The burial chamber under the mound had been ransacked, although some gold clothing ornaments and a silver drinking cup with a Greek inscription were collected.

The second year was luckier. The archaeologists uncovered another chamber, near the edge of the mound, which robbers had never discovered. It had three niches in its walls: the owner of the tomb had been buried in one of them, and the other two contained an enormous number of gold and silver objects—magnificent examples of ancient art. On the skeleton were gold bracelets, a torque, and clothing ornaments (cat. no. 72), some depicting two Scythians sharing a drinking horn, in a ritual described by Herodotus. Silver vessels stood all around, and near the skeleton lay an iron sword in a wooden sheath, both covered with gold. By his head was a bronze helmet of Greek type and an extraordinary gold comb that is rightly considered a masterpiece (color plates 12, 13, cat. no. 71). Made in the beginning of the fourth century B.C. by a Greek craftsman for Scythians, the comb depicts a battle between two horsemen (one of whom has lost his mount) and a soldier on foot. In a secret hiding place was a massive gold libation bowl, completely covered with scenes of animal combat (color plate 11, cat. no. 70).

The next important discoveries in the Ukraine took place forty years later; in 1954 A. I. Terenozhkin explored a plundered kurgan of the fourth century B.C. in the town of Melitopol: many gold ornaments for clothing were found in the burial of a woman, including a curious plaque depicting a spider and an insect (color plate 30, cat. no. 178). A hidden recess contained a gorytus—a case for bow and arrows, typically Scythian—covered with gold leaf stamped with animal combats and a scene from the life of Achilles; it was so similar to examples from the Chertomlyk and Ilyintsy kurgans that it was obvious they had been made with the same stamp; five years later a fourth gorytus of this type was found within the delta of the Don river, and they all must have been produced in the same workshop (cat. no. 186).

Excavations of Scythian burials were increased during 1960 and 1961, when work on an extensive irrigation system was undertaken in the steppes around the Black Sea. During this period, archaeologists from the Institute of History of the Ukrainian Academy of Sciences excavated some three hundred kurgans.

Some very interesting finds were made in 1969 and 1970 in the course of excavations at the Gaimanova Mogila kurgan, directed by V. I. Bidzil. A silver-gilt drinking cup is one such find: of Greek workmanship, it represents two groups of seated Scythians, while under the handles are servants carrying leather gourds with wine and a goose (color plate 29, cat. no. 172). It is

possible that this represents some legend or event well known to the Scythians; archaeologists studying Scythian art are becoming more and more convinced that representations called "scenes from the daily life of the Scythians" may be meaningful rather than simply decorative.

The excavations of the Tolstaya Mogila kurgan, near the town of Ordzhonikidze, have been of special importance. They were carried out in 1971 under B. N. Mozolevskii. The main burial had been robbed, but graves of servants and horses were discovered nearby. One of the horses was wearing a frontlet identical to one found in the Tsimbalka kurgan (excavated by I. E. Zabelin) with a representation of a snake-legged woman (color plate 11, cat. no. 69). In addition to gold ornaments and a gorytus, the central grave contained a sword in a handsome gold scabbard (color plate 30, cat. no. 170).

The greatest discovery at Tolstaya Mogila, however, is a gold pectoral of magnificent workmanship (cover, color plates 31-33, cat. no. 171). Its three tiers of decoration include meticulously detailed figures of Scythians and animals, each individually cast. Two Scythians are shown making a shirt, another is milking a ewe, and a fourth holds an amphora. They are shown in the midst of their livestock–horses, cows, sheep, goats, and a pig–while nearby are creatures ranging from birds and grasshoppers to griffins savagely tearing at horses. It is possible that this superb piece comes from the same workshop as a simpler one from the Great Bliznitsa kurgan.

The detailed study of Scythian burials of the sixth century B.C. in the Ukraine has shown that there is a direct link between the Scythians and the Caucasus.

Bronze chariot finials found near the town of Romny are quite close to those from Ulski Aul in the Caucasus, while a Koban battle axe was found near Lubny, in the Sula river area. In the Podgortsy treasure trove in the Kiev district an engraved bronze belt of Caucasian type was found, while a kurgan near Zhabotin village contained a Caucasian bronze vessel with handles shaped like small animal heads.

Conversely, archaeological material in the Caucasus also clearly documents the Scythian penetration into the Near East, corroborating Herodotus' account of Scythian campaigns in the Near East and their sojourn there. There are many burials all over the southern Caucasus that without doubt belong to the Scythian culture: they occur in Georgia, Armenia, and Azerbaijan. As mentioned earlier, numerous Scythian objects, especially horse trappings, were found in the ruins of the ancient Urartean fortress Teishebaini (Karmir-Blur): the closest analogies for them come from the kurgans of the Kuban district and Scythian burials in the Ukraine. Thus the connection between the Scythians and Urartean cities in the southern Caucasus is clear, and it was apparently from these centers that iron was brought to Scythia.

Modern archaeological research is being devoted not only to kurgans but also to Scythian fortified settlements and to Greek outposts where Greek civilization and Scythian traditions overlapped. Much study is also being devoted to the other tribes who seem to have shared many elements of Scythian culture, such as the Sarmatians and the Siberian peoples discussed earlier. Gradually such research is clearing away the mists still shrouding these ancient peoples who left us such bold and powerful works of art.

Color Plates

Plate 1

This elegant pin is in the shape of an axe characteristic of the Koban culture, which arose in the north Caucasus about 1000 B.C. Flat metal strips were once attached to the loops to make a jingling noise. (Cat. no. 6)

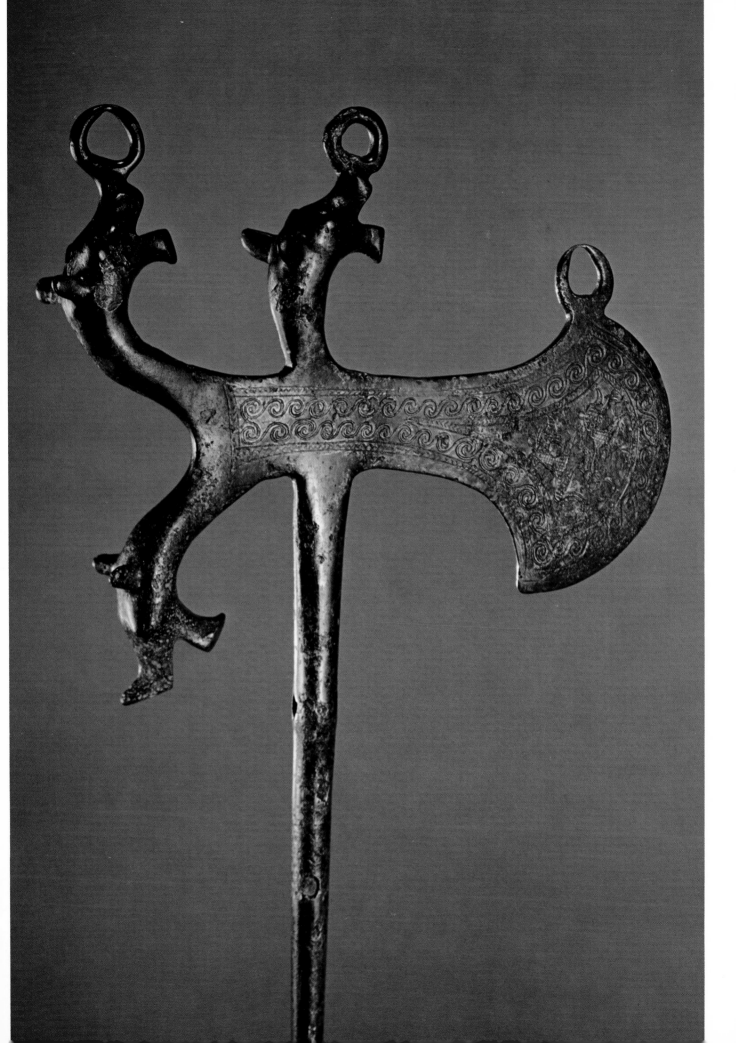

Plate 2

From the rich burial of a chieftain
at Maikop and dating from the end of
the 3rd millennium B.C., these gold
plaques were probably ornaments from
a funerary canopy. The form of both
lion and bull indicates the influence of
the civilizations of Anatolia and
Mesopotamia on the people of the
North Caucasus. (Cat. no. 1)

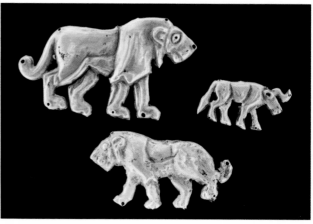

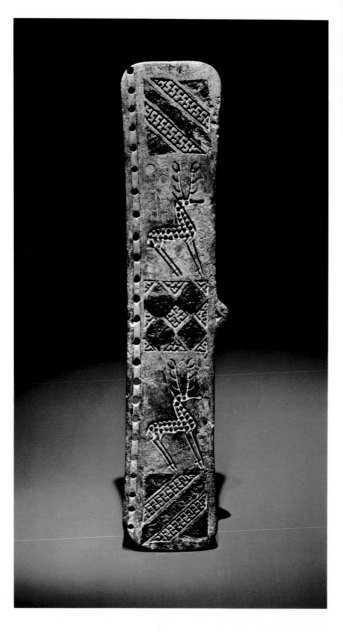

Many examples of the important bronze
industry of Urartu—a state established
in Armenia about 1000 B.C.—have
survived. Fantastic animal-human figures
such as the ones at the right were
favorite motifs: the creature above
probably decorated a throne, and the
bird with a female torso was a cauldron
handle. (Cat. nos. 13, 14)

The vivacious animals and geometric
forms decorating this Koban belt clasp
are inlaid with iron, illustrating the
ornamental use of this metal before
it was used in the manufacture of
weapons or tools. (Cat. no. 8)

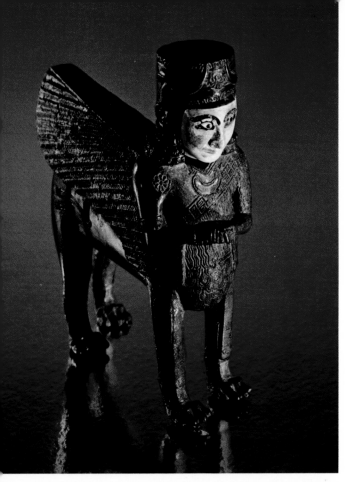

Plate 3 (overleaf)

This golden stag—12½ inches long—
was found lying on an iron shield
that it must originally have decorated,
one of the few instances in which it is
absolutely certain how the Scythians
used such large, animal-shaped plaques.
It was found at Kostromskaya, between
the Black and Caspian seas, and was
made in the late 7th or early 6th century
B.C. The stag was one of the most
popular Scythian motifs, and was
possibly one of their totems. The beveled
surface suggests that this style was
developed in some carved material such
as wood or bone. (Cat. no. 18)

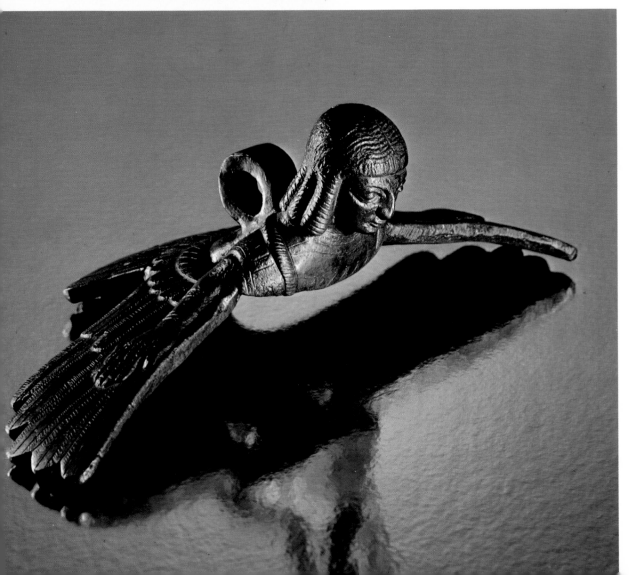

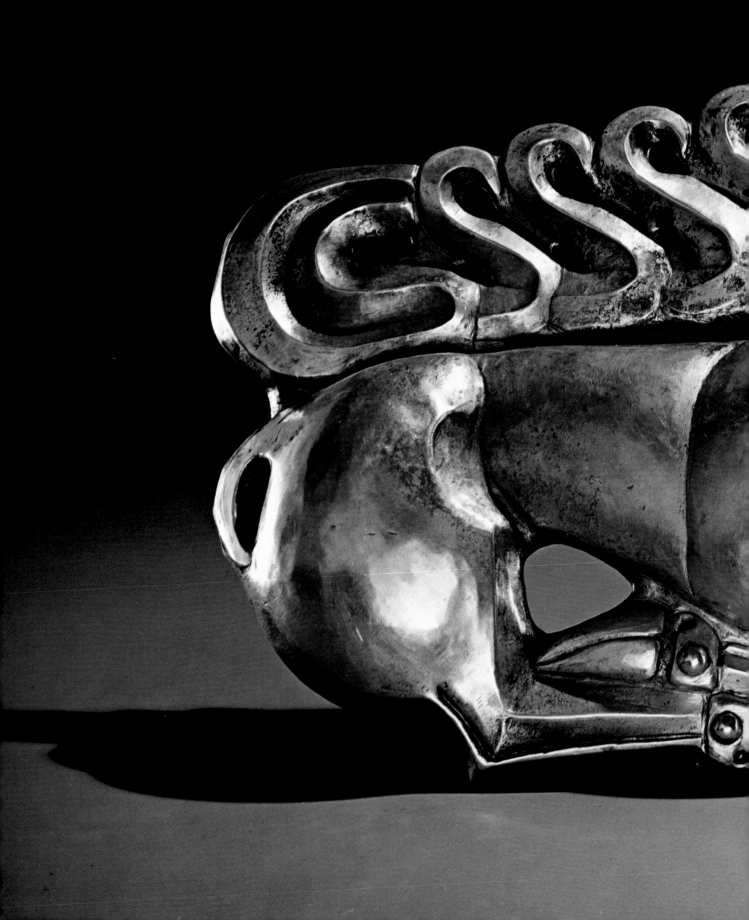

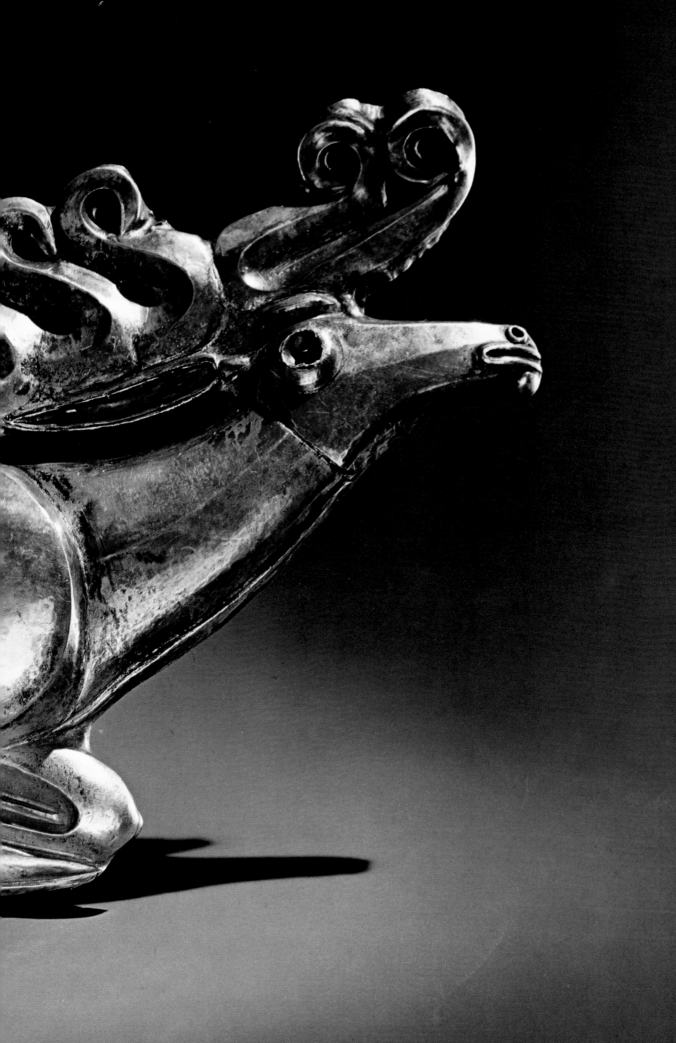

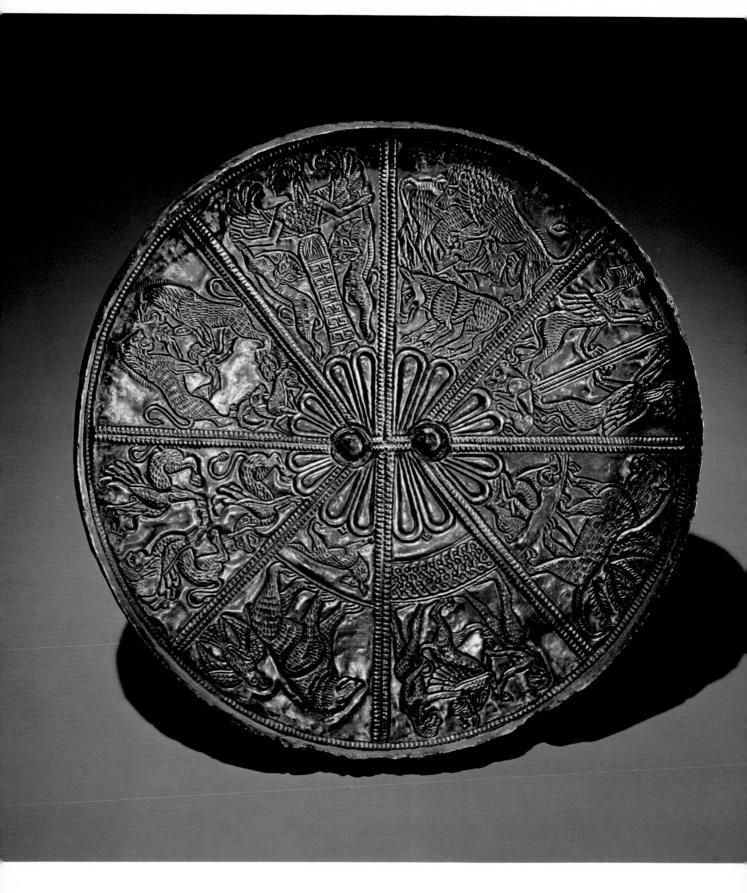

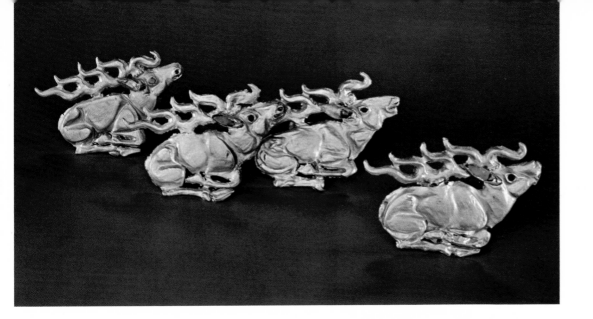

Plate 4

Made of silver covered with gold leaf, the mirror back at the left combines a Far Eastern shape with Greek, Near Eastern, and Scythian decorative themes. (Cat. no. 25)

The turquoise for the inlay of the ears of the reindeer shown above was available in Siberia and eastern Iran. (Cat. no. 29)

Stags and felines of symbolic significance were considered to be appropriate decorations for weapons. The positions of both animals on the plaque at the right are those endlessly repeated in Scythian works of art. (Cat. no. 26)

Plate 5 (overleaf)

Found in one of the two earliest Royal Scythian tombs, this extraordinary panther was made in the late 7th or early 6th century B.C. Its tail and paws are made up of other small felines. The inlays of glass paste and stone are a minor part of the design, but the taste for such colorful additions increases during the following centuries until it becomes a major element in the art of the Sarmatians and Huns. (Cat. no. 28)

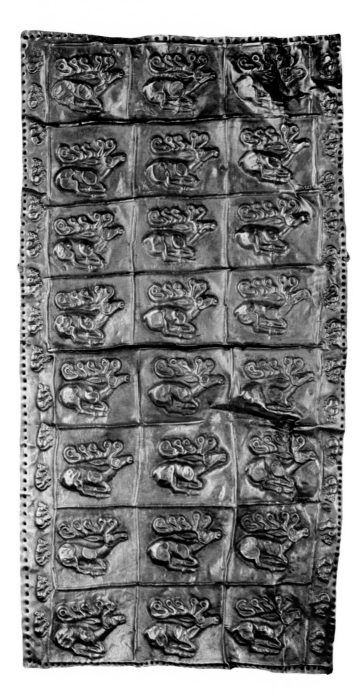

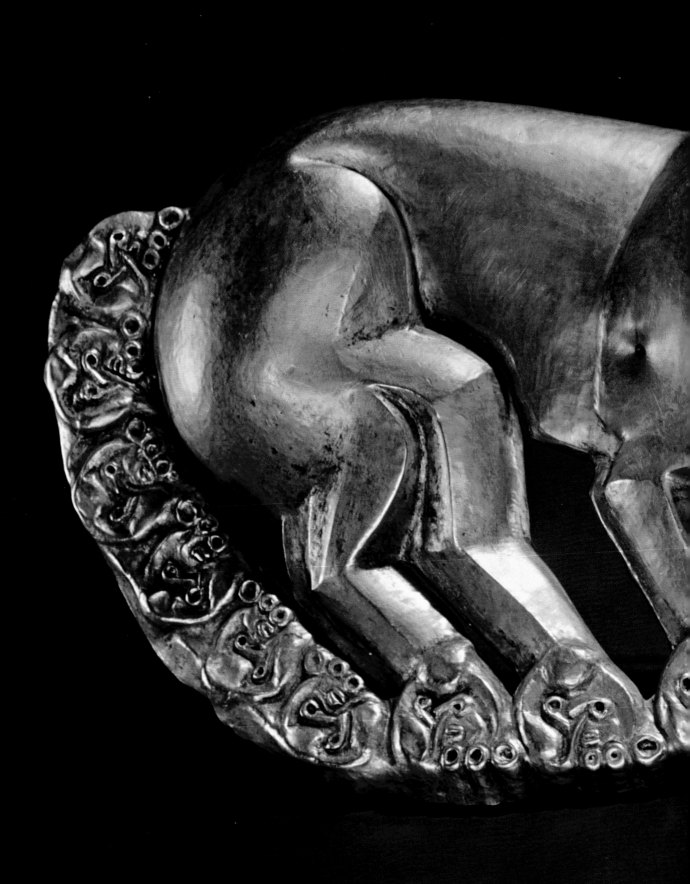

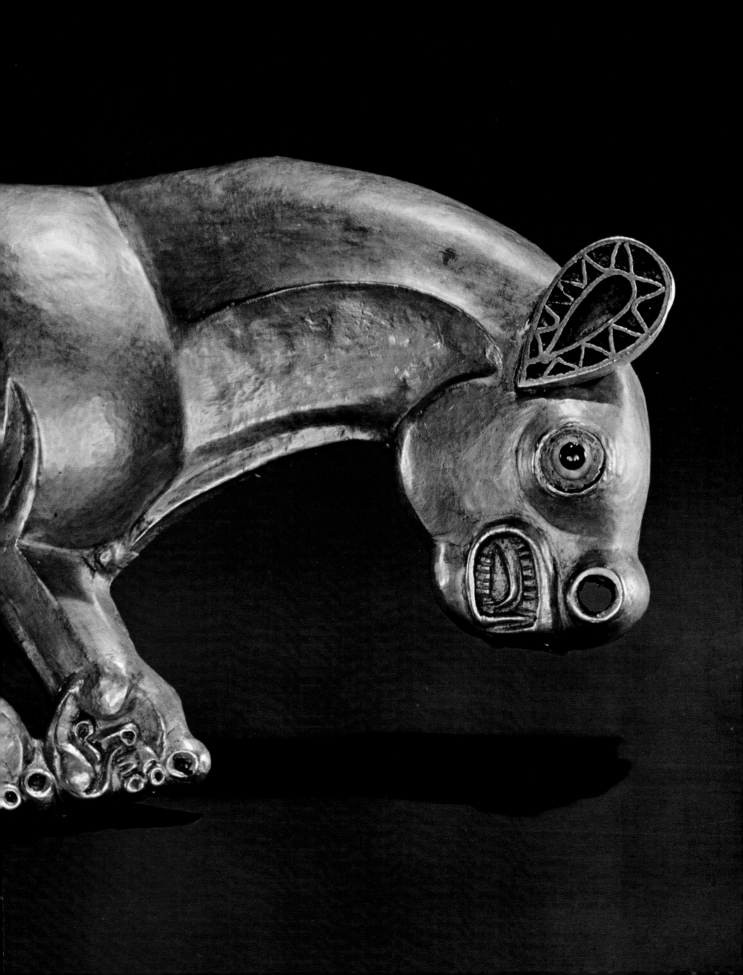

Plate 6

A griffin's head tops this standard, which enclosed a bell. Such objects, frequently found in Scythian tombs, may have been attached to chariots or carts but they are not actually found with either vehicles or horses when discovered in place. It is possible that they were ceremonial objects originally mounted on wooden shafts and carried by hand. (Cat. no. 31)

The contracted pose of these small panthers, unnatural for a live animal, is often repeated in Scythian art; it may indicate that the creature is passive or dead. (Cat. no. 32)

The coiling of the body of this animal (possibly a snow leopard) is a convention that occurs earlier in China than in Siberia or the Black Sea region, although it becomes a characteristic Scythian design. (Cat. no. 34)

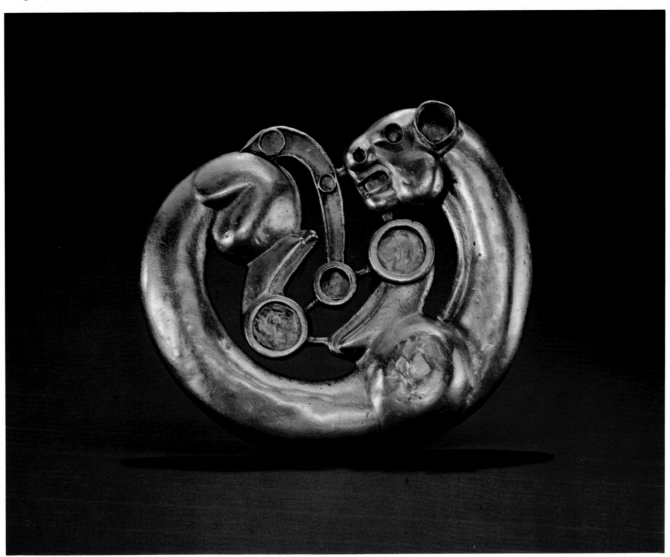

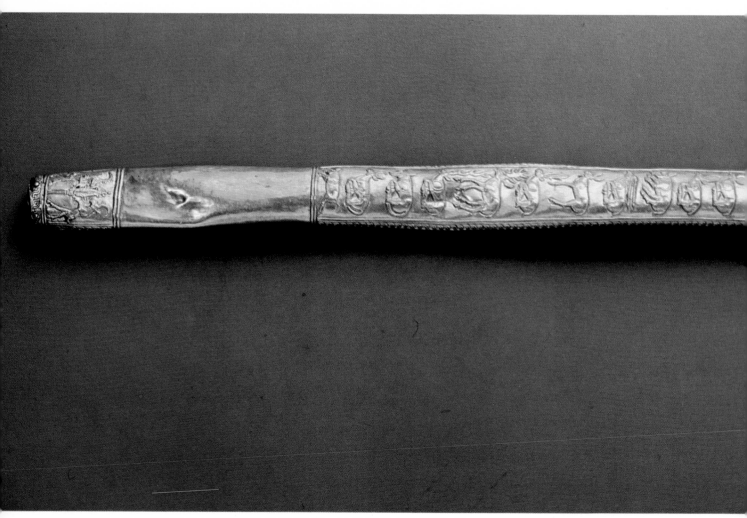

Plate 7 The battle axe is one of the three
weapons characteristically associated
with the Scythians, the others being the
bow and short sword. This magnificent
ceremonial axe—withdrawn from
the exhibition because it was considered
too fragile to travel—is iron sheathed
in gold. It incorporates typically
Scythian motifs (the row of animals or

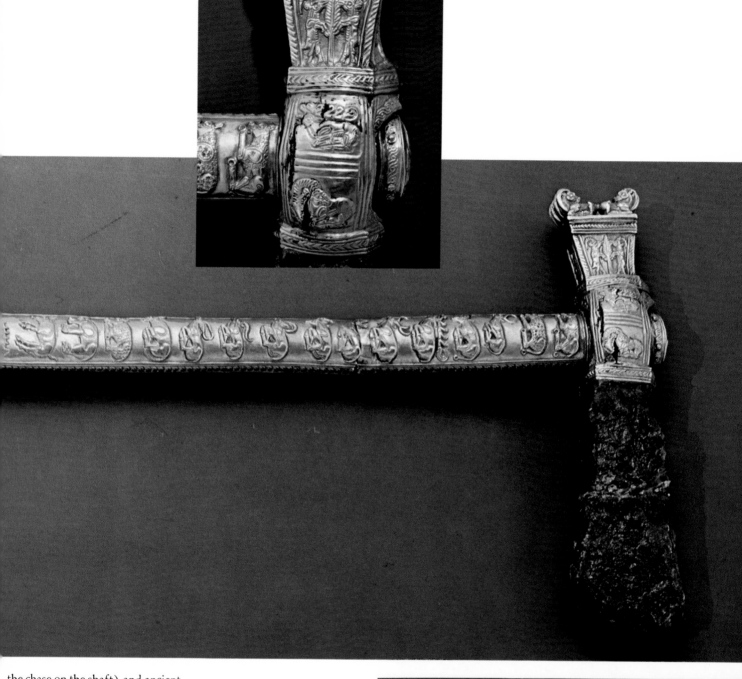

the chase on the shaft) and ancient
Near Eastern designs (the rams standing
upright on either side of a sacred tree,
on the axe head). Ceremonial weapons
made of gold are part of the regular
inventory of Royal Scythian tombs. They
are usually decorated with animals whose
various powers were believed to pass
symbolically to the weapon's owner.

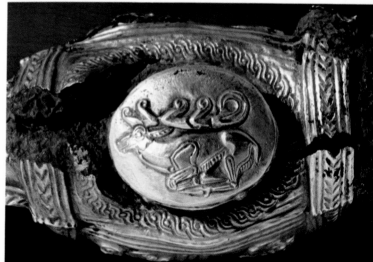

Plate 8

This elaborate object, photographed on
a mirror, is one of a pair and its function
is unknown. It somewhat resembles Iranian
works in style and in the use of inlay, and
may have been made on the western borders
of the Achaemenid empire. It was one of
two pieces withdrawn from the exhibition
because of their fragility (two works of
similar importance will be sent in their place).

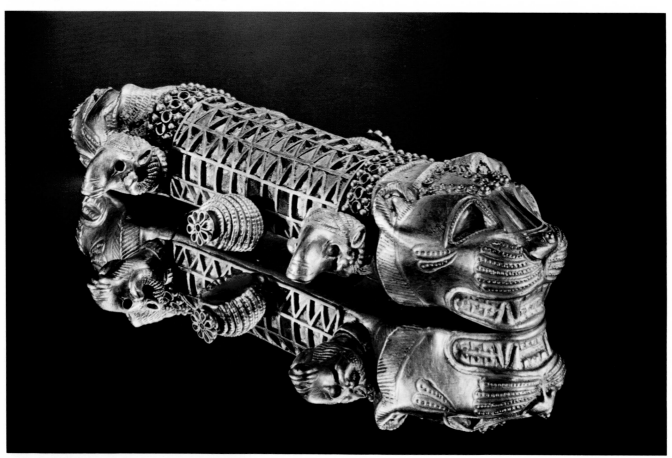

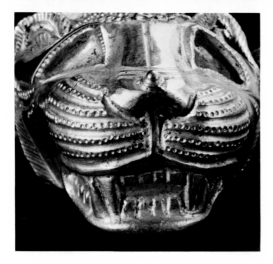

The silhouette of the head of a bird of prey
decorating this dramatic bronze standard
encloses many other animals. Such
incorporation of small creatures within larger
ones is characteristic of Scythian art: the
object was then believed to contain all the
powers of the subjects represented.
(Cat. no. 33)

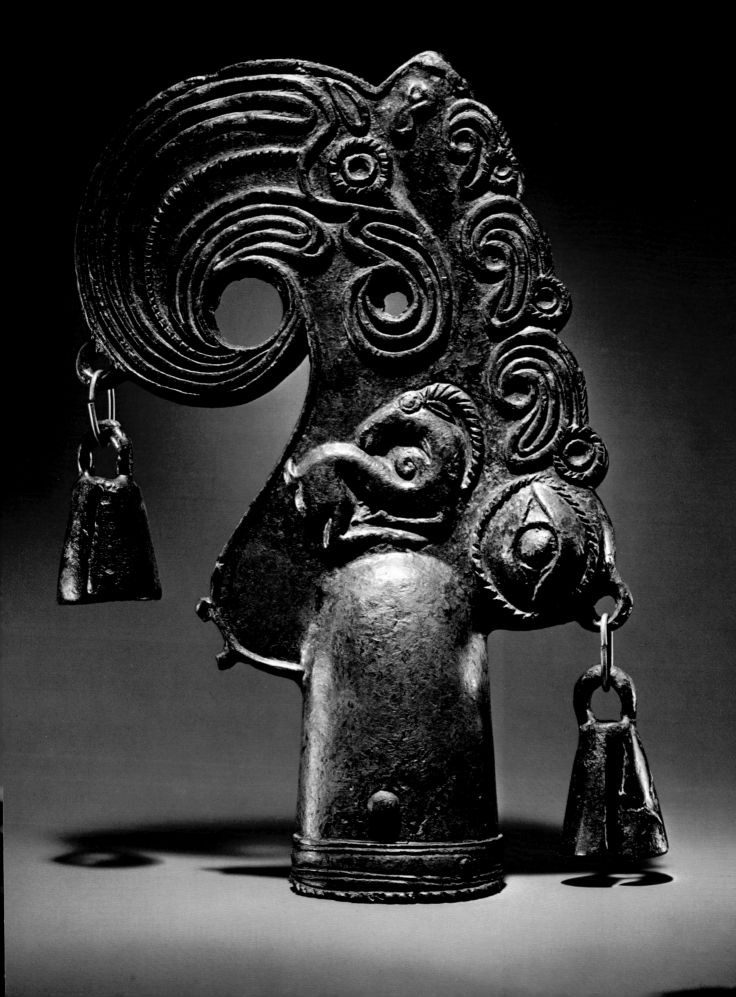

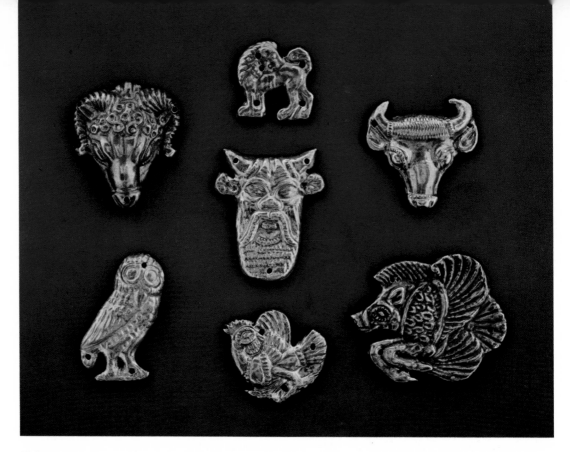

Plate 9

The clothing ornaments above are rather
coarse adaptations of standard Greek
motifs. (Cat. no. 51)

The helmet at the right was probably
worn over a lining of colorful felt or fur
against which the golden openwork
would have gleamed sumptuously.
(Cat. no. 61)

These gold plaques of dancing figures
were found in the tomb of a priestess
of Demeter, and the dances may have been
performed at a festival of this goddess.
(Cat. no. 65)

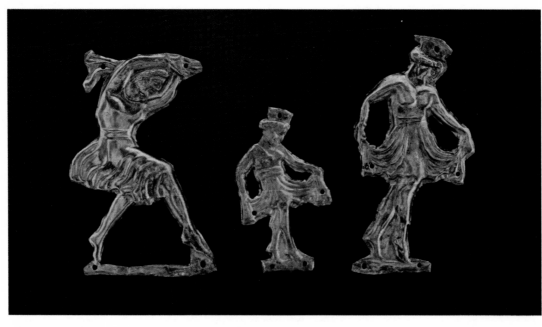

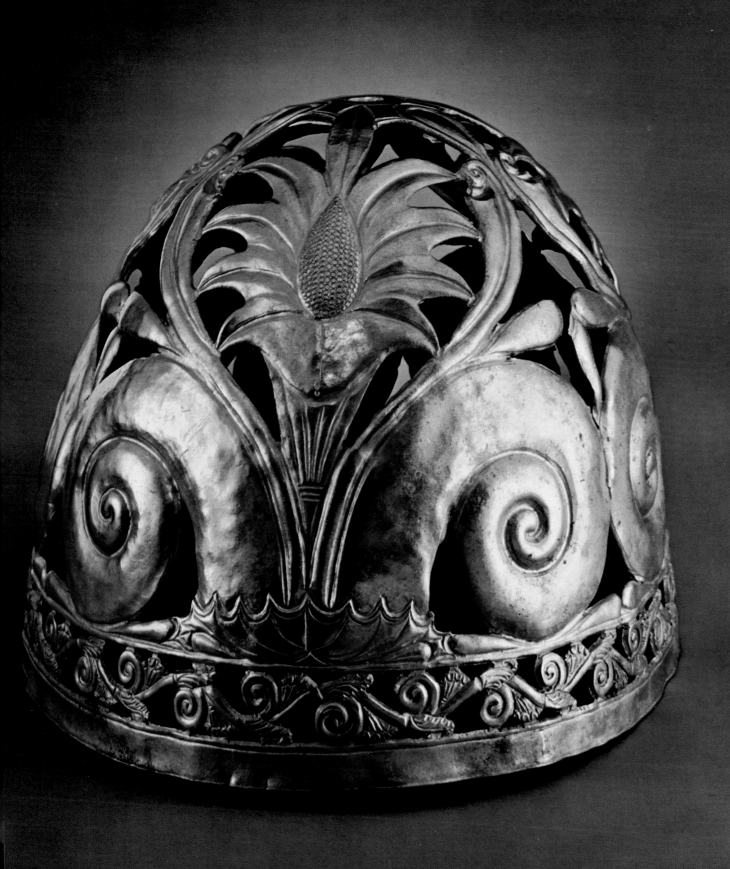

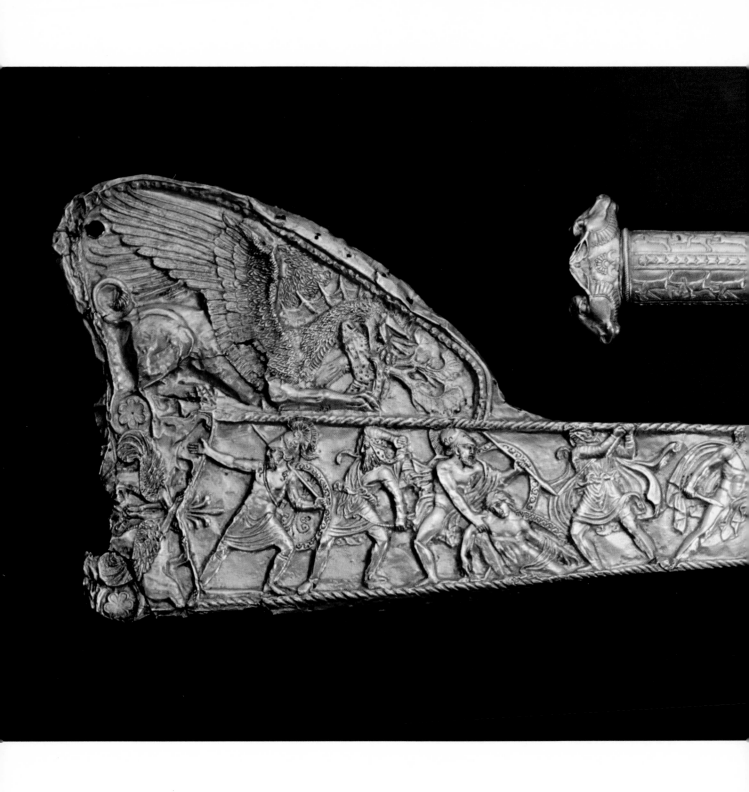

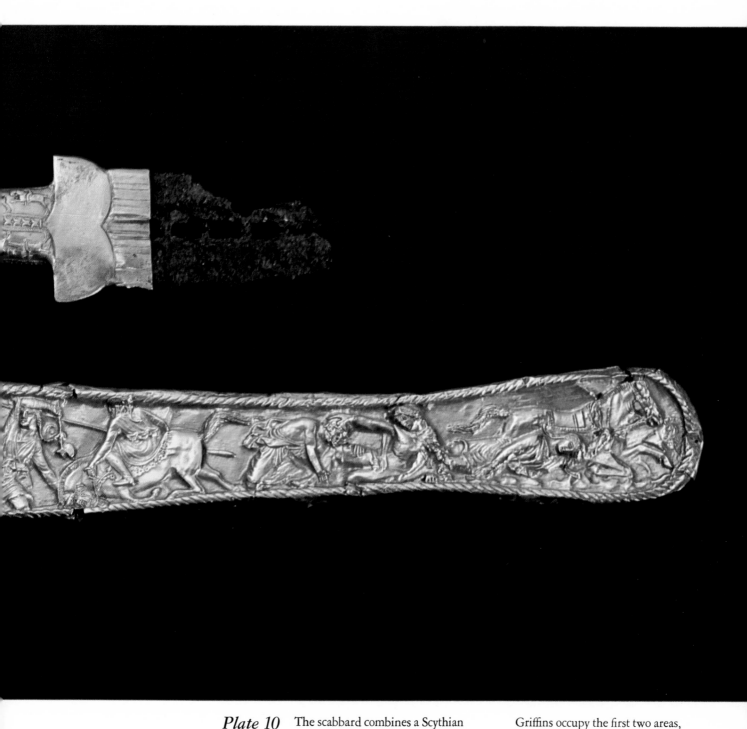

Plate 10 The scabbard combines a Scythian shape with a scheme of decoration devised by a Greek. It is divided into three parts: a short band into which the guard of the hilt would have fitted; a triangular extension that represents the leather flap by means of which the scabbard was attached to the belt; and the sheath proper. The artist has respected these divisions.

Griffins occupy the first two areas, and the complex battle scene of Greeks and Persians on the sheath may be an echo of the famous painting of the battle of Marathon by Polygnotos in Athens. The sword, although buried with the scabbard, is not of the Scythian type and is distinctly Iranian in style. (Cat. nos. 67, 68)

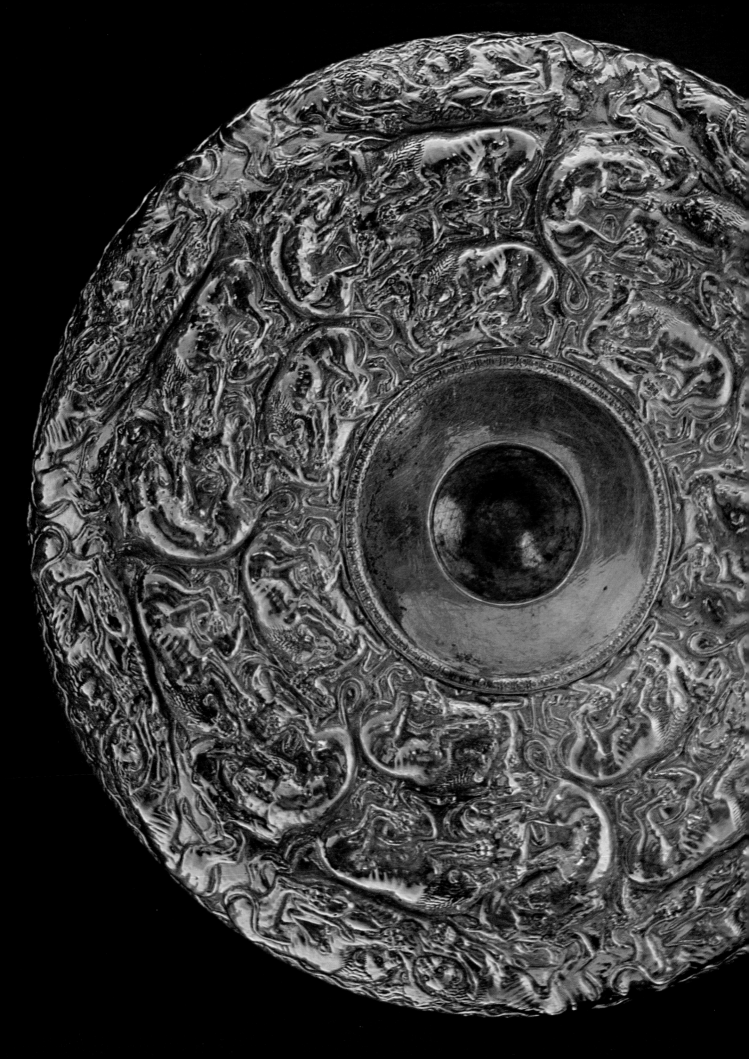

Plate 11

The shape of the libation bowl at the left is thoroughly Greek, but the fluid profusion of fighting animals covering most of the surface betrays a non-Greek taste, and is closer to the Scythian preference for animal combats and dislike of rigid organization. (Cat. no. 70)

The decoration of the horse's frontlet at the right depicts a woman whose lower extremities terminate symmetrically in griffins and snakes. It has been suggested that this is a representation of the snake-legged female creature who, from a union with Heracles, gave birth to the ancestor of the Scythian kings (a legend recounted by Herodotus). (Cat. no. 69)

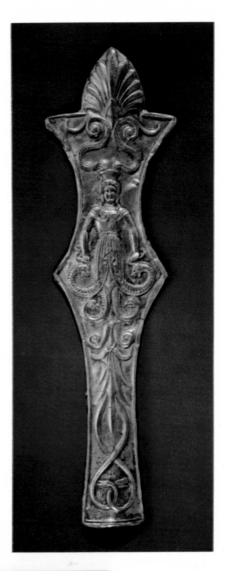

On the plaque below, a winged panther has jumped on the back of a seated goat. The ornaments are common in Greek art, but winged panthers are rare, as is the docile goat. (Cat. no. 48)

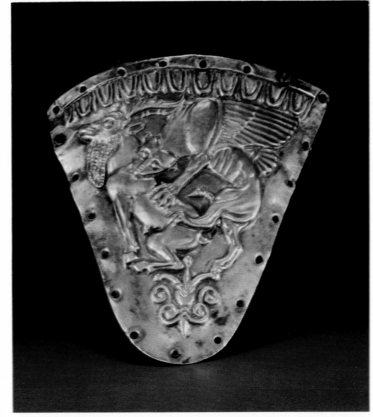

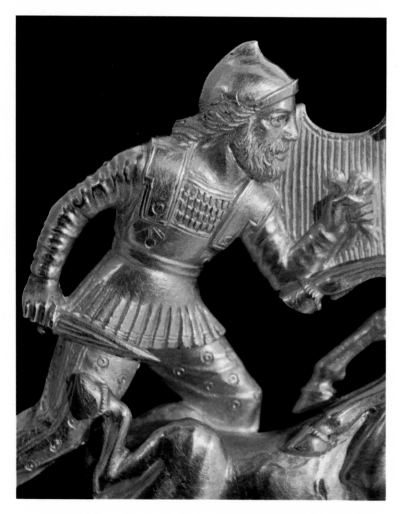

Plate 12

This beautiful comb is worked in relief
on both sides, giving the illusion of
being sculptured in the round. The dress
combines Scythian costume (soft cap,
tunic, and trousers) with Greek armor
such as the helmet and cuirasses, but
the workmanship itself is purely Greek.
(Cat. no. 71)

Plate 13 (overleaf)

In Western art, the victor usually
proceeds from left to right, so this side
of the comb, giving the horseman and
his squire the left half of the scene,
is probably the principal one.

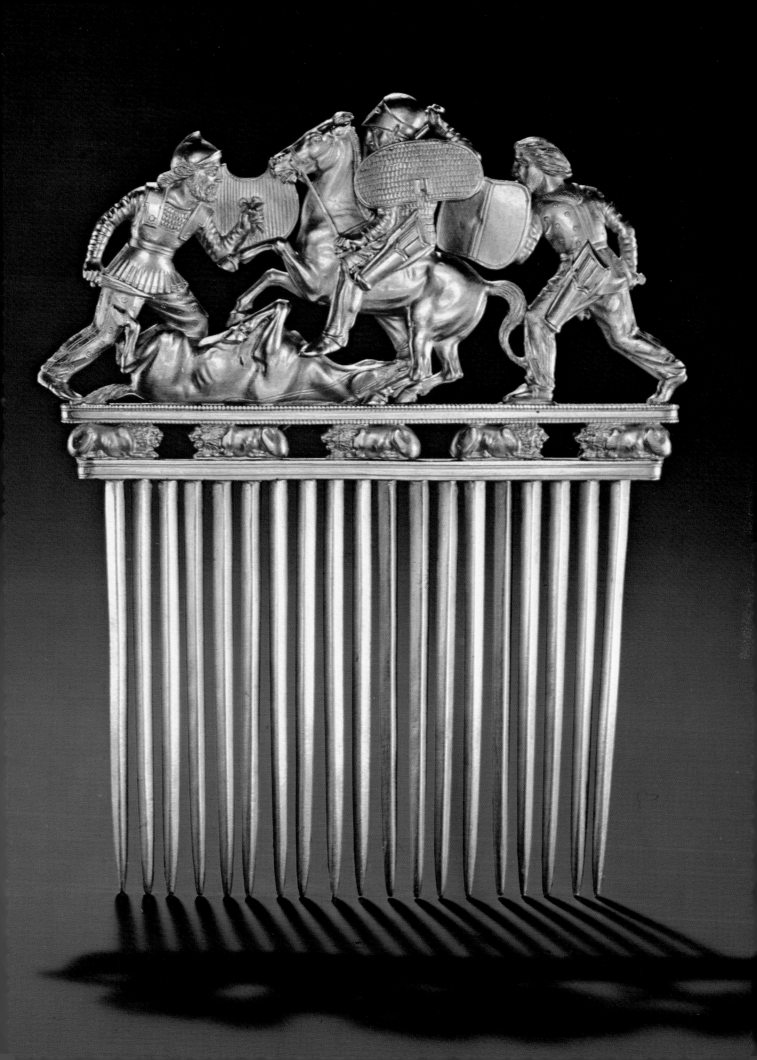

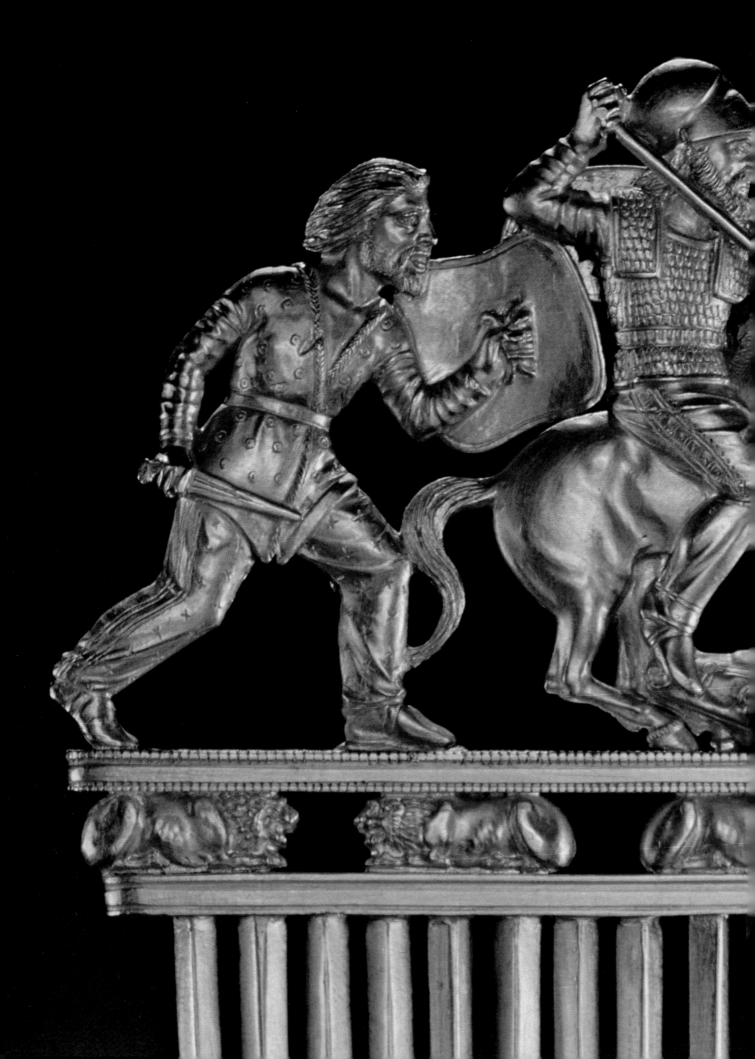

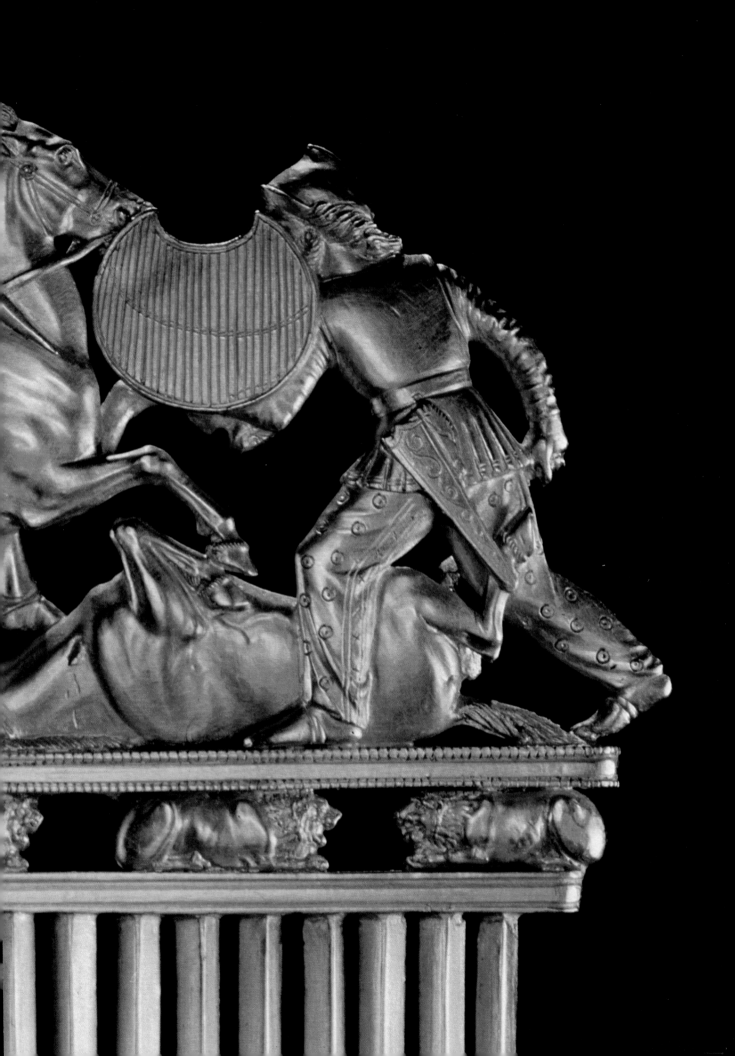

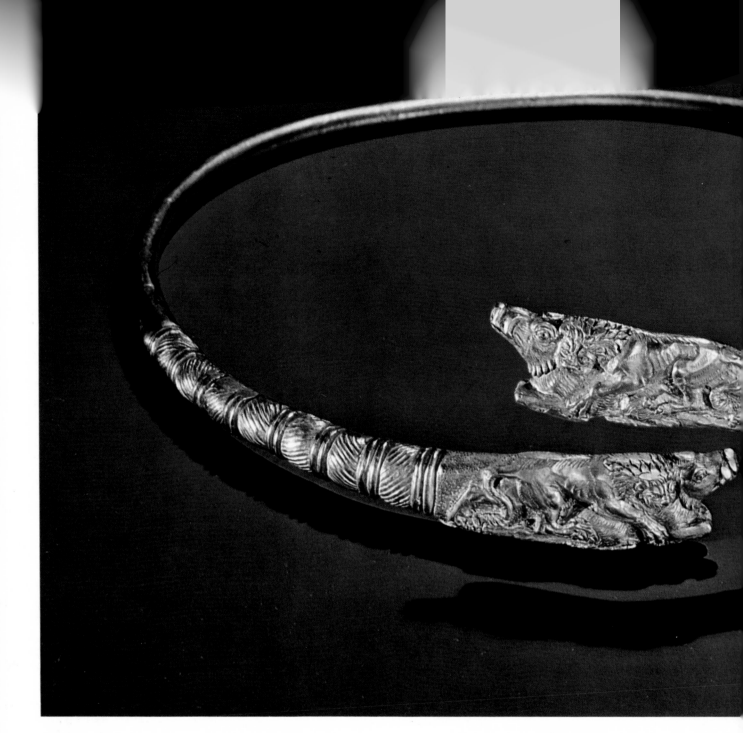

Plate 14

This torque was made in a region and workshop where Greek influence was not very strong. In Near Eastern and Greek art, the finials would normally be limited to an animal's head or foreparts; here, instead, each portrays two entire animals, a lion attacking a boar. (Cat. no. 73)

Plate 15 (overleaf)

Among the large gold plaques that are generally assumed to be shield emblems, this stag occupies a special place. It embodies important characteristics of Scythian art, such as the shaping of the body by sharply contrasting planes and the elaboration of the contour into zoomorphic shapes. (Cat. no. 77)

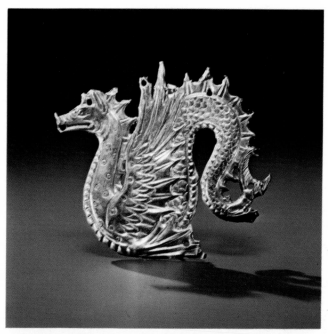

At the right are two small clothing ornaments (each is less than 2 inches high). The upper one is in the shape of a ketos or sea monster, and the remarkable plaque below depicts two Scythians sharing the same drinking horn in a ritual actually described by Herodotus. (Cat. nos. 75, 76)

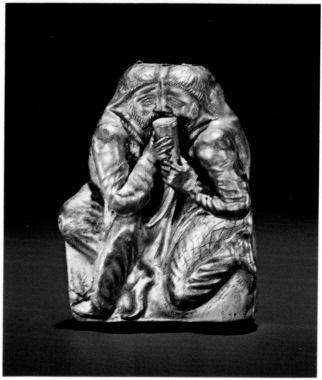

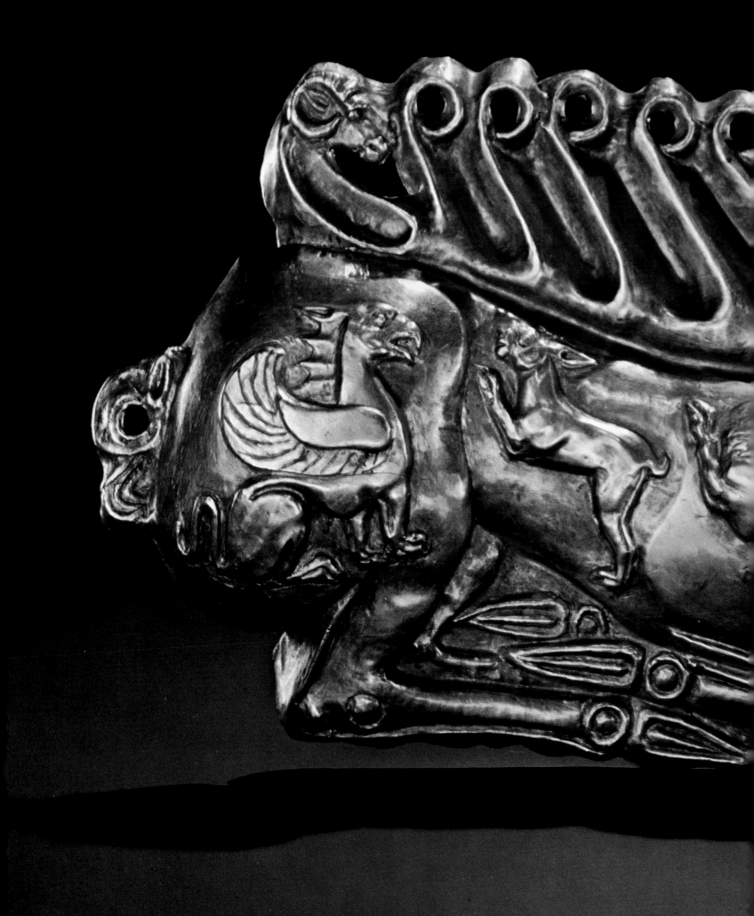

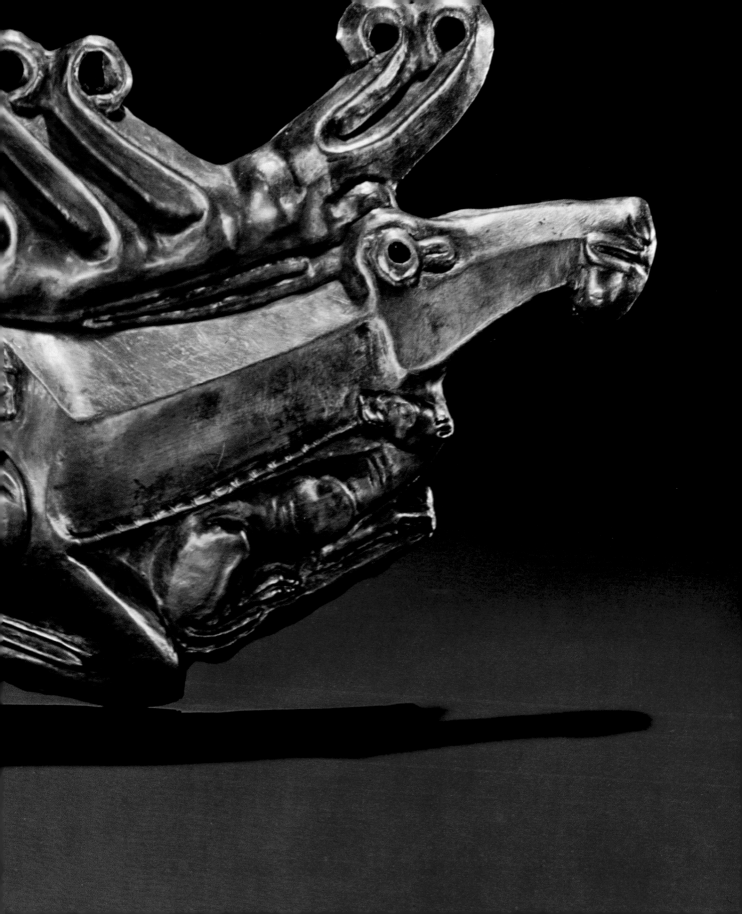

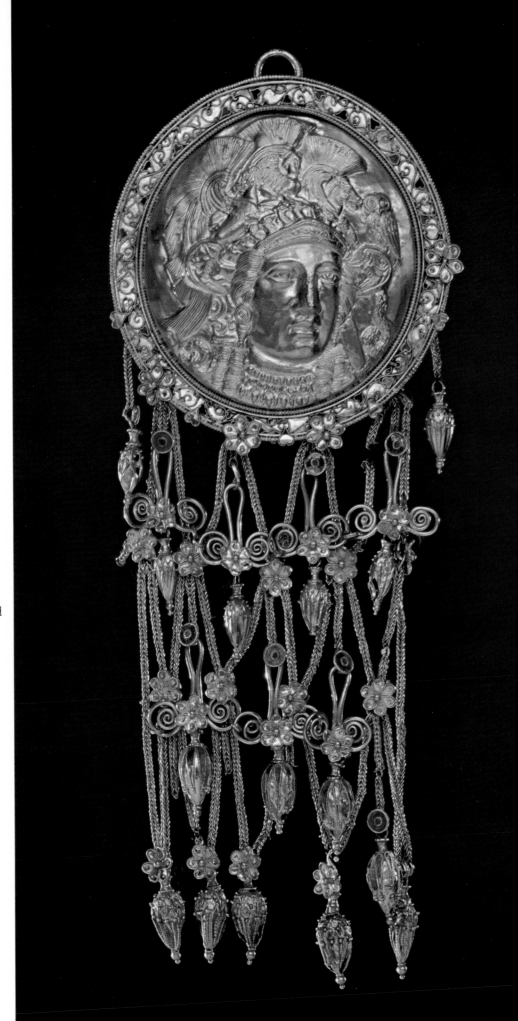

Plate 16

The central motif of this large
pendant, with decoration of
exquisite delicacy, was inspired
by the cult statue of Athena by
Phidias, in the Parthenon in
Athens. (Cat. no. 78)

Drinking vessels in the shape of animal horns are frequently found in Scythian tombs. Scythians are often represented drinking from such horns on Greek works depicting scenes from nomad life. This one is made of silver, with gold decoration. (Cat. no. 79)

The two archers shown below differ from other representations of Scythians in that, although fighting, they do not wear the typical Scythian cap or helmet, and their hair is tied in a topknot, a coiffure described by Herodotus as typical of the Thracians. (Cat. no. 80)

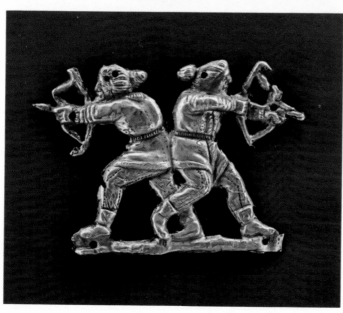

Plates 17, 18 (overleaf)

The shape and ornaments of this intriguing gold bottle are Greek, as is the workmanship, but the subject matter is taken from the daily life or mythology of the Scythians. Although many interpretations of the scenes have been proposed, none is certain. (Cat. no. 81)

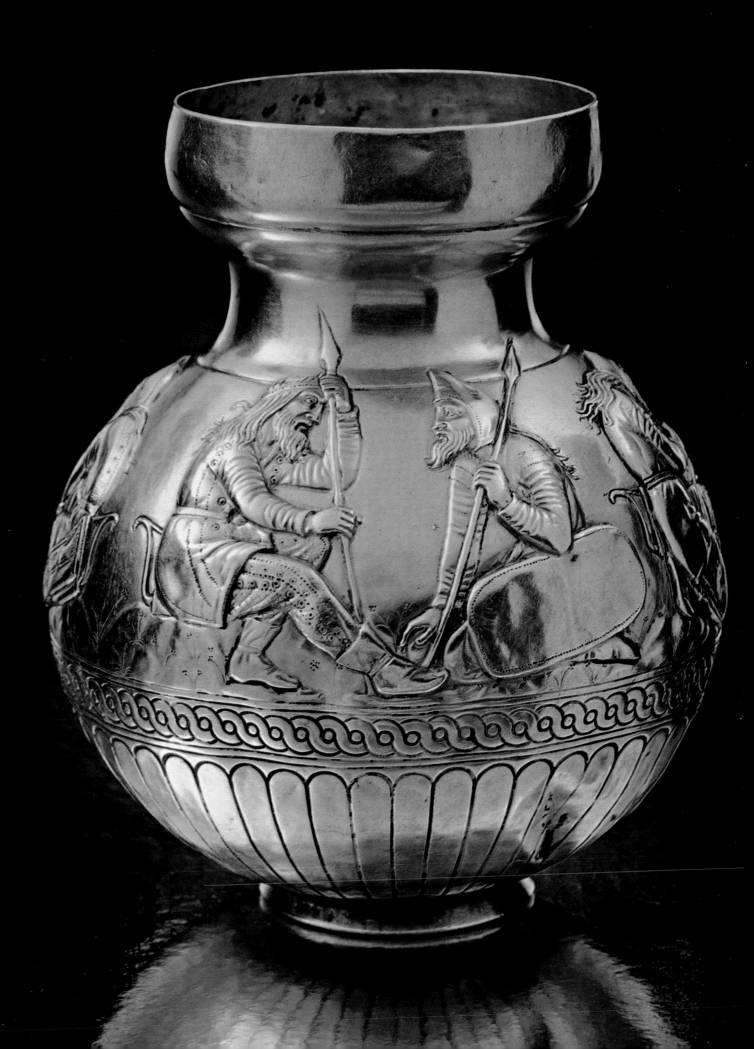

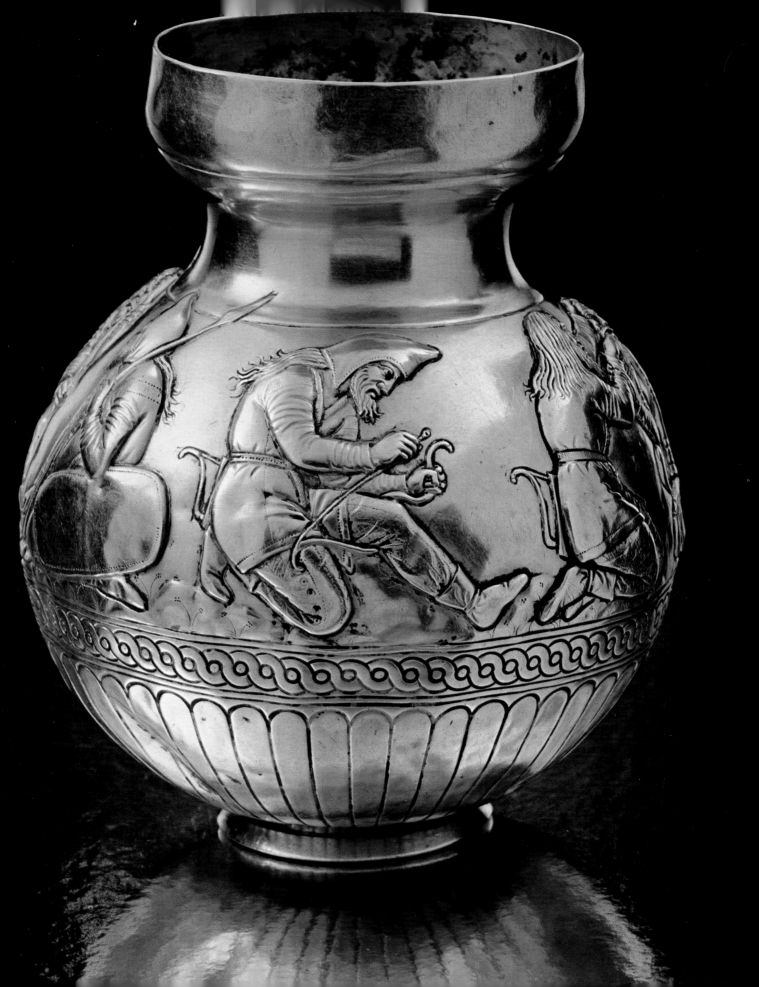

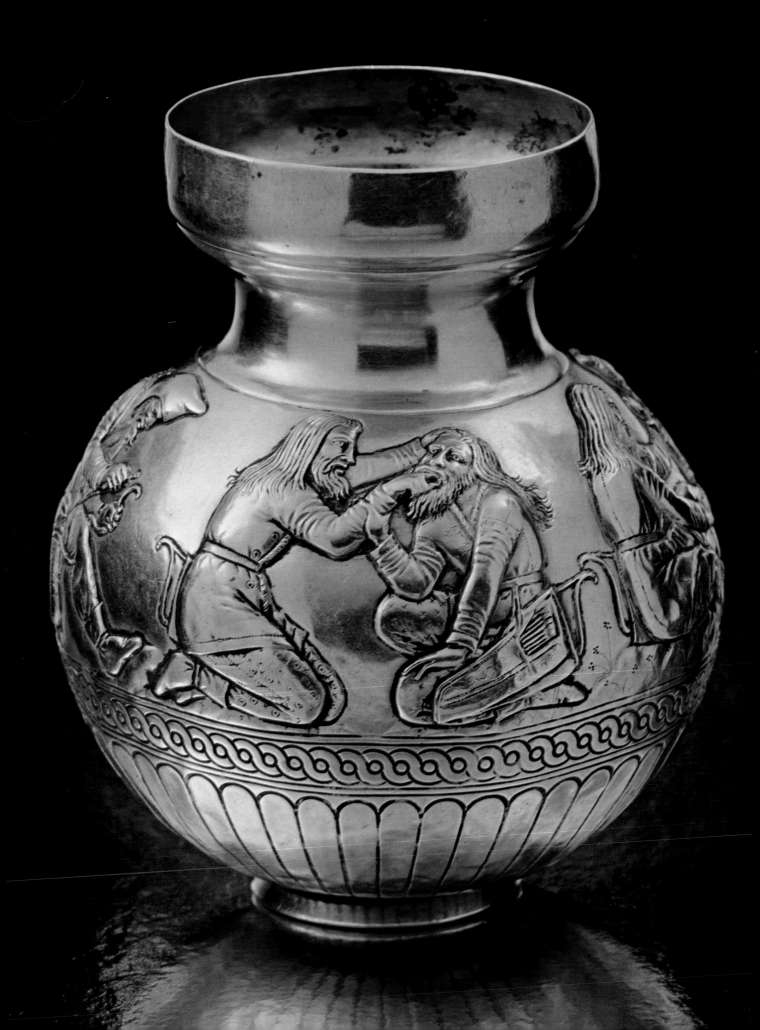

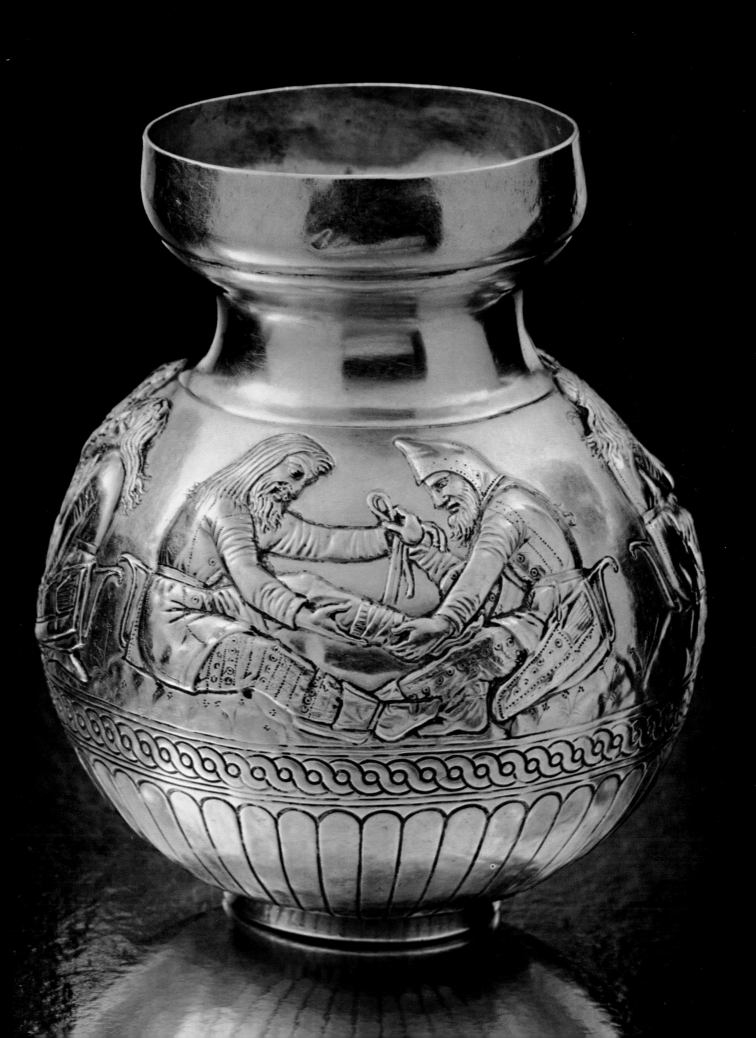

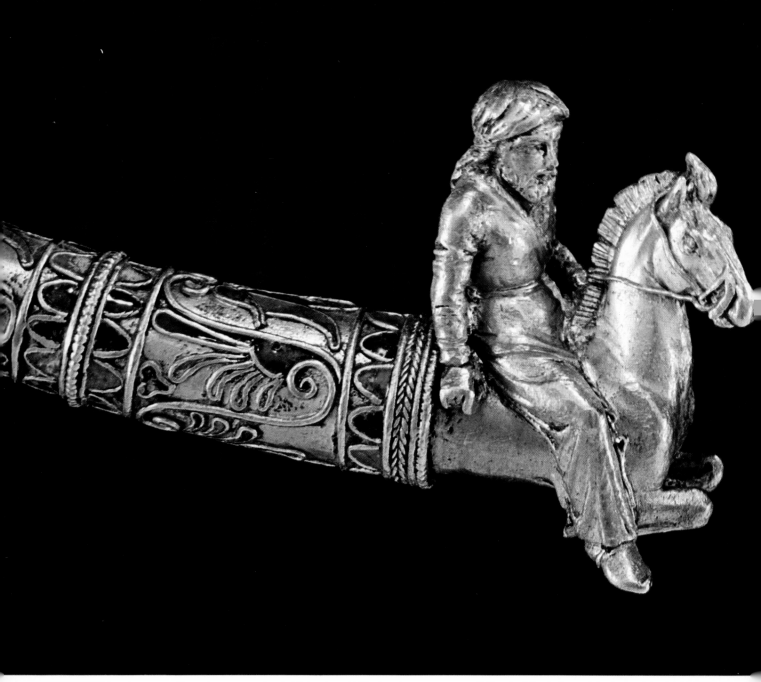

Plate 19 Scythians on horses, as if on parade, are portrayed in the classical Greek style on this torque. The modeled finials are set off from the twisted gold necklace by bright blue and green enamel. (Cat. no. 82)

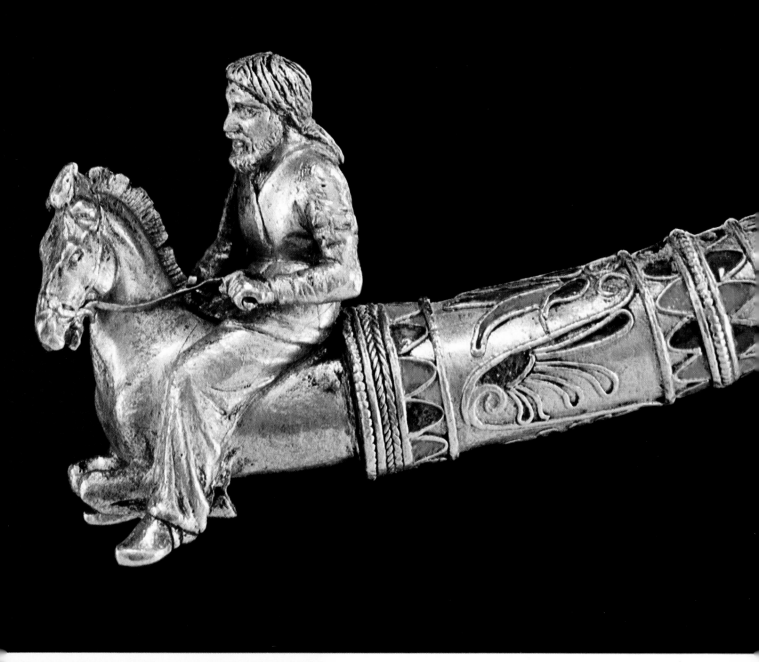

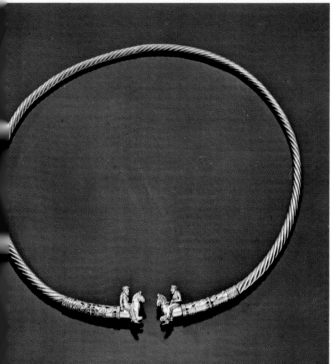

Plate 20 (overleaf) Bearded heads near the rim of the libation bowl on the next page may represent Scythians or deities of the Samothracian mysteries. They are accompanied by bees and heads of boars and gorgons; below, panther heads face the other way. Dolphins and fish cavort around the center. Two crude rings have been soldered to the edge, recalling Herodotus's comment that Scythians wore drinking cups fastened to their belts. (Cat. no. 83)

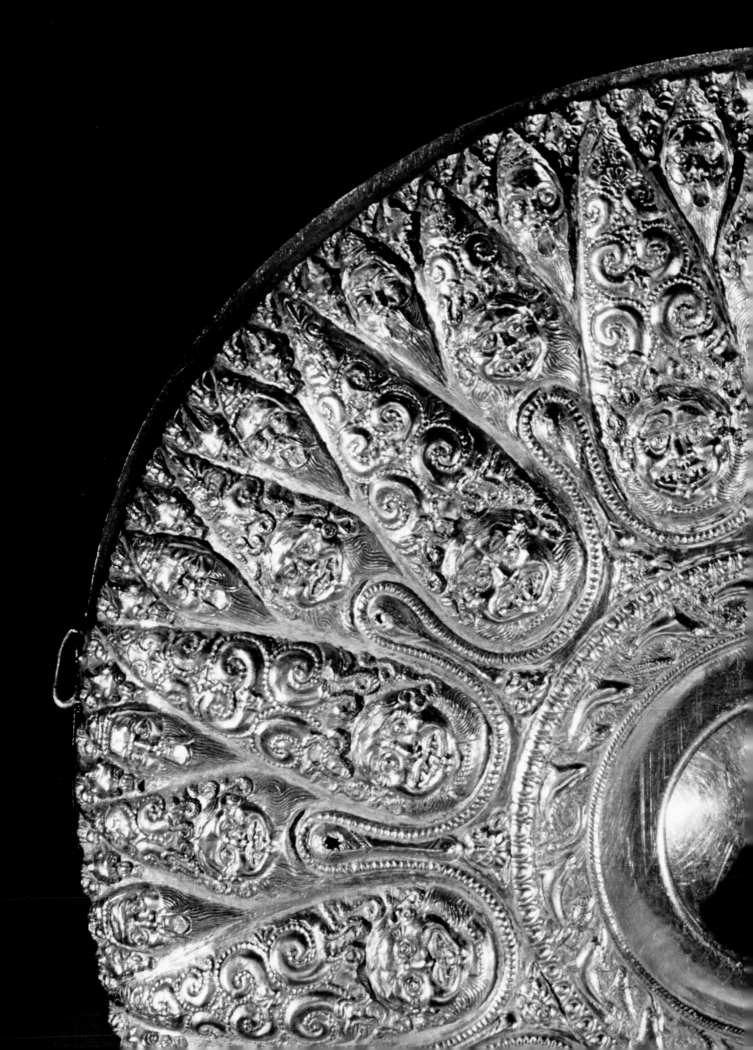

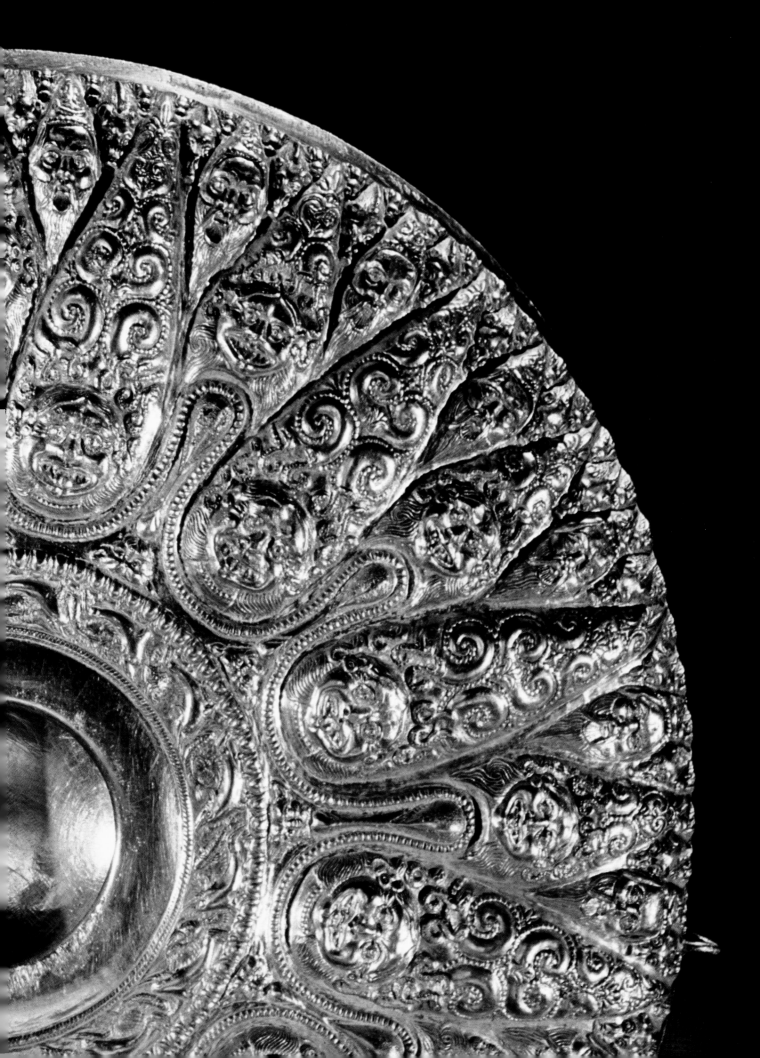

Plate 21

The works on the next four pages come from Peter
the Great's personal collection. Upon the birth
of their son in 1715, the empress was presented with
a group of ancient gold works of art that were said
to have been found in Siberia. Struck by their quality,
Peter issued a decree placing all antiquities found
in Russia under the protection of the crown. Peter's
collection, the first Russian museum, came to the
Hermitage in 1859.

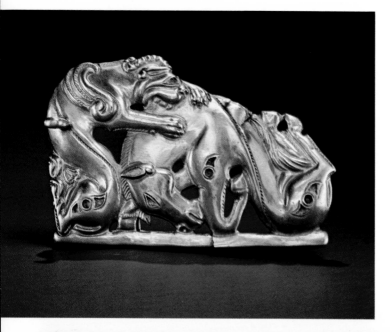

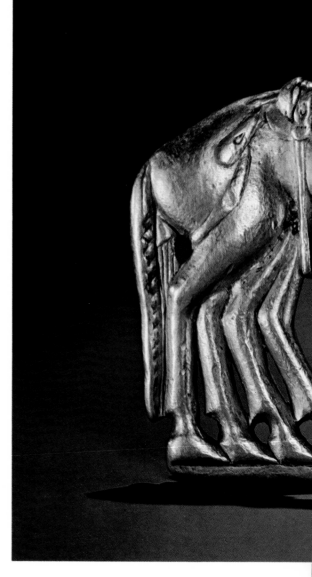

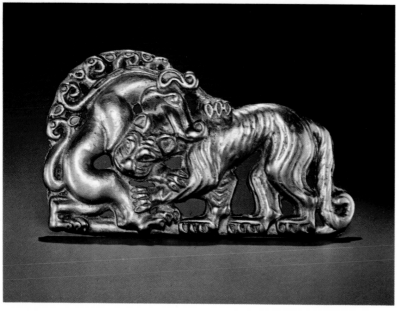

In the plaques at the left, the artists have
deliberately contrasted the realistic and
imaginary features of the fiercely struggling
animals. (Cat. nos. 93, 94)

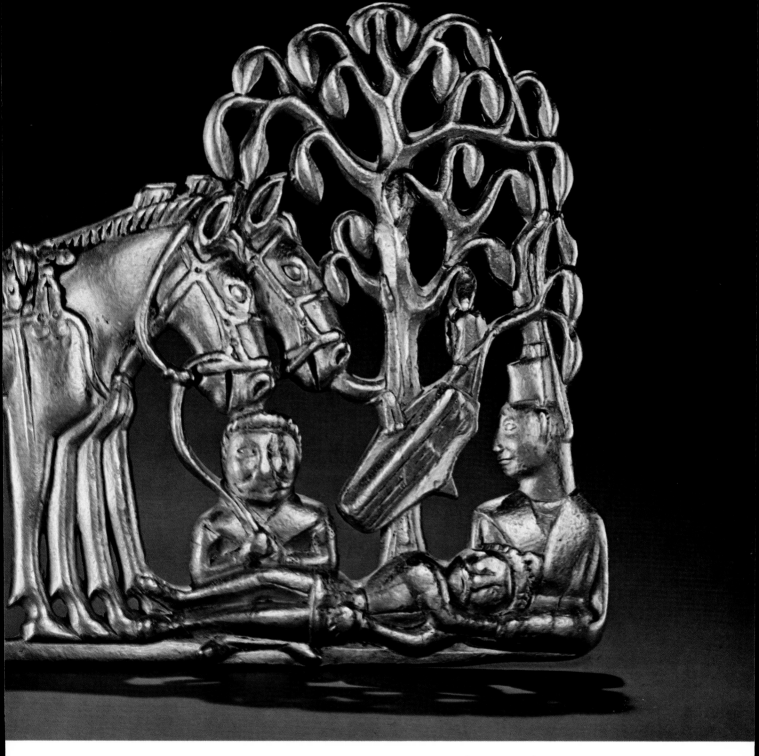

e plaque above, showing a warrior lying
der a tree with his head in a woman's
, probably reflects a legend that has
rvived to this day: such a story is
ounted in medieval epics and is still
rrent in a Hungarian folk ballad. Plaques
like the one shown here come in pairs and
were probably scabbard mounts; the hero
of the medieval stories is distinguished
by wearing two swords, a characteristic that
apparently reflects a nomad custom.
(Cat. no. 95)

Plate 22

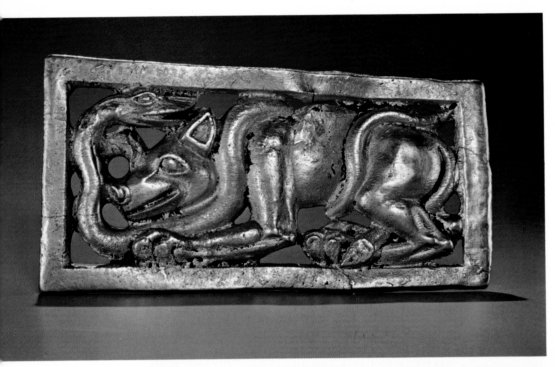

At the left, a snake winds itself around its tormentor. (Cat. no. 96)

Power and vitality radiate from the ornament at the right, depicting a fantastic creature clutching a goat in its talons. The goat's inverted hindquarters, a stylization common in Siberian art, are intended to suggest that the animal is dead. (Cat. no. 99)

The fluting and animal handles of the cup below are signs of Iranian influence, although the shape is not typically Near Eastern, and the exaggerated stylization of the animals' rib cage is characteristic of many Siberian objects. (Cat. no. 97)

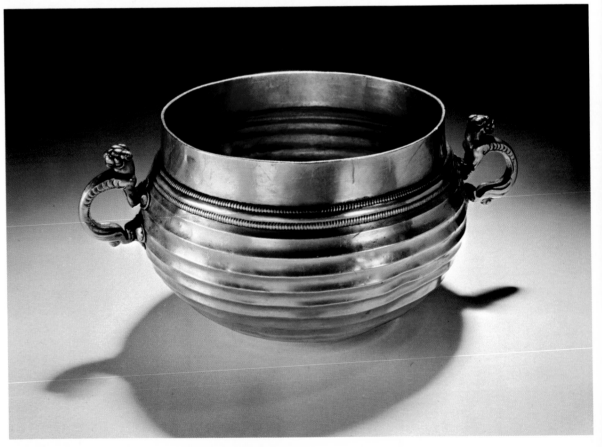

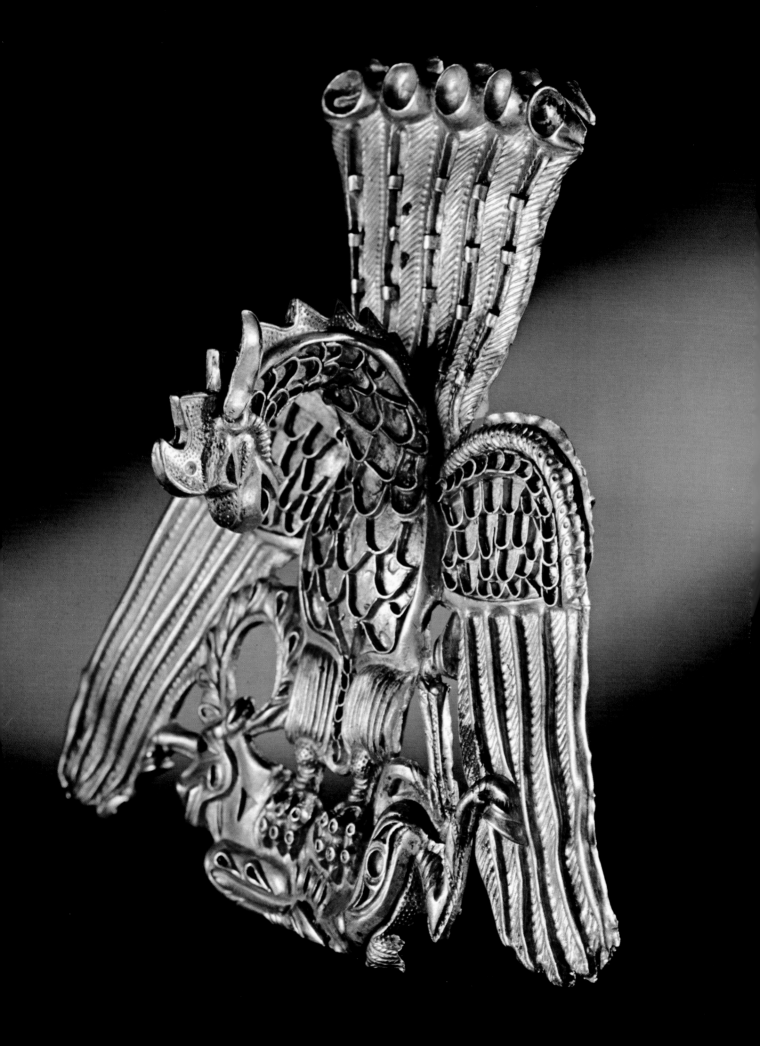

Plate 23

Sealed in ice-filled tombs in the
Altai Mountains of Siberia,
an astounding collection of fragile
and perishable objects such as
textiles, leatherwork, and wood-
carvings has been unearthed
by Russian archaeologists. These
works preserve a record of the life
of a group of highly civilized
nomads of the 5th to 4th century
B.C., who were in touch with
Achaemenid Persia on the west
and feudal China on the east. The
saddle blanket illustrated on this
page consists of a piece of fine,
embroidered Chinese silk—one of
the earliest known—mounted on
felt by its nomadic owners.
(Cat. no. 117)

This magnificently antlered elk in a sort of flying gallop must have come from a saddle cover like the one on the next page. The exuberant shapes on the animal's body are derived from a traditional, more restrained Iranian treatment. (Cat. no. 113)

Felt lions' heads are applied to this hanging in the same fashion as the better-known gold plaques were sewn onto garments or attached to cloth or leather hangings. Small gold lions' heads of closely similar design have been found in Iran. The lion is unknown in the Altai region and its presence on this piece indicates the influence of Iranian works. (Cat. no. 115)

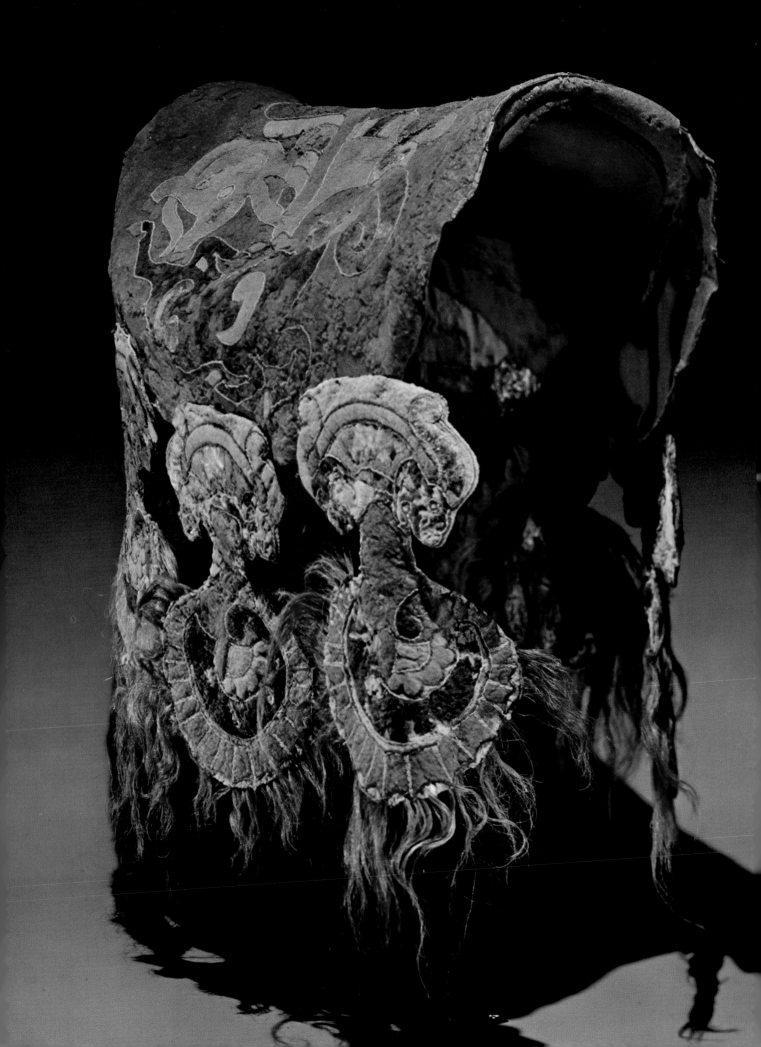

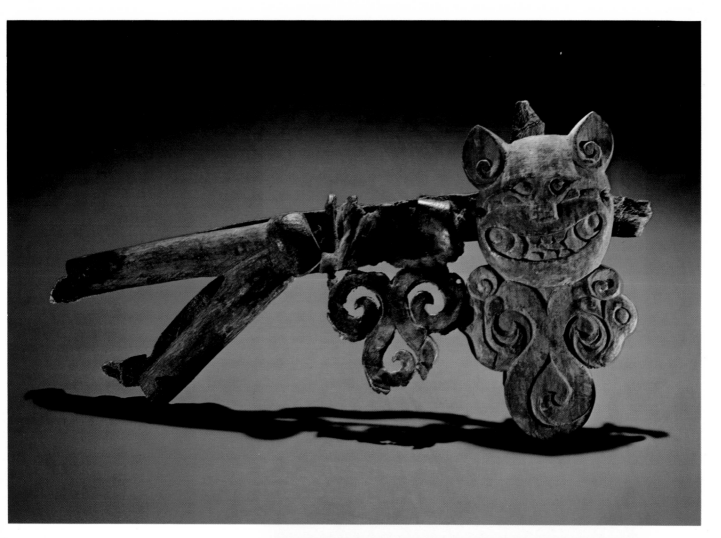

Plate 24

The symmetry of the composition of the harness ornament above is subtly enlivened by the inward-turning scrolls of the lower loop. (Cat. no. 100)

Complete saddle covers like the one at the left are rarely found in the Altai tombs. The griffins attacking mountain goats on the sides, in felt appliqué outlined in cords, are striking examples of animal combat, a theme found in many ancient Near Eastern civilizations. The nomads probably borrowed it from the Achaemenids of Iran, on the western borders of their grazing territory. (Cat. no. 112)

On the wooden roundel at the right, the foreparts of two griffins swirl around the central boss. (Cat. no. 107)

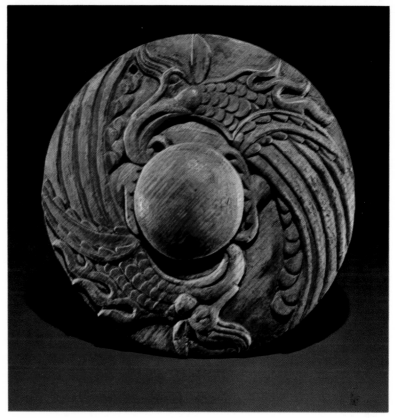

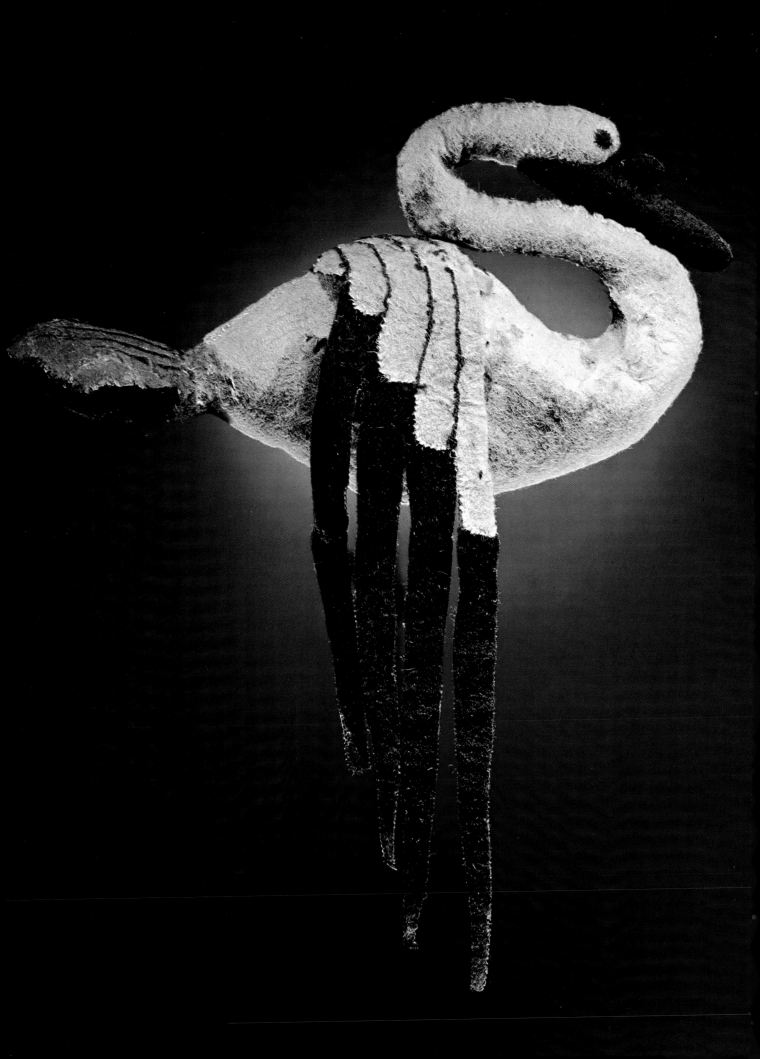

Plate 25

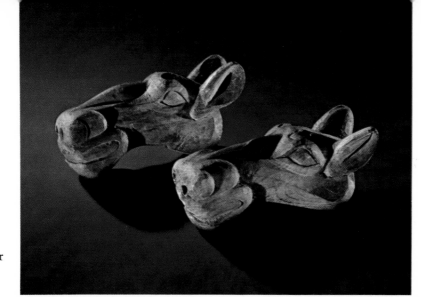

The masterly handling of felt is characteristic of the northern nomads, and this swan has the sculptural quality of their other arts of woodcarving and metalworking. (Cat. no. 118)

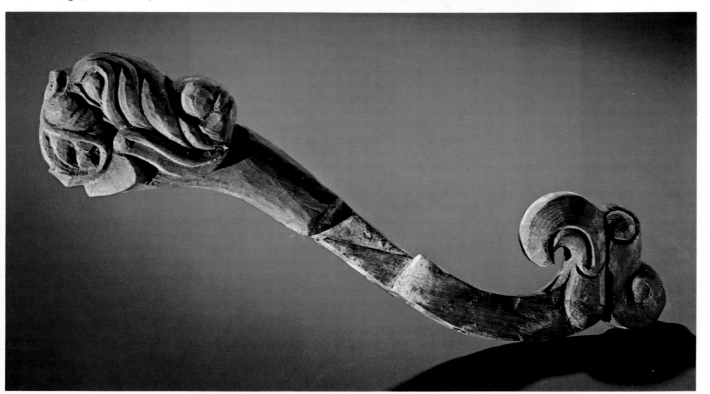

Three pieces of horse equipment are shown on this page. The cheekpiece in the center ends in fantastic heads of exaggerated ferocity, and the stylized design on the ornament at the bottom consists of two elks' heads facing outward. (Cat. nos. 134-136, 140)

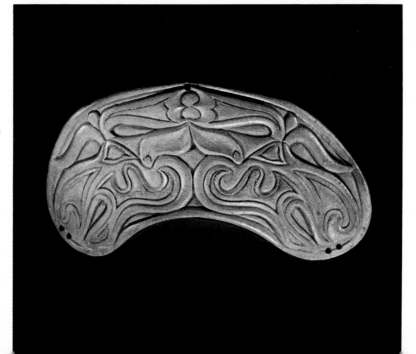

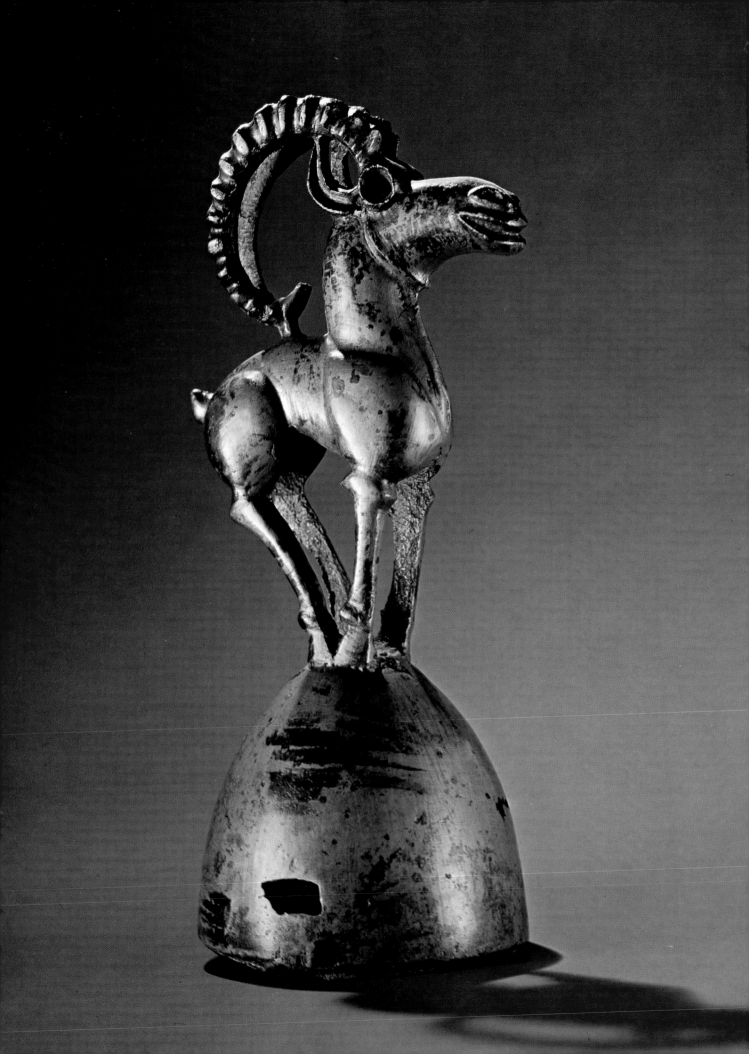

Plate 26

In the finial at the left, probably
from a pole of a funerary couch,
the extreme simplification of the
animal's body and the pose with
feet drawn together at the base are
hallmarks of the "animal style"
of Siberia and Mongolia.
(Cat. no. 144)

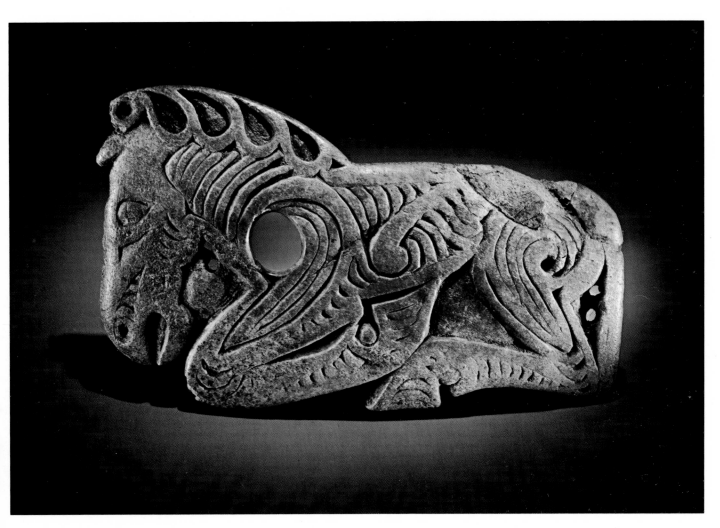

Of characteristic P-shape, plaques
such as this have been interpreted
as belt buckles, dress appliqués,
or mounts for sword scabbards.
This one is especially interesting in
that it depicts a horse; in spite
of the dependence of the nomads'
culture on their domesticated
animals, most of the creatures
represented in their art are wild
species. (Cat. no. 160)

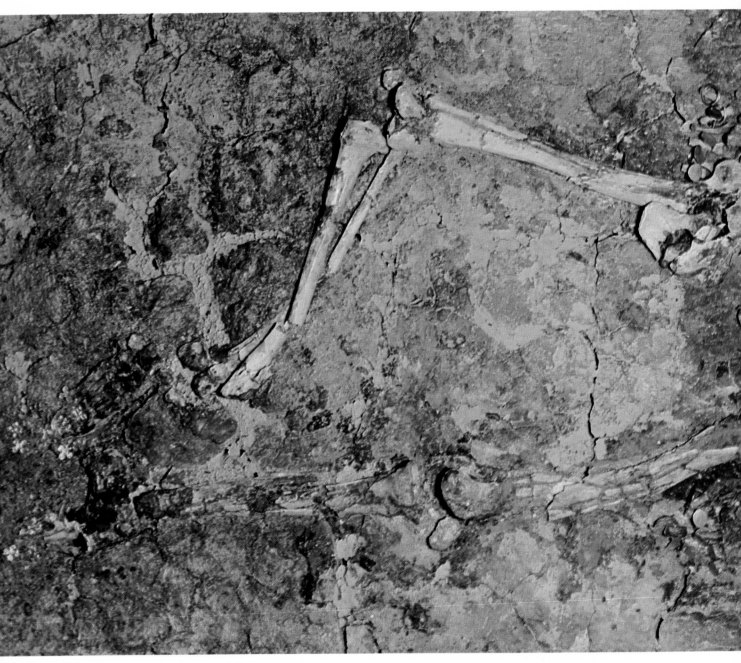

Plate 27 This 4th-century burial of a young Scythian woman has been preserved as it was discovered. Her finery includes 250 gold plaques, bracelets, rings, and a sumptuous crown. A bowl and a mirror lie nearby.

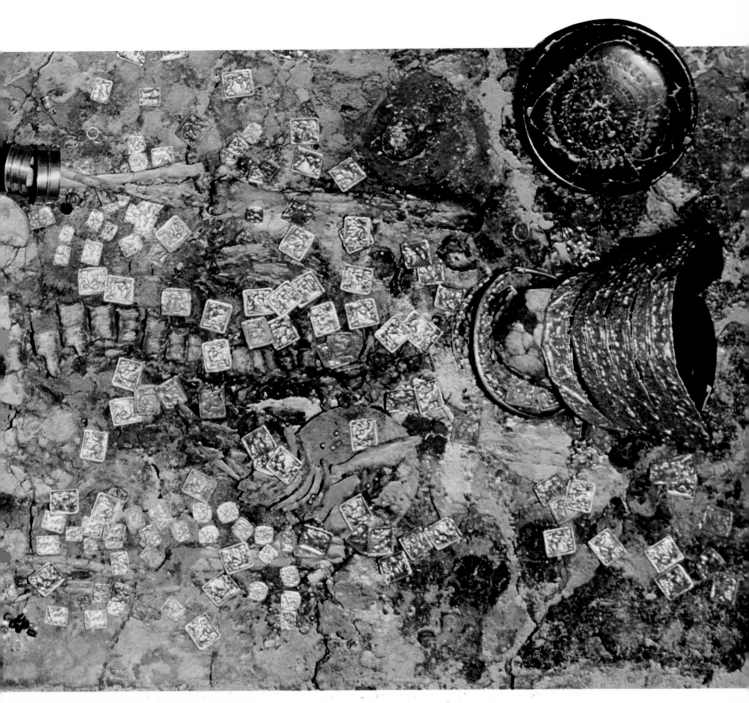

It is a curiously Scythian conceit to join a human head to that of an animal; here a youth's head is combined with a lion's head, almost as if the artist remembered the common Greek motif of Heracles wearing the lion skin. (Cat. no. 183)

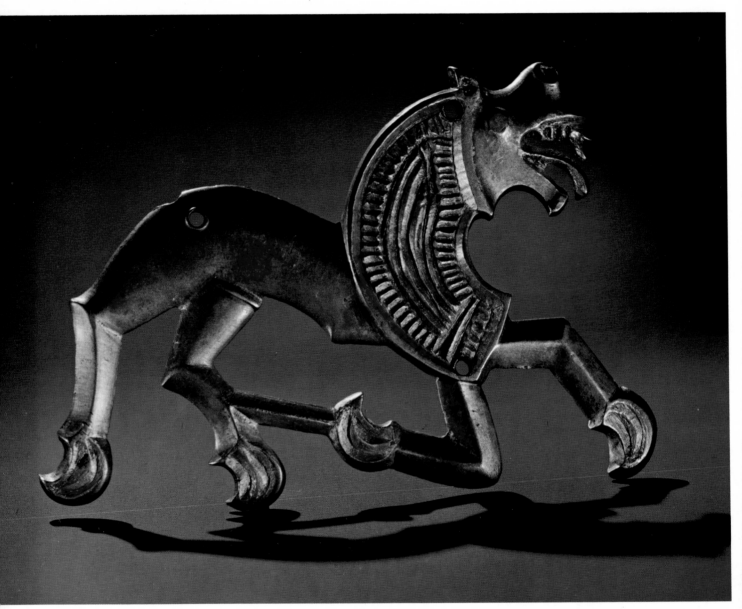

Plate 28 Human figures are quite rare in the art of the steppes, in contrast to the overwhelming number of animals. Though severely simplified, the dress of the man at the right can be identified as that of a horse nomad. Both he and the lion at the left are made of gilded silver, and were part of a treasure trove found near the upper Dnieper river. (Cat. nos. 184, 185)

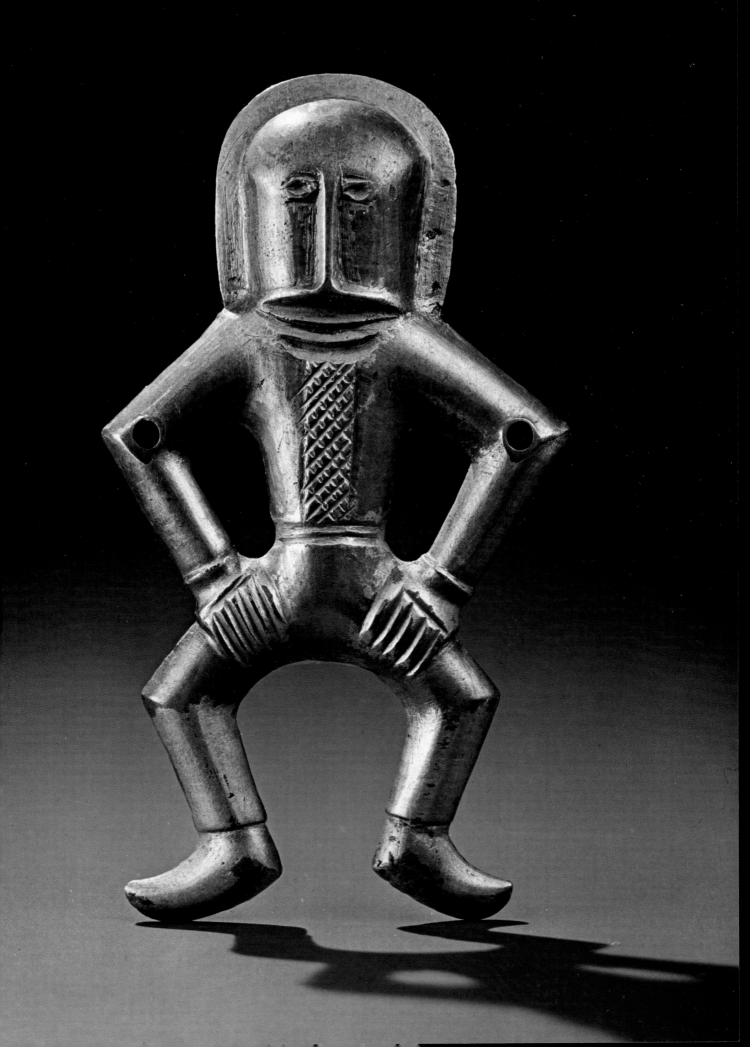

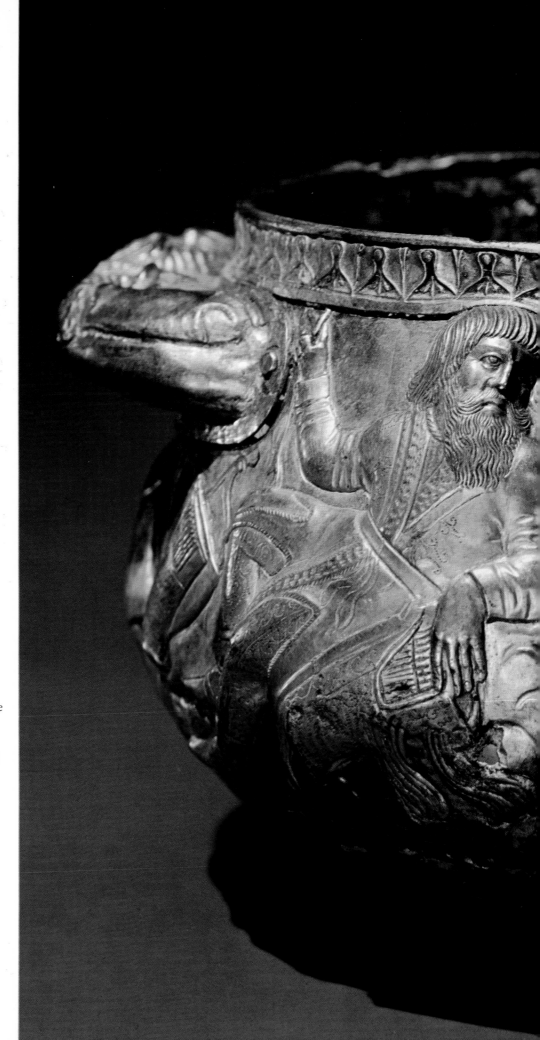

Plate 29

On this gilded silver cup, Scythians are shown in full panoply, with their characteristic shield, bow, and gorytus (the combination quiver and bow-case typical of the Scythians). The careful rendering of features reveals Greek workmanship, and the three-quarter view is typical of classic Greek art of the 4th century B.C. (Cat. no. 172)

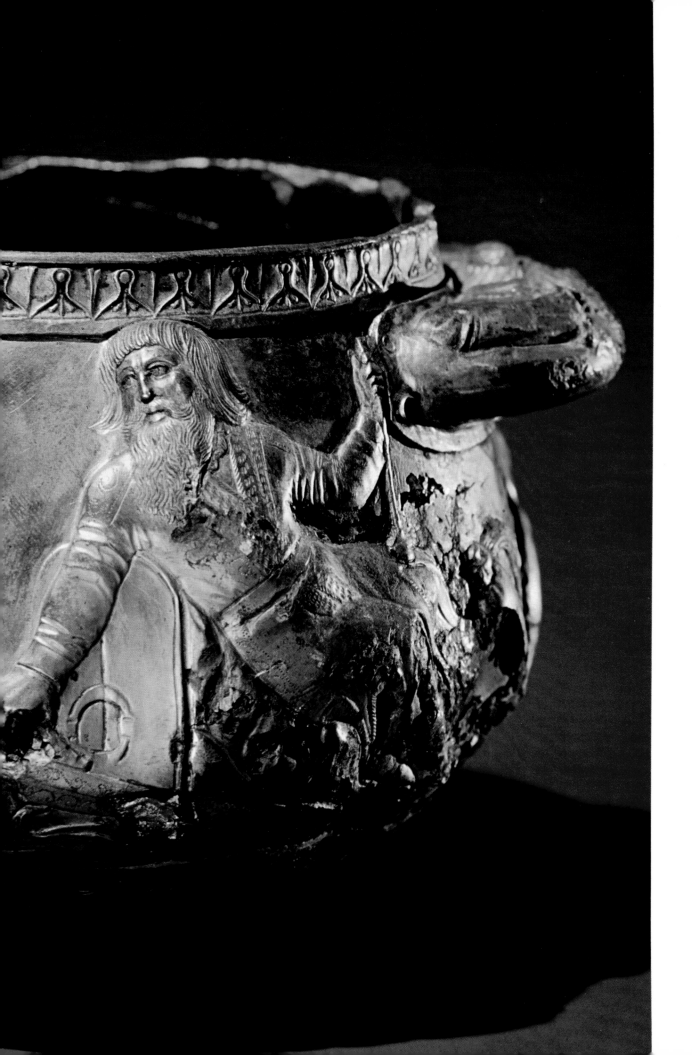

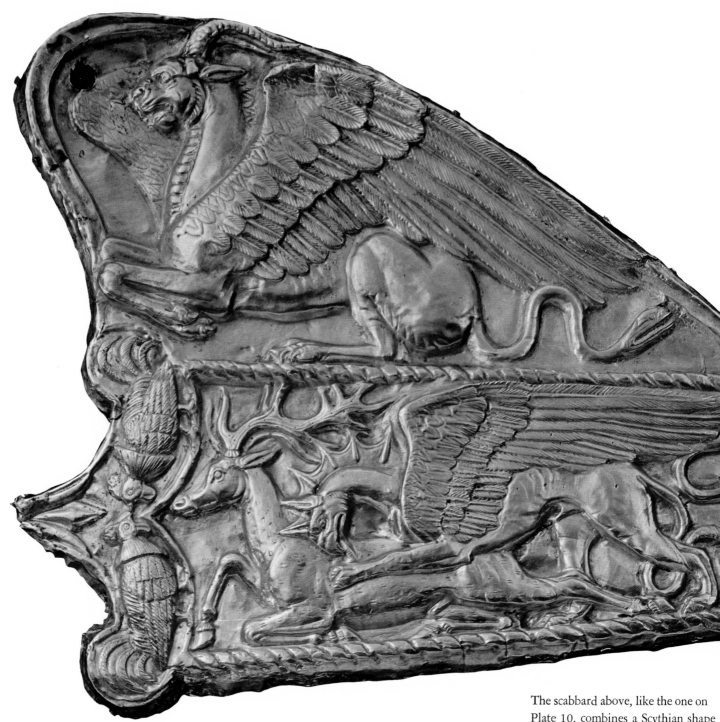

The scabbard above, like the one on
Plate 10, combines a Scythian shape
and decoration devised by a Greek.
On the upper part is a splendid
horned lion-griffin, while animal
combats rage along the sheath.
(Cat. no. 170)

Plate 30

This unusual ornament shows a
spider in combat with an insect, con-
forming to the Scythian notion of
constant battle pervading even the
insect kingdom. (Cat. no. 178)

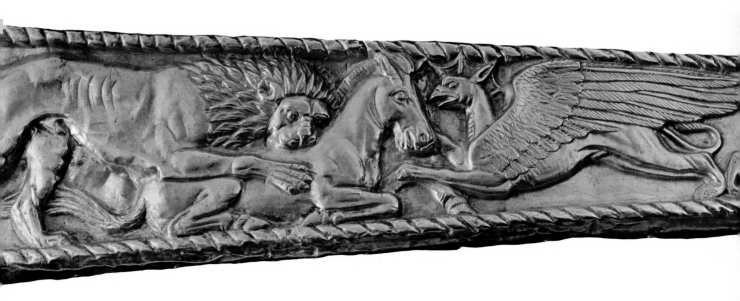

Plate 31 (overleaf)

Of all the superb works in gold
that have been found in South Russia,
this great pectoral is easily the
most splendid. The Greek artist has
contrasted scenes from the home
life of the Scythians with the wildness
outside the encampments. The
48 figures—from human beings to
grasshoppers—are individually
cast and soldered onto the frame.
(Cat. no. 171)

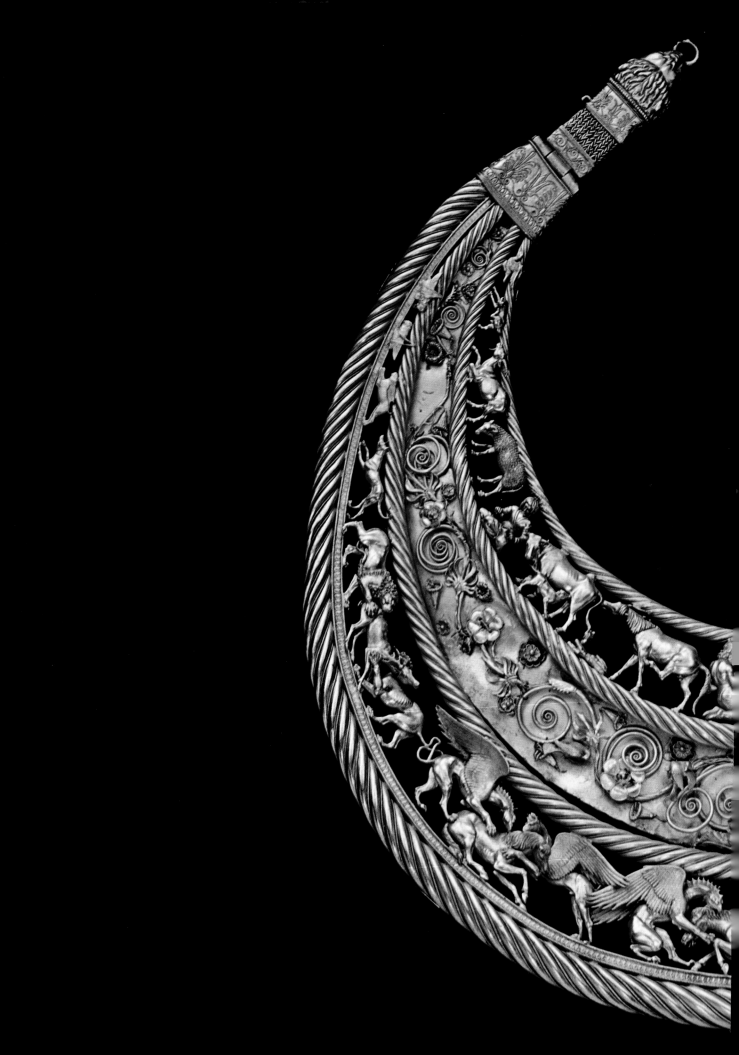

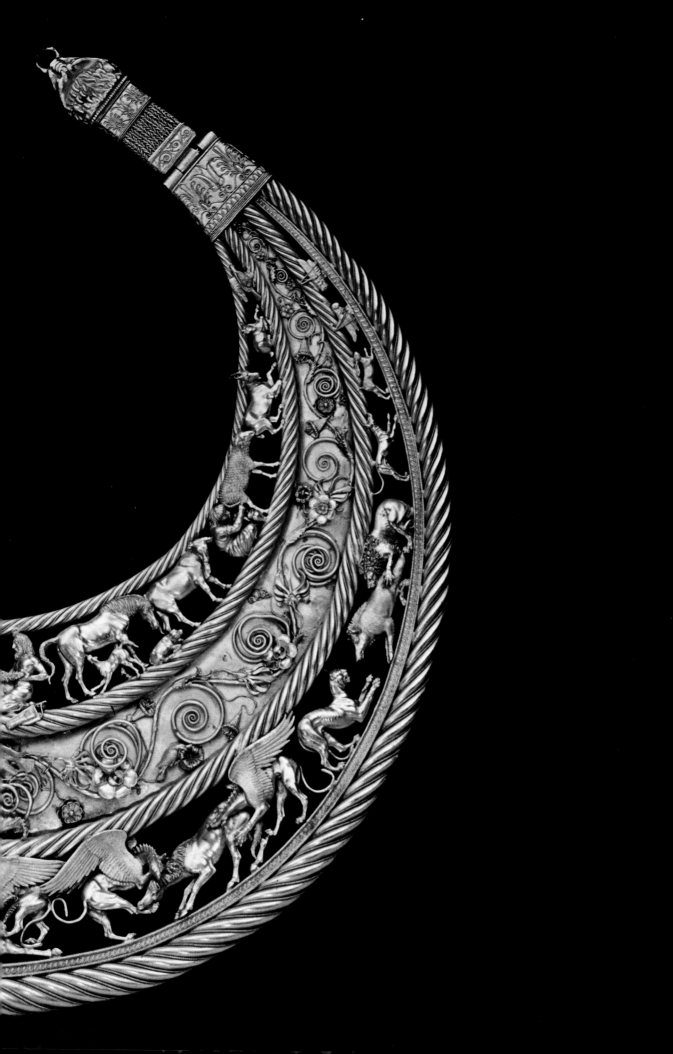

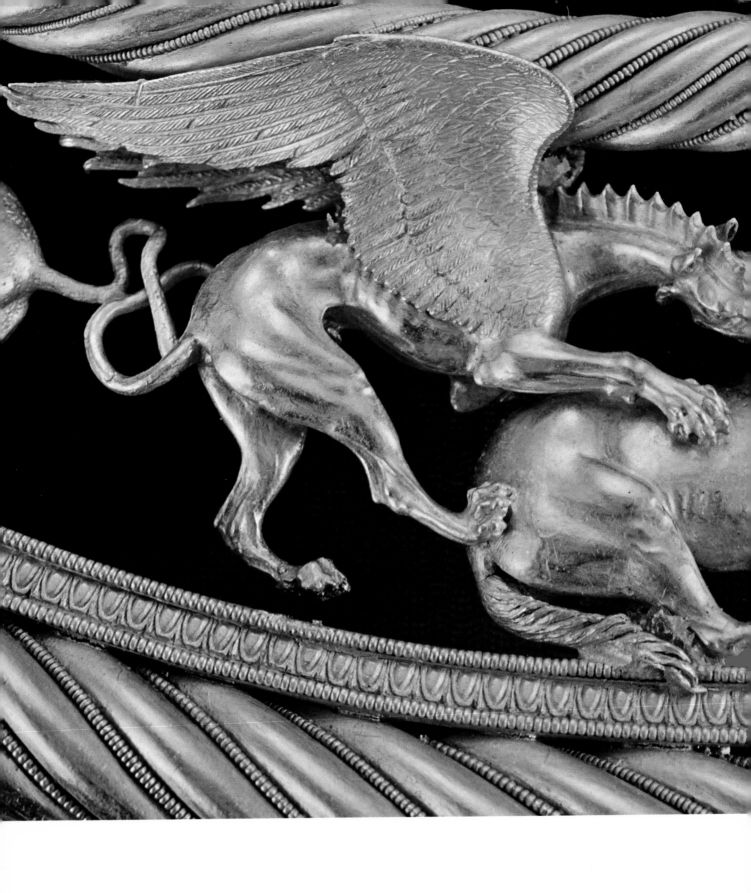

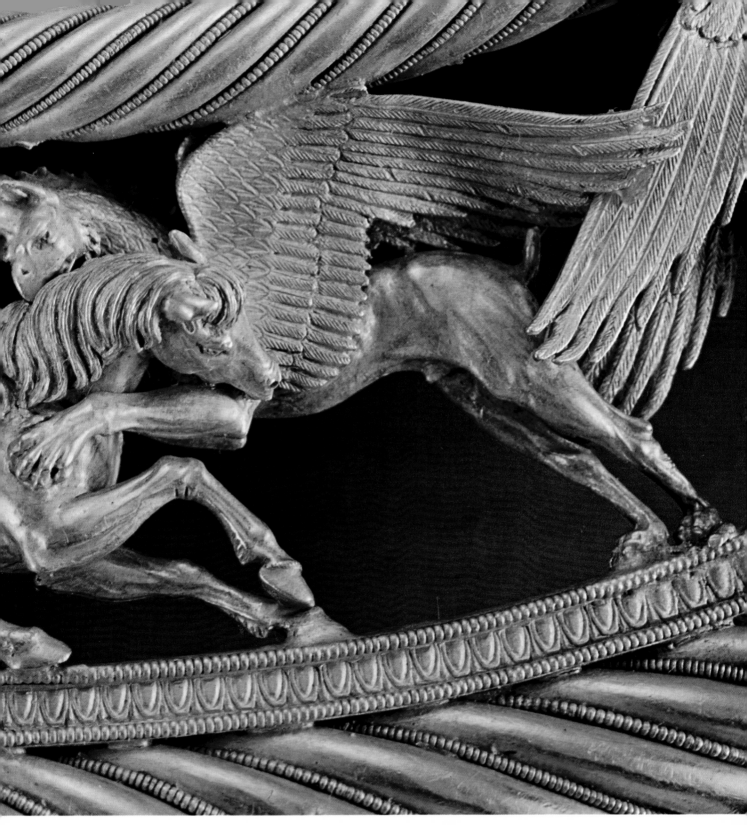

Plate 32 In this poignant scene from the pectoral shown on the preceding page, two griffins attack a horse. Although the workmanship is purely Greek, this is a non-Greek theme: in Greece horses were carefully guarded, in contrast to the Scythians' vast herds that roamed on the steppes, which must often have been preyed upon by mysterious and violent predators.

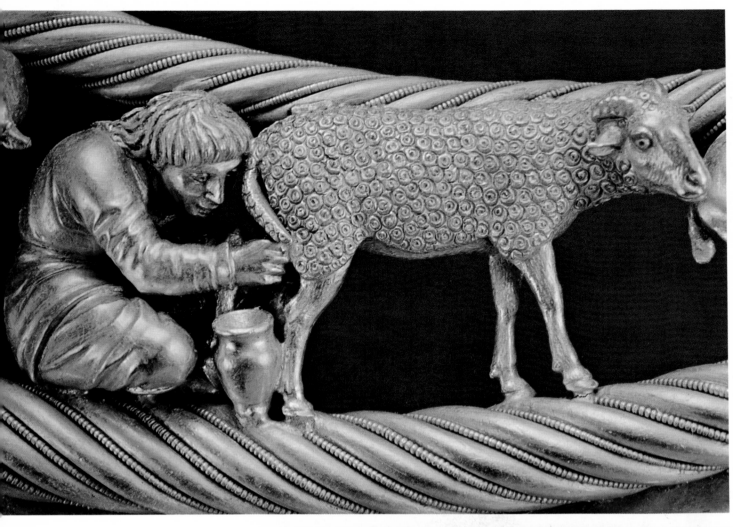

Plate 33

On the pectoral, Scythians go about their daily chores, milking a ewe and sewing a shirt (even the needle and thread have been depicted). Their matter-of-factness stands in dramatic contrast to the liveliness of the animals and the artist's breathtaking skill.

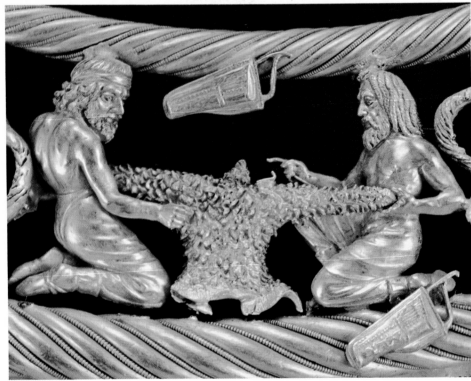

Catalogue

The State Hermitage Museum, Leningrad

Maikop culture of the North Caucasus

Late 3rd millennium B.C.

1 (Color plate 2)

The form of both the lion (an animal unknown in the Kuban river region) and the bull as well as the lavish use of gold and silver in this chieftain's burial indicate the influence of the civilizations of Anatolia and Mesopotamia on the culture of the peoples living in this area.

Striding lions and bull, ornaments from a funerary canopy. Gold, lengths 6, 5, 3 cm. (2⅜, 2, 1¾₆ in.).

Culture of the North Caucasus, end of the 3rd millennium B.C. North Caucasus, Maikop kurgan (burial mound). Excavations of N. I. Veselovsky, 1897. Hermitage, 34/30,31,32.

OAK 1897 (St. Petersburg, 1900), pp. 2-11; B. V. Farmakovsky, "Arkhaichesky period na yuge Rossii," *MAR* (St. Petersburg, 1914), no. 34, pp. 50-76.

2

With curved back and lowered head, this bull may be intended to be dead—a representative of the animals actually killed and mounted on poles during burial ceremonies.

Bull, one of four supports of a funerary canopy. Silver, height 8 cm. (3⅛ in.).

Culture of the North Caucasus, end of the 3rd millennium B.C. North Caucasus, Maikop kurgan. Excavations of N. I. Veselovsky, 1897. Hermitage, 34/22.

Farmakovsky, *MAR* (1914), no. 34, pl. XXI.

3

Vessel. Gold, height 13.6 cm. (5⅜ in.).

Culture of the North Caucasus, end of the 3rd millennium B.C. North Caucasus, Maikop kurgan. Excavations of N. I. Veselovsky, 1897. Hermitage, 34/89.

OAK 1897.

Koban culture of the North Caucasus

Early 1st millennium B.C.

4

This axe and the next represent the two most common types in the Koban culture: with a curving shaft, and with a straight one. The asymmetrical blades are decorated with hunting scenes or animals associated with the chase.

Axe engraved with stags, dogs, and arrows. Bronze, length 17.9 cm. (7¹¹⁄₁₆ in.).

Koban culture, beginning of the 1st millennium B.C. North Ossetia, Koban burial. K. I. Olshevsky Collection. Hermitage, 1731/6.

G. I. Smirnova, J. V. Domansky, *Drevnee iskusstvo* (Leningrad, 1974), pl. 27.

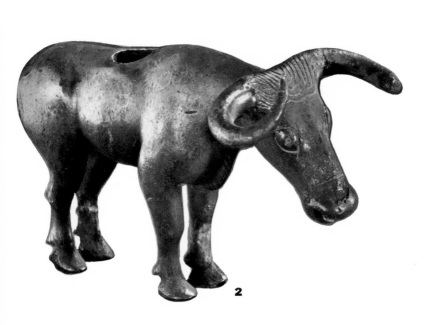

2

4 3

5

Axe engraved with stags. Bronze, length 18.1 cm. (7⅛ in.).

Koban culture, beginning of the 1st millennium B.C. North Ossetia, Koban burial. K. I. Olshevsky Collection. Hermitage, 1731/4.

Pervobytnaya kultura (Ermitazh. Putevoditel po Vystavke), (Moscow, 1955), issue 1.

6 (Color plate 1)

This pin is in the shape of an axe characteristic of the Koban culture. Flat metal strips were once attached to the loops to make a jingling noise.

Axe-shaped pin decorated with animal heads and engraved ornament. Bronze, length 28 cm. (11 in.).

Koban culture, beginning of the 1st millennium B.C. North Ossetia, Koban burial. A. A. Bobrinsky Collection. Hermitage, 1747/6.

P. S. Uvarova, "Mogilniki Severnogo Kavkaza," *MAK* (1900), issue 8, p. 51, fig. 51.

7

The narrow, elongated form typical of Koban buckles is here converted into the shape of a galloping horse. The simple outline of the body is in sharp contrast to the elaborate linear decoration.

Galloping horse, belt buckle. Bronze, 12.9 cm. (5¹/₁₆ in.).

Koban culture, beginning of the 1st millennium B.C. North Ossetia, Koban burial. K. I. Olshevsky Collection. Hermitage, 1731/24.

Smirnova, Domansky, *Drevnee iskusstvo*, pl. 30.

8 (Color plate 2)

This clasp illustrates the ornamental use of iron at a period before it was employed in the manufacture of weapons or tools. A large hook on the reverse entered a hole or loop in a leather or metal belt; such belts are found in large numbers in graves in the Koban. They are characteristically decorated with geometric forms (perhaps derived from textiles) and rather vivacious animal figures.

Belt clasp engraved with carved geometric ornament and stags. Bronze, inlaid with iron, length 24.1 cm. (9½ in.).

Koban culture, beginning of the 1st millennium B.C. North Ossetia, Koban burial. Murié Collection. Hermitage, 2192/4.

Unpublished.

9

Frequently only the head of an animal decorates Koban weapons or horse trappings—the part representing the powe[r] of the whole creature, as it does in later Scythian works. The exaggerated size o[f] the horns indicates their particular significance.

Ram's-head pendant. Bronze, height 5.8 cm (2⁵/₁₆ in.).

Koban culture, beginning of the 1st millennium B.C. North Ossetia, Koban burial. Hermitage, 333/7.

Unpublished.

Culture of Urartu
9th–beginning of the 6th century B.C.

10

Cup with the name of the Urartean king Argishti I and an inscription in hieroglyph[ic] characters. Bronze, diameter 19.5 cm. (7⅝ in.).

Urartean culture, 8th century B.C. Armeni[a] SSR, Karmir-Blur (Teishebaini) near Erivan. Excavations of B. Piotrovsky, 194[9]. Hermitage, 17748.

Karmir-Blur II. Rezultaty raskopok 1949-1950 (Erivan, 1952), p. 55, fig. 27.

11

Cup with the name of the Urartean king Sarduri II and an engraved lion's head and tower with tree. Bronze, diameter 19 cm. (7½ in.).

Urartean culture, 8th century B.C. Armeni[a] SSR, Karmir-Blur near Erivan. Excavation[s] of B. Piotrovsky, 1949. Hermitage, 17752.

Karmir-Blur II, p. 55.

5

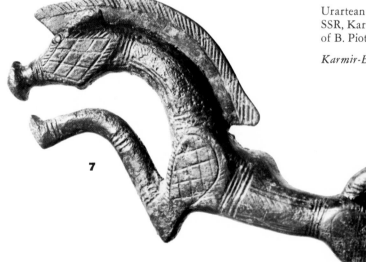

7

12

Quiver decorated with horsemen and battle chariots and inscribed, "To the god Haldi Sarduri I gave." Bronze (the leather backing has been lost), height 5 cm. (2 in.).

Urartean culture, 8th century B.C. Armenian SSR, Karmir-Blur. Excavations, 1948. Hermitage, 17762.

Karmir-Blur III. Rezultaty raskopok 1951-1953 (Erivan, 1955), fig. 26.

13 (Color plate 2)

Urartu had a rich bronze industry, of which many remains have survived. Fantastic animal-human figures were favorite motifs, and this bird with a female torso is frequently found in Urartean and Syrian art (the Greek siren was a similar being). The use of female-bird forms as cauldron handles spread from Urartu to the west, and examples influenced by this type have been found in Greece and Italy.

Bird with a female torso, handle from a cauldron. Bronze.

Urartean culture, 8th-7th century B.C. Found in a rock-cut sepulcher near the Russian frontier post at Alishtar, Iran, 1859. Acquired from N. P. Koliubakin. Hermitage, 16003.

B. B. Piotrovsky, *Iskusstvo Urartu* (Leningrad, 1962), p. 56, pl. I.

14 (Color plate 2)

The part-animal–part-human being, the decorative linear patterns on its body, and the combination of materials of different colors (here, bronze, gold foil, and white stone) are typical of Urartean works of art. This example is thought to have decorated the throne of a statue of Haldi, the chief Urartean god.

Winged lion with a female torso, figure from a throne. Bronze (originally covered with gold leaf) and inlaid stone, height 16 cm. (6¼ in.).

Urartean culture, 7th century B.C. Site of the settlement of Toprak-Kale near the town of Van, Turkey. Chance find, 1884. Acquired from K. Kamsarakan, 1885. Hermitage, 16002.

Piotrovsky, *Iskusstvo Urartu,* pp. 48-49, pls. II, III.

15

Belt decorated with kneeling archers, lions, bulls, and mythical creatures. Bronze.

Urartean culture, 7th century B.C. Turkey, Zakim settlement, near Korss village. From a burial discovered in 1904. Hermitage, KV 6250.

B. B. Piotrovsky, *Vanskoe Tsarstvo* (Moscow, 1959), p. 249.

16

Griffin's head with ram's horns, possibly part of a cheekpiece. Horn.

Scythian type. Armenian SSR, Karmir-Blur near Erivan. Excavations of B. Piotrovsky, 1947. Hermitage.

Karmir-Blur I. Rezultaty raskopok 1939-1949 (Erivan, 1950), pp. 95-96.

Scythian culture
End of the 7th–4th century B.C.

17

The shape of this leg and its decoration of pendent leaves indicate that it is probably an import from Urartu. Other objects from this tomb show influence from the same region.

Taboret leg. Silver gilt, height 11 cm. (4⁵⁄₁₆ in.).

Urartean style, 7th–beginning of the 6th century B.C. Ukrainian SSR, Kirovograd region, Melgunov (Litoy) kurgan. Excavations of A. P. Melgunov, 1763. Hermitage, Dn 1763, 1/23.

E. Pridik, "Melgunovsky klad 1763," *MAR* (1911), no. 31, pl. I.

17

9

12

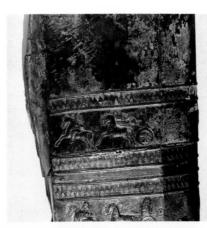

18 (Color plate 3)

This golden stag was found lying in place on an iron shield that it must originally have decorated—one of the few instances in which it is absolutely certain how such large, animal-shaped plaques were used. The stag, one of the most popular Scythian motifs, was possibly one of their totems; it is customarily shown in this passive (possibly dead) pose. The beveled form of the surface–planes meeting at sharp angles–suggests that this style was developed in some carved material such as wood or bone.

Recumbent stag, shield plaque. Gold, length 31.7 cm. (12½ in.), height 19 cm. (7½ in.).

Scythian, late 7th–early 6th century B.C. Krasnodar region, Kostromskaya kurgan. Excavations of N. I. Veselovsky, 1897. Hermitage, Ku 1897, 1/1.

M. I. Artamonov, *The Splendor of Scythian Art* (New York, 1969), pls. 62-64.

19

Chariot finial, stag on an openwork sphere. Bronze, height 26 cm. (10¼ in.).

Scythian, late 7th–early 6th century B.C. Krasnodar region, Makhoshevskaya village. Chance find, 1895. Hermitage, Ku 1895, 2/1.

Smirnova, Domansky, *Drevnee iskusstvo,* pl. 39.

20

The onager, a small Asiatic wild ass, has long pointed ears, here exaggerated. The simplified rendering of the animal's head and neck gives it a particularly arresting appearance.

Onager's head, chariot finial. Bronze, height 16.5 cm. (6½ in.).

Scythian, late 7th–early 6th century B.C. Krasnodar region. Kelermes, kurgan 1. Excavations of N. I. Veselovsky, 1904. Hermitage, Ku 1904, 2/29.

Artamonov, *Splendor,* pl. 5.

21

Ram's head, part of a bridle. Bone, height 3 cm. (1¾₁₆ in.).

Scythian, late 7th–early 6th century B.C. Krasnodar region, Kelermes, kurgan 1. Excavations of N. I. Veselovsky, 1904. Hermitage, Ku 1904, 2/66.

Unpublished.

22

Curled-up panther, part of a bridle. Bone, height 2 cm. (¾ in.).

Scythian, late 7th–early 6th century B.C. Krasnodar region, Kelermes, kurgan 1. Excavations of N. I. Veselovsky, 1904. Hermitage, Ku 1904, 2/178.

Artamonov, *Splendor,* p. 12, fig. 7 (left center).

23

Griffin's head with ram's horns, part of a bridle. Bone, height 2.9 cm. (1⅛ in.).

Scythian, late 7th–early 6th century B.C. Krasnodar region, Kelermes, kurgan 1. Excavations of N. I. Veselovsky, 1904. Hermitage, Ku 1904, 2/73.

Artamonov, *Splendor,* p. 12, fig. 7 (right center).

24

Two golden diadems were wound around the cast-bronze helmet at Kelermes, symbolizing both the man's rank and his warlike qualities. Helmets of this type occur earlier in the Far East.

Helmet. Bronze, height 20 cm. (7⅞ in.).

Scythian culture of the Kuban region, late 7th–early 6th century B.C. Krasnodar region, Kelermes, kurgan 1. Excavations of N. I. Veselovsky, 1904. Hermitage, Ku 1904, 2/149.

B. Z. Rabinovich, "Shlemy skifskogo perioda," *Trudy otdela istorii pervobytnoi kultury* 1 (Leningrad, 1941), pp. 107-108, pl. II.

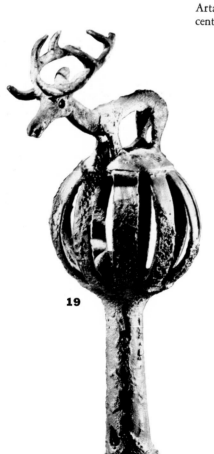

19

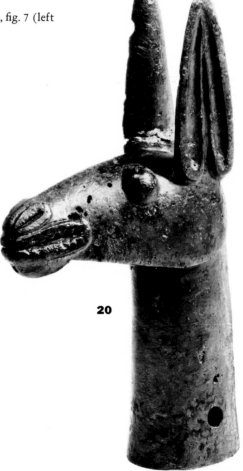

20

25 (Color plate 4)

The subject matter on this mirror combines purely Greek compositions—such as a winged Artemis holding two wild beasts by the forelegs (the *potnia theron*, mistress of animals) and heraldic sphinxes—with Near Eastern motifs such as the lion and tree and with Scythian themes like the two men fighting a griffin. The Greek elements in this mirror are Ionian, and it was perhaps in Asia Minor that the artist became familiar with Greek and Near Eastern compositions flourishing side by side. The scheme of dividing a disk into sectors and the lack of any thematic organization in the decoration, coupled with a certain crudity of style, speak for native Scythian rather than Greek workmanship. Payne has dated the mirror in the middle of the 6th century B.C. The mirror is a type common to Siberia and China and introduced to the west from that region; the distinctive feature is that the loop handle (now broken off) was placed in the center of the disk.

Mirror. The handle on the back has been broken off. Silver, back covered with gold leaf, diameter 17.3 cm. (6¹³⁄₁₆ in.).

Ionic style (possibly of Scythian workmanship following Ionic examples), late 7th–early 6th century B.C. Krasnodar region, Kelermes, kurgan 4. Excavations of D. G. Schulz, 1903. Hermitage, Ku 1904, 1/27.

M. N. Maksimova, "Serebryanoe zerkalo iz Kelermesskogo kurgana," *SA* (1959), no. 21, p. 281; Artamonov, *Splendor,* pls. 29-33.

26 (Color plate 4)

Stags and felines of symbolic significance were considered to be appropriate decorations for weapons. The positions of both animals on this plaque, a covering for a gorytus—the combination quiver and bow-case typical of the Scythians—are those endlessly repeated in Scythian works of art.

Plaque, plating from a gorytus stamped with stags and panthers. Gold, height 40.5 cm. (15¹⁵⁄₁₆ in.).

Scythian, late 7th–early 6th century B.C. Krasnodar region, Kelermes, kurgan 4. Excavations of D. G. Schulz, 1903. Hermitage, Ku 1904, 1/28.

Artamonov, *Splendor,* pl. 21.

27

Recumbent stag, finial. Gold, length 8.3 cm. (3¼ in.).

Scythian, late 7th–early 6th century B.C. Krasnodar region, Kelermes, kurgan 2. Excavations of D. G. Schulz, 1903. Hermitage, Ku 1904, 1/18.

Artamonov, *Splendor,* pl. 50.

28 (Color plate 5)

This large plaque—over 12 inches long—was found resting on iron scales of armor, and may once have decorated a breastplate or shield made of some perishable material. The animal's tail and paws are made up of other small felines. The inlays of glass paste and stone are a minor part of the design, but the taste for such colorful additions increases during the following centuries until it becomes a major element in the art of the Sarmatians and the Huns.

Panther. On the feet and tail are small figures of curled-up panthers. Gold, inlaid, length 32.6 cm. (12¹³⁄₁₆ in.).

Scythian, late 7th–early 6th century B.C. Krasnodar region, Kelermes, kurgan 1. Excavations of D. G. Schulz, 1903. Hermitage, Ku 1904, 2/1.

Artamonov, *Splendor,* pls. 22-24.

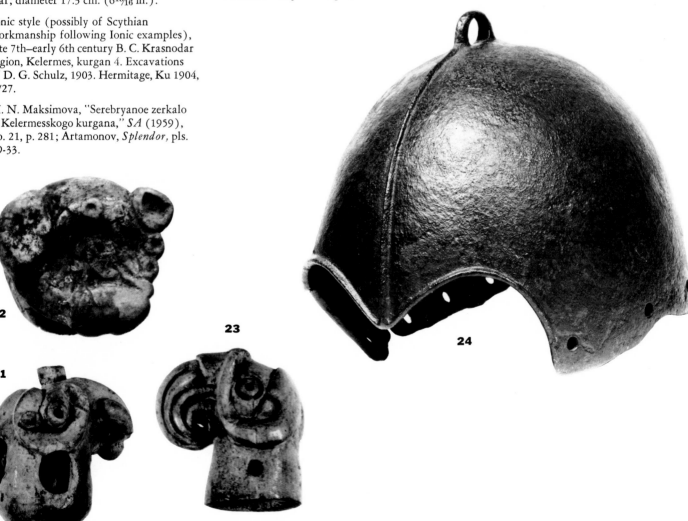

22

23

21

24

29 (Color plate 4)

In the eastern region from which these pieces come, the reindeer is more naturalistically portrayed than in the art of the Pontic steppes; compare the form of the antlers and hooves to those of the Kostromskaya stag (no. 18). The turquoise for the inlay of the ears was available in Siberia and eastern Iran.

Reindeer, four plaques from a wooden quiver. Gold, ears inlaid with turquoise, lengths 7.1 cm. (2¾ in.).

Scythian, 7th–6th century B.C. Kazakhstan, Chiliktin valley, near Ust-Kamenogorsk, kurgan 5 (The Golden One). Excavations of S. S. Chernikov, 1960. Hermitage, 2326/1.

S. S. Chernikov, *Zagadka zolotogo kurgana* (Moscow, 1965), p. 29, pl. XI.

30

Five arrowheads. Bronze, lengths 4-5 cm. (1 9⁄16-2 in.).

Scythian culture, 7th–6th century B.C. Kazakhstan, Chiliktin valley, near Ust-Kamenogorsk, kurgan 5 (The Golden One). Excavations of S. S. Chernikov, 1960. Hermitage, 2326/20,21.

Chernikov, *Zagadka zolotogo kurgana,* p. 27, pl. X.

31 (Color plate 6)

A griffin's head tops this standard, which enclosed a bell. These objects, frequently found in Scythian tombs, may have been attached to chariots or carts but they are not actually found with either vehicles or horses when discovered in place in Scythian burials. It is therefore possible that they were ceremonial objects originally mounted on wooden shafts and carried by hand.

Finial, openwork cone decorated with a griffin's head with ram's horns. Bronze, height 22 cm. (8⅝ in.).

Scythian, late 7th–early 6th century B.C. Kuban region, Ulski Aul, kurgan 1. Excavations of N. I. Veselovsky, 1908. Hermitage, Ku 1908, 3/10.

Artamonov, *Splendor,* pl. 59.

32 (Color plate 6)

The contracted pose, unnatural for a live animal, is often repeated in Scythian art. Holes for the attachment of these gold plaques onto another material are placed in areas where inlays often occur on larger works.

Four panthers, plaques. Gold, lengths 2.7 cm. (1 1⁄16 in.).

Scythian, beginning of the 6th century B.C. Kuban region, Ulski Aul, kurgan 1. Excavations of N. I. Veselovsky, 1908. Hermitage, Ku 1908, 3/3.

OAK 1908, p. 118, fig. 168.

33 (Color plate 8)

The silhouette of a bird of prey's head decorating this standard encloses many other animals: inside the curve of its beak and head appears a fantastic creature hovering above its prey, the goat; on the goat's shoulder is a spiral form, doubtless stylization of another bird's head. Three additional birds' heads occur above the large eye at the lower right. The incorporation of smaller creatures within the form of a large animal or bird is characteristic of Scythian art: the object was then believed to contain all the powers of the subjects represented.

Finial, fantastic bird's head decorated with animals, a human eye, and bells (one of the bells has been lost). Bronze, height 26 cm. (10¼ in.), width 18.9 cm. (7⅞ in.).

Scythian, 6th–5th century B.C. Kuban region, Ulski Aul, kurgan 2. Excavations of N. I. Veselovsky, 1909. Hermitage, Ku 1909, 1/111.

Artamonov, *Splendor,* pl. 58.

30

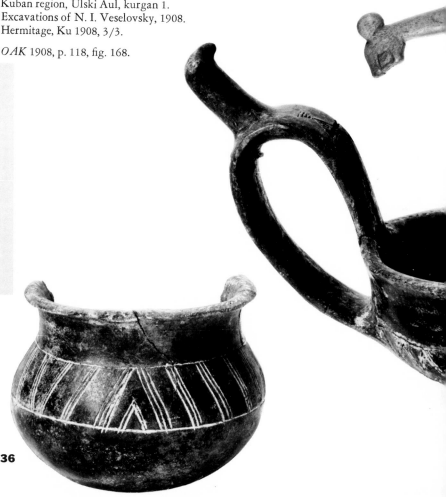

36

34 (Color plate 6)

The coiling of the animal's body is a convention that occurs earlier in China than in Siberia or the Black Sea region, although it becomes a characteristic Scythian design. The animal in this instance may be a snow leopard, native to Siberia. The circle of the body is repeated in the smaller ones that originally held colored inlays.

Curled-up panther, shield plaque. Gold, diameter 11 cm. (4⅝ in.).

Scytho-Sarmatian style, late 7th–early 6th century B.C. Siberian collection of Peter I. Location of find unknown. Hermitage, Si 1727, 1/88.

S. I. Rudenko, *Sibirskaya kollektsiya Petra I* (Moscow-Leningrad, 1966), pl. VI, I.

35

Cheekpiece decorated with panther heads. Bone, length 12.7 cm. (5 in.).

Scythian, 7th–6th century B.C. Dnieper river region. Chance find, 1888. Hermitage, Dn 1888, 1/1.

Unpublished.

35

36

Pottery with white-filled incised decoration is associated with the forest cultures of the mid-Dnieper region. This type of decoration, however, was used by other nomads in Siberia as well as by many of the settled peoples in the Near East.

Drinking bowl. Burnished earthenware, incised design filled with white paste, height 9.4 cm. (3¹¹⁄₁₆ in.).

Scythian, culture of the agricultural population of the forest-steppe region, end of the 7th–beginning of the 6th century B.C. Dnieper river region, Cherkassy district, Makeyevka village, kurgan 455. Excavations of N. E. Brandenburg, 1900. Hermitage, Dn 1932, 55/3.

V. A. Ilyinskaya, "Otnositelnaya khronologiya ranneskifskikh kurganov basseyna reki Tyasmin," *SA* (1973), no. 3, p. 11, figs. 5,37.

37

Ladle. Burnished earthenware, incised design filled with white paste, height 6.3 cm. (2⅝ in.).

Scythian, culture of the agricultural population of the forest-steppe region, end of the 7th–beginning of the 6th century B.C. Dnieper river region, Cherkassy district, Makeyevka village, kurgan 455. Excavations of N. E. Brandenburg, 1900. Hermitage, Dn 1932, 55/4.

Smirnova, Domansky, *Drevnee iskusstvo,* pls. 33,34.

38

Jar. A scratched inscription in Greek has been translated "Obtain me." Burnished earthenware, height 37 cm. (14½ in.).

Scythian, culture of the agricultural population of the forest-steppe region, end of the 7th–beginning of the 6th century B.C. Bug river basin, Vinnitsa district, Nemirovskoe settlement. Excavations of A. A. Spitzyn, 1910-1911. Hermitage, Dn 1933, 1/2591, 94,97,98.

B. N. Grakov, "Grecheskoe graffito iz Nemirovskogo gorodishcha," *SA* (1959), no. 1, p. 259, fig. 1.

39

Two felines in a heraldic pose, bridle ornament. Bronze, height 4.3 cm. (1¹¹⁄₁₆ in.).

Scythian, showing influence of western Asiatic art, beginning of the 6th century B.C. Taman, shore of Tsukur estuary (on the Black Sea). Chance find, 1913. Hermitage, T 1913, 55.

Artamonov, *Splendor,* p. 15, fig. 14.

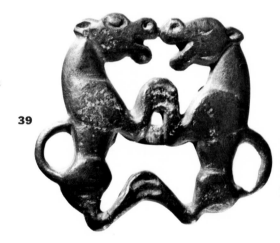

39

37

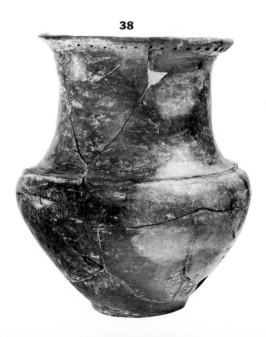

38

40

Recumbent stag, plaque. Gold, length
4.3 cm. (1⅝ in.).

Scythian, 6th century B.C. Ukrainian SSR,
Kiev region, Chigirin district, Goryachevo,
kurgan 407. Excavations of A. A. Bobrinsky,
1903. Hermitage, Dn 1903, 9/61.

A. A. Bobrinsky, "Otchet o raskopkakh,
proizvedennykh v 1903 g v Chigirinskom
uezde Kievskoy gubernii," *IAK* (1905),
issue 14, pp. 1-43, fig. 79.

41

Recumbent elk on a bird's-leg pedestal,
plaque. Bronze, height 10.1 cm. (4 in.).

Kiev region, Zhurovka, kurgan G.
Hermitage, Dn 1903, 11/7.

Artamonov, *Splendor,* pl. 76.

42

Panther lying on a horseshoe-shaped object,
plaque. Bronze, height 7 cm. (2¾ in.).

Kiev region, Zhurovka, kurgan G.
Hermitage, Dn 1903, 11/1.

Artamonov, *Splendor,* pl. 77.

43

Cheekpiece decorated with animal heads.
Bone, length 16.5 cm. (6½ in.).

Scythian, 6th century B.C. Sula river basin,
Sumy district, Velikiye Budki village, kurgan
478. Excavations of N. E. Brandenburg,
1901. Hermitage, Dn 1932, 18/14.

Unpublished.

44

Cheekpiece decorated with a horse's head.
Bone, length 16 cm. (6¼ in.).

Scythian, 6th century B.C. Sula river basin,
Sumy district, Velikiye Budki village, kurgan
477. Excavations of N. E. Brandenburg,
1901. Hermitage, Dn 1932, 17/7.

Unpublished.

45

Mirror with a panther at the end of the
handle. Bronze, length 33.5 cm. (13³⁄₁₆ in.).

Scythian, 6th century B.C. North Caucasus,
Stavropol region. Chance find, 1885.
Hermitage, Ku 1885, 1/1.

Smirnova, Domansky, *Drevnee iskusstvo,*
pl. 38.

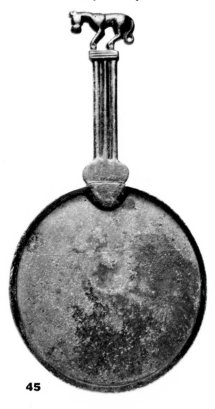

45

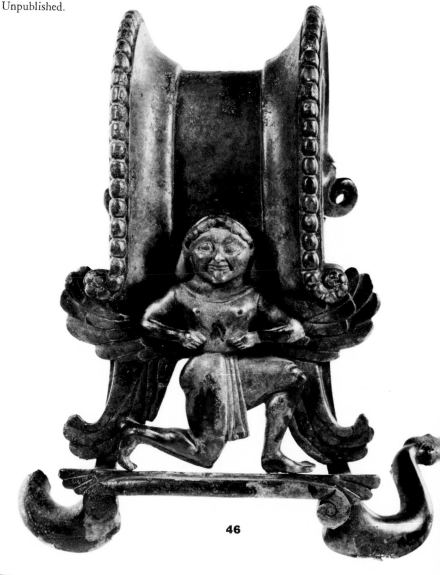

46

43

44

46

The volute-krater was a Laconian invention and the shape is known both in terracotta and bronze. In Greek bronze vessels the handles, the foot, and sometimes the rim were cast, while the body was hammered ("raised") from sheet metal. In contrast to other shapes like the hydria, relatively few bronze volute-kraters have survived. Often the hammered walls of the body disintegrated, leaving only the cast portions; parts of the krater from which this handle comes are in Odessa.

Volute-krater handle with the figure of a gorgon and snakes. Bronze, height 16 cm. (6⁵⁄₁₆ in.).

Greek, 6th century B.C. Dnieper region, Kirovograd district, Martonosha village. Chance find, 1870. Hermitage, Dn 1870, 1/1.

Artamonov, *Splendor,* pl. 67.

47

Curled-up predatory animal with a goat and bird's head decorating its body, bridle plaque. Bronze, length 10.5 cm. (4⅛ in.).

Scythian, beginning of the 5th century. Crimea, Kulakovsky kurgan 2. Excavations of J. A. Kulakovsky, 1895. Hermitage, Cr 1895, 10/2.

Artamonov, *Splendor,* pl. 78.

48 (Color plate 11)

A winged panther has jumped on the back of a seated goat. The ornaments—the egg and dart pattern above, and a stylized lotus below—are common in Greek art, but winged panthers are rare, as is the docile goat. A silver cup found in this kurgan depicts a seated Nike and allows us to date the burial sometime after 470 B.C.

Winged feline attacking a goat, curved triangular plaque from a wooden rhyton. Gold, height 9.8 cm. (3¹³⁄₁₆ in.).

Scythian, showing Iranian influence, 5th century B.C. Taman, Seven Brothers, kurgan 4. Excavations of V. G. Tiesenhausen, 1876. Hermitage, SBr IV, 5.

Artamonov, *Splendor,* pl. 116.

49

Senmurv (mythical Iranian animal), curved triangular plaque from a wooden rhyton. Gold, height 8.3 cm. (3¾ in.).

Scythian, showing Iranian influence, 5th century B.C. Taman, Seven Brothers, kurgan 4. Excavations of V. G. Tiesenhausen, 1876. Hermitage, SBr IV, 8.

Artamonov, *Splendor,* pl. 121.

50

Recumbent stag looking backward, bridle plaque. Bronze, length 4.7 cm. (1⅞ in.).

Scythian, 5th century B.C. Taman, Seven Brothers, kurgan 4. Excavations of V. G. Tiesenhausen, 1876. Hermitage, SBr IV, 38.

Artamonov, *Splendor,* pl. 130.

51 (Color plate 9)

These small ornaments, intended to be fastened to clothing as shown by the attachment holes, are rather coarse adaptations of standard Greek motifs. The male head with the horns of a bull represents Acheloös; the winged boar is known from coins of Clazomenae (a Greek town in Anatolia); the owl, sacred to Athens, is a standard device of Athenian coins.

Ram's head, standing lion, bull's head, head of a bearded man with horns and bovine ears, owl, rooster, and protome of a winged boar: clothing ornament plaques. Gold, heights 3.3–1.9 cm. (1⁵⁄₁₆–¾ in.).

Scythian, showing Greek influence, 5th century B.C. Taman, Seven Brothers, kurgan 2. Excavations of V. G. Tiesenhausen, 1875. Hermitage, SBr II, 1-5, 9,22.

Artamonov, *Splendor,* figs. 48, 43, 44, 46, 50, 47, 49.

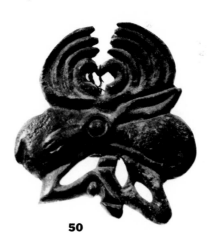

50

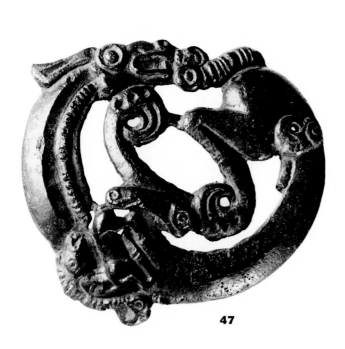

47

52

Bird's head with a volute-shaped beak, bridle plaque. Bronze, length 9 cm. (3½ in.).

Taman, Seven Brothers, kurgan 2. Hermitage, SBr II, 55.

Artamonov, *Splendor,* pl. 115.

53

Sitting bird, cheekpiece plaque. Bronze, length 12.1 cm. (4¾ in.).

Taman, Seven Brothers, kurgan 3. Hermitage, SBr III, 20.

54

Recumbent stag, plaque from a wooden vessel. Gold, height 7.1 cm. (2¾ in.).

Scythian, 5th century B.C. Crimea, kurgan near Kara-Merket village, near Ak-Mechet bay. Chance find, 1885. Hermitage, Cr 1885, 1/1.

Artamonov, *Splendor,* pl. 72.

55

Bird with outstretched wings, plaque. Bronze, height 6.6 cm. (2⁷⁄₁₆ in.).

Crimea, near Simferopol, Golden kurgan. Hermitage, Cr 1890, 1/28.

Artamonov, *Splendor,* pl. 74.

56

Bird's head, bridle plaque. Bronze, length 4.1 cm. (1⅝ in.).

Scythian, middle of the 5th century B.C. Crimea, Kerch peninsula, Geroyevskoye village, necropolis of the Nymphaeum, horse burial, kurgan 24. Excavations of A. E. Lyutsenko, 1876. Hermitage, GK-N 118.

Artamonov, *Splendor,* pl. 92.

57

Lion's head, plaque. Bronze, height 7.5 cm. (2¹⁵⁄₁₆ in.).

Crimea, Kerch peninsula, Geroyevskoye village, necropolis of the Nymphaeum, kurgan 32. Hermitage, GK-N 57.

Artamonov, *Splendor,* fig. 40.

58

Curled-up lion, openwork bridle plaque. Bronze, diameter 6.1 cm. (2⅜ in.).

Scythian, second half of the 5th century B.C. Crimea, near Kerch, Cape Ak-Burun, kurgan 5. Excavations of A. E. Lyutsenko, 1862. Hermitage, AkB 6.

Unpublished.

59

Cross-shaped plaque. Bronze, height 11.2 cm (4⅜ in.).

Olbia. Hermitage, Ol 3023.

Artamonov, *Splendor,* fig. 34.

58

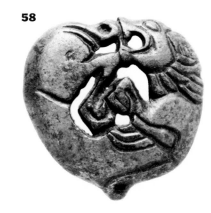

54

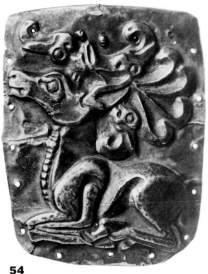

56

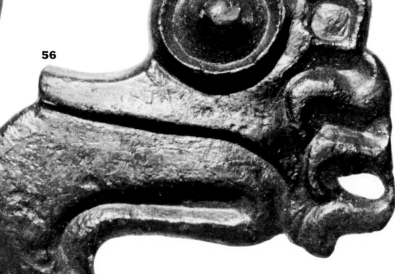

60

This type of cauldron, with upright handles and conical hollow foot, frequently appears in Scythian graves. It is known earlier in China and Siberia. Both the body and the decoration are cast.

Cauldron with two handles and slim foot, and relief ornament of bulls' heads, palmettes, and triangles. Bronze, height 47 cm. (18½ in.).

Scythian culture, beginning of the 4th century B.C. Dnieper river region, Kherson district, Raskopana kurgan. Excavations of D. J. Evarnitsky, 1897. Hermitage, Dn 1897, 2/14.

Artamonov, *Splendor,* fig. 21.

61 (Color plate 9)

This helmet was probably worn over a lining of colorful felt or fur, against which the golden openwork would have gleamed sumptuously. The flowers are shown in a rare three-quarter view, and the heavy scrolls contrast with the delicate acanthus leaves and the diminutive scrollwork in the lower zone.

Openwork helmet decorated with scrolls, acanthus, and flowers. Gold, height 14.4 cm. (5⅝ in.).

Greek workmanship, 4th century B.C. Crimea, near Kerch, kurgan on Cape Ak-Burun. Excavations, 1875. Hermitage, AkB 28.

Artamonov, *Splendor,* pl. 272.

62

In the first millennium B.C., the Egyptian god Bes begins to occur with some frequency in Near Eastern art. Generally beneficent, he was considered a protective and lucky divinity for women in childbirth.

The Egyptian deity Bes, amulet. Faïence, height 7.8 cm. (3¹/₁₆ in.).

Egyptian, 6th–5th century B.C. Taman peninsula, Great Bliznitsa kurgan, burial 4. Excavations of A. E. Lyutsenko, 1868. Hermitage, BB 190.

OAK 1869, p. 9, pl. I, 31.

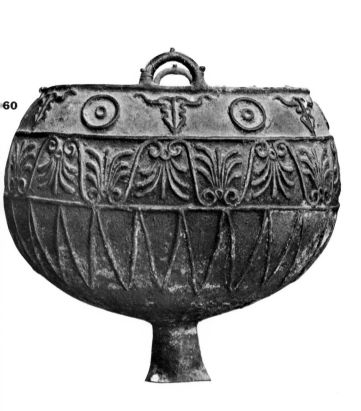

60

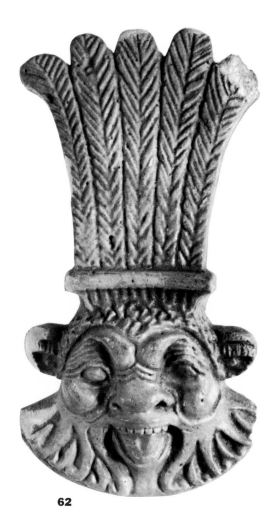

62

63

A hero in Persian dress holds a short sword with which he will stab the rearing lion. Above is an identifying sign. The seal is probably a century earlier than the 4th-century tomb in which it was found. It may have been made in Anatolia, a western province of the Achaemenid empire, rather than in Iran.

Finger ring with octagonal seal of a king confronting a lion. Chalcedony and gold, length of seal 2.3 cm. (⅞ in.).

Achaemenid, 5th–4th century B.C. (Mounting, 4th century B.C.). Taman peninsula, Great Bliznitsa kurgan, burial 4. Excavations of A. E. Lyutsenko, 1868. Hermitage, BB 123.

OAK 1869, p. 140, pl. I, 18.

64

The motif of Aphrodite leaning on a pillar while Eros ties the straps of her sandals enters Greek art in the late 5th century B.C., but the representation of Aphrodite with her body bared does not occur before the 4th century. This ring is unusual in that the decoration on the bezel is not engraved but in low relief, indicating that it would not have been used for sealing.

Finger ring, scarab bezel with Aphrodite and Eros on the reverse. Gold, length of scarab 2.5 cm. (1 in.).

Greek, 4th century B.C. Taman peninsula, Great Bliznitsa kurgan, burial 1. Excavations of I. E. Zabelin and A. E. Lyutsenko, 1864. Hermitage, BB 40.

Artamonov, *Splendor,* fig. 144, pl. 280.

65 (Color plate 9)

The dancer at the left performs the *oklasma,* a Persian dance described by Xenophon in which the arms are held above the head with the hands clasped. The others wear a special headdress called a kalathos and dance on tiptoe. These gold plaques (dating from the second and third quarters of the 4th century B.C.) were found in the tomb of a priestess of Demeter, and the dances may have been performed at a festival of Demeter.

Dancers, clothing ornament plaques. Gold, heights 4.8, 5.1, 3.6 cm. (1⅞, 2, 1⅜ in.).

4th century B.C. Taman peninsula, Great Bliznitsa kurgan, burial 1. Excavations of I. E. Zabelin and A. E. Lyutsenko, 1864. Hermitage, BB 50, 51, 52.

Artamonov, *Splendor,* pls. 266,267.

66

Cheekpiece composed of a stag's head in a frame and a horse's foreleg. Bronze, length 13.5 cm. (5¼ in.).

Taman peninsula, Great Bliznitsa kurgan. Hermitage, BB 77.

Artamonov, *Splendor,* fig. 151.

67 (Color plate 10)

The back-to-back calf heads on the hilt and the palmette between them are distinctly Iranian in style, although similar conventions are also known from East Greek art in Anatolia. The repetitious hunters on horseback evoke the style of Persepolis.

The sword was buried with the scabbard, no. 68.

Sword hilt decorated with a scene of horsemen hunting goats and rams, and sculptured calves' heads. Gold and iron, length of hilt 15 cm. (5⅞ in.).

Iranian, 5th–4th century B.C. Ukrainian SSR. Dnepropetrovsk region, Chertomlyk kurgan. Excavations of I. E. Zabelin, 1863. Hermitage, Dn 1863, 1/448.

Artamonov, *Splendor,* pls. 183,184.

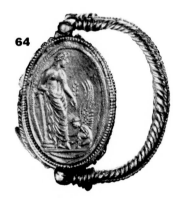

64

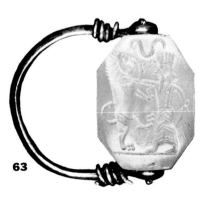

63

68 (Color plate 10)

This scabbard combines a Scythian shape, proper for the Scythian sword, with a scheme of decoration devised by a Greek (see also no. 170). It is divided into three parts: a top band into which the kidney-shaped guard of the hilt fitted; a triangular extension that represents the leather flap by means of which the scabbard was attached to the belt; and the sheath proper. The artist has respected these divisions. On top he has put 2 heraldic griffins, which are thus parallel to the animals on the sword's pommel. In the triangular "flap" he has put a very large griffin attacking a stag, and on the long, tapering sheath he has depicted a battle of Greeks and Persians. The composition recalls certain Greek architectural friezes of the late 5th-early 4th century B.C. (temple of Athena Nike in Athens, Bassae, Trysa), which in turn may echo the picture of the battle of Marathon in the Painted Porch at Athens.

Scabbard decorated with fighting beasts, and Greeks battling Persians. Gold, length 54.4 cm. (21⅜ in.).

Greek workmanship, 4th century B.C. Ukrainian SSR, Dnepropetrovsk region, Chertomlyk kurgan. Excavations of I. E. Zabelin, 1863. Hermitage, Dn 1863, 1/447.

Artamonov, *Splendor,* pls. 183,185.

69 (Color plate 11)

The decoration, pure Greek in style, shows a woman whose lower extremities terminate symmetrically in lion-griffins, eagle-griffins, and, finally, two snakes that issue from an acanthus flower.

Bridle frontlet, plaque with a representation of a woman with snake legs, possibly the snake-legged Scythian goddess referred to by Herodotus. Gold, height 41.4 cm. (16⁵⁄₁₆ in.).

Greek workmanship, 4th century B.C. Ukrainian SSR, Melitopol region, Tsimbalka kurgan. Excavations of I. E. Zabelin, 1868. Hermitage, Dn 1868, 1/8.

Artamonov, *Splendor,* pl. 186; D. S. Raevsky,"Skifsky mifologichesky suzhet," *SA* (1970), no. 3, p. 90.

70 (Color plate 11)

The shape of this libation bowl is thoroughly Greek, as is perhaps the execution, but the scheme of decoration– a fluid profusion that covers most of the surface–betrays a non-Greek taste and is closer to the Scythian preference that rejected rigid organization. There are 56 animals in 3 zones or 7 sectors; the lions predominate, and it is significant that most of the victims are horses.

Libation bowl *(phiale)* decorated with lions and panthers attacking stags and horses. Gold, diameter 21.8 cm. (8⅝ in.), weight 865 gr.

Greek workmanship, beginning of the 4th century B.C. Ukrainian SSR, Melitopol region, Solokha kurgan. Excavations of N. I. Veselovsky, 1913. Hermitage, Dn 1913, 1/48.

A. P. Mantsevich, "Greben i fiala iz kurgana Solokha," *SA* (1950), no. 13, pp. 217-238; Artamonov, *Splendor,* pls. 157-159.

71 (Color plates 12, 13)

The group is worked in relief on both sides, giving the illusion of being sculptured in the round. In Western art, the direction of the victor is usually from left to right, so the side of the comb giving the horseman and his squire the left half of the scene is probably the principal one. Their opponent has been thrown off his mount, which lies helplessly on its back. Dress and armor combine local costume with such Greek elements as the Corinthian helmet on the rider and the metal cuirasses. The workmanship is purely Greek and may go back to the last quarter of the 5th century B.C., though some scholars have connected the rider with the Attic tomb relief of Dexileos, which is dated 394 B.C.

Comb ornamented with three warriors in combat, and five crouching lions below. Gold, height 12.6 cm. (4¹³⁄₁₆ in.), width 10.2 cm. (4¹⁵⁄₁₆ in.).

Greek workmanship, beginning of the 4th century B.C. Ukrainian SSR, Melitopol region, Solokha kurgan. Excavations of N. I. Veselovsky, 1913. Hermitage, Dn 1913, 1/1.

Mantsevich, "Greben i fiala iz kurgana Solokha," pp. 217-238; Artamonov, *Splendor,* pls. 147,148,150.

72

These five gold plaques come from the second tomb at Solokha, the burial of a man. They were found near the legs of the skeleton and are thought to have been sewn on his trousers. The scene of two Scythians drinking from the same horn in a ritual described by Herodotus is also shown on a plaque made some fifty years later (no. 76).

Lion, two Scythians sharing a drinking horn, stag, reclining goat, and lion attacking a stag, clothing ornament plaques. Gold, lengths 3.2–2.3 cm. (1¼–⅞ in.).

Scythian, beginning of the 4th century B.C. Ukrainian SSR, Melitopol region, Solokha kurgan. Excavations of N. I. Veselovsky, 1913. Hermitage, Dn 1913, 1/42, 14,15,45,16.

Artamonov, *Splendor,* figs. 77-81.

73 (Color plate 14)

This torque was made in a region and workshop where Greek influence was not very strong. The native element in the decoration is the form of the finials, showing lions attacking boars; in Near Eastern and Greek art, such finials would normally be limited to the head or protome (foreparts) of an animal.

Torque with lions attacking boars at the ends. Gold, diameter 19 cm. (7½ in.).

4th century B.C. Kuban region, near Krymskaya village, Karagodeuashkh kurgan. Excavations of E. D. Felitsin, 1888. Hermitage, Ku 1888, 1/38.

A. Lappo-Danilevsky, V. Malmberg, "Kurgan Karagodeuashkh," *MAR* 1894, pl. II, 7,8,9.

74

Like the gold torque (no. 73), this gold plaque was made in a native workshop, an the subject matter is taken from local cults. Vases found in this kurgan allow u to date it in the third quarter of the fourth century B.C., before the beginning of the Hellenistic period. The plaque's tapering shape is awkward, but the artist has grouped his composition along a central axis, and has insisted on strict frontality for all his human figures.

Triangular plaque with three bands of figures: a woman, a woman or man driving a chariot, and a queen or goddess and attendants. Gold, length 21 cm. (7¹⁵⁄₁₆ in.).

End of the 4th century B.C. Kuban region, near Krymskaya village, Karagodeuashkh kurgan. Excavations of E. D. Felitsin, 188 Hermitage, Ku 1888, 1/7.

Artamonov, *Splendor,* pl. 318.

75 (Color plate 14)

The ketos was a fierce sea monster with a wolf-like head, the body of a fish, wing and a serrated mane. Andromeda and Hesione were exposed to such monsters but were rescued by Perseus and Heracle

Ketos, clothing ornament plaque. Gold, height 4.7 cm. (1⅞ in.).

Greek workmanship, 4th century B.C. Crimea, near Kerch, Kul Oba kurgan. Excavations, 1830. Hermitage, KO 63.

Artamonov, *Splendor,* pl. 256.

76 (Color plate 14)

Two Scythians are sharing the same drinking horn in a ritual described by Herodotus. They are shown with their foreheads and noses pressed together, creating the illusion of a single frontal face and two bodies. The conceit of two creatures with their heads conjoined is common in ancient art in the depiction of animals, but is here applied to human beings. This plaque is about fifty years late than the similar one from Solokha (no. 72).

Two Scythians sharing a drinking horn, clothing ornament plaque. Gold, heigh 4.9 cm. (1¹⁵⁄₁₆ in.).

4th century B.C. Crimea, near Kerch, Kul Oba kurgan. Excavations, 1830. Hermitage, KO 41.

Artamonov, *Splendor,* pl. 203.

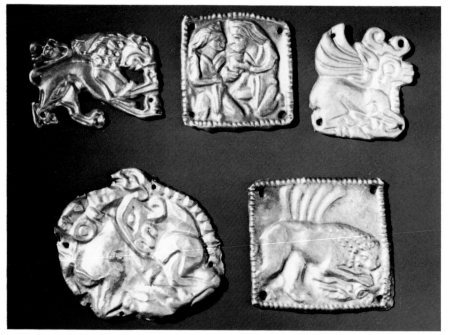

72

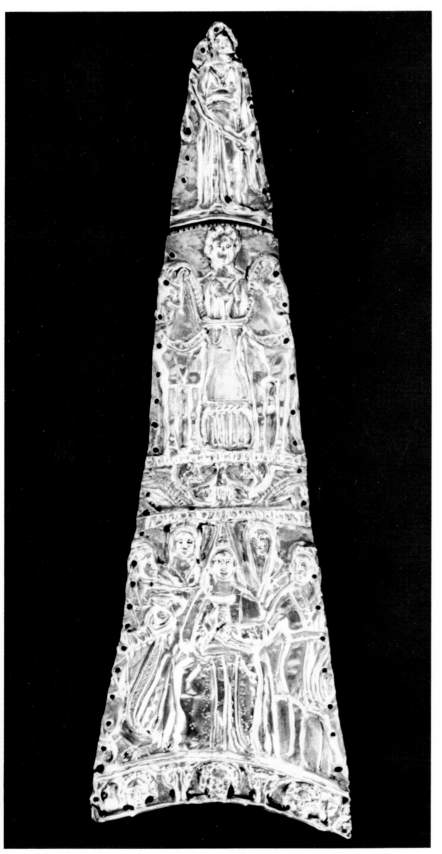

77 (Color plate 15)

Among the large gold plaques that are generally assumed to be shield emblems, this stag occupies a special place. It embodies important characteristics of Scythian art, such as the shaping of the body by sharply contrasting planes and the elaboration of the contour into zoomorphic shapes: the antler tips turn into a ram's head and the tail becomes a griffin's head. In addition, several more naturalistically represented animals have been included: a greyhound against the stag's throat, and a lion, hare, and griffin in relief on its body. The tines of the antlers are nine, a number of the greatest magical significance. The emblematic importance of the stag is reflected in the fact that a large unit within the ever-shifting tribal pattern of the steppes was that of the Sakas, whose name meant "stags."

Recumbent stag, decorated on the body with figures of winged griffin, hare, lion, dog, and, at the antler tips, a ram's head. Gold, length 31.5 cm. (12⅜ in.).

Greek workmanship, executed for the Scythians, 4th century B.C. Crimea, near Kerch, Kul Oba kurgan. Excavations, 1830. Hermitage, KO 120.

Artamonov, *Splendor,* pls. 264,265.

78 (Color plate 16)

The central motif of this large pendant with delicate ornamentation evokes the cult statue of Athena Parthenos by Phidias. The goddess' helmet has three crests, supported by a sphinx and two horses; the upturned cheekpieces are decorated with griffins, and on one of them perches an owl while a snake coils in the background.

Pendant, disk with a head of Athena (inspired by the statue by Phidias in the Parthenon) and braided chains linked by rosettes, and vase-shaped beads. Gold and enamel, length 18 cm. (7⅛ in.).

Greek workmanship, 4th century B.C. Crimea, near Kerch, Kul Oba kurgan. Excavations, 1830. Hermitage, KO 5.

Artamonov, *Splendor,* pl. 214.

79 (Color plate 16)

This drinking vessel, made to resemble a long, tapering animal horn, is a type frequently found in Scythian tombs. Those of gold and silver are usually made of many pieces, ending in a small animal's head. Scythians are often represented drinking from such horns on Greek works depicting scenes from nomad life (see nos. 72,76).

Drinking horn (rhyton) with a lion's-head finial. Silver with gold finial, height 29 cm. (11⅜ in.).

4th century B.C. Crimea, near Kerch, Kul Oba kurgan. Excavations, 1830. Hermitage, KO 105.

Artamonov, *Splendor,* pl. 251.

80 (Color plate 16)

The two archers differ from other representations of Scythians in that, although they are fighting, they do not wear the typical Scythian cap or helmet, and their hair is tied in a topknot, a coiffure described by Herodotus as typical of Thracians.

Two archers drawing their bows, clothing ornament plaque. Gold, height 2.8 cm. (1⅛ in.).

4th century B.C. Crimea, near Kerch, Kul Oba kurgan. Excavations, 1830. Hermitage, KO 65.

Artamonov, *Splendor,* pl. 224.

81 (Color plates 17, 18)

The shape and ornaments of this vessel are Greek, as is the workmanship, but the subject matter is taken from the daily life or mythology of the Scythians. Although many interpretations of the scenes on this bottle have been proposed, none is certain.

Bottle with ring base depicting Scythians engaged in various activities: conversing, bow stringing, treating a mouth ailment, and bandaging a wounded leg. Raevsky interprets the decoration on this vessel as scenes from the myth about the origin of the Scythians recorded by Herodotus: represented are the three sons of the snake-legged goddess and Heracles (the Scythian Targitaus), who, before mounting the throne, had to string Heracles's bow. Only the youngest, Scythes, succeeded; the others, Agathyrsus and Gelonus, suffered wounds usual during an unsuccessful stringing: on the left side of the jaw and the calf of the left leg. Gold, height 13 cm. (5⅛ in.).

Greek workmanship, executed for the Scythians, 4th century B.C. Crimea, near Kerch, Kul Oba kurgan. Excavations, 1830. Hermitage, KO 11.

Artamonov, *Splendor,* pls. 226-229, 232, 233; Raevsky, *SA* (1970), no. 3, p. 90.

82 (Color plate 19)

This piece is purely Greek, from the ornaments to the finials, which are in the classical Greek style and depict standardized Scythians on horses, as if on parade.

Torque made of twisted gold wire with sculptured Scythian horsemen at the ends. Gold and enamel, diameter 25.8 cm. (10⅛ in.).

Greek workmanship, executed for the Scythians, 4th century B.C. Crimea, near Kerch, Kul Oba kurgan. Excavations, 1830. Hermitage, KO 17.

Artamonov, *Splendor,* pls. 201,202.

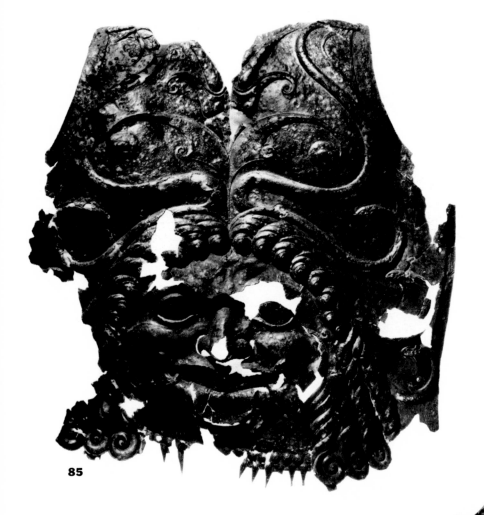

85

86

83 (Color plate 20)

The decoration follows the traditional Persian and Greek organization of a phiale into lobes. On the 12 employed here, gorgons' heads are surmounted by stylized volutes, and smaller gorgons' heads are repeated in the spandrels. Toward the rim 24 bearded heads (which may portray Scythians or the Cabiric deities of the Samothracian mysteries) alternate with 48 boars' heads and 96 bees. Twelve panthers' heads along the lower border face the other way. The omphalos in the center of the phiale is framed by a zone decorated with 16 dolphins accompanied by smaller fish. Two crude suspension rings are soldered to the rim, perhaps at a later date.

Libation bowl (*phiale*) with embossed decorations in the shape of a multipetaled rosette, including heads of gorgons and bearded men, boars, panthers, and bees; around the *omphalos* is a band of dolphins and fish. Gold, diameter 23.1 cm. (9⅟₁₆ in.).

Greek workmanship, 4th century B.C. Crimea, near Kerch, Kul Oba kurgan. Excavations, 1830. Hermitage, KO 31.

Artamonov, *Splendor,* pls. 207,210.

84

The inscription, painted before firing, identifies the vase as one of the prizes at the Panathenaic festival in Athens. In the boxing match shown here, observe that the fallen boxer is yielding: he has raised his finger, signaling that he accepts defeat. This amphora is the namepiece of the vase painters known as the Kuban Group, dated at the end of the 5th century B.C.

Panathenaic prize amphora with a representation of a statue of Athena and boxers on the reverse. Inscribed in Greek. Terracotta, height 70 cm. (27½ in.).

Attic, 5th century B.C. Krasnodar region, Elizavetinskaya kurgan. Excavations of N. I. Veselovsky, 1913. Hermitage, Ku 1913, 4/389.

Artamonov, *Splendor,* pls. 140,141.

85

On this breastplate appears the head of the gorgon Medusa, considered an apotropaic device, to turn away harm. It is executed in an archaizing style, echoing the ferocity of early gorgons' heads, but the floral ornaments confirm that it was made in the late 5th century B.C.

Breastplate decorated with the head of Medusa. Bronze, height 41 cm. (15¾ in.).

Greek workmanship, 5th century B.C. Krasnodar region, Elizavetinskaya kurgan. Excavations of N. I. Veselovsky, 1914. Hermitage, Ku 1914, 8/1.

Artamonov, *Splendor,* pl. 144.

86

This griffin reveals characteristics of the later Scythian style, such as the flattening of the body and the increased use of linear patterns to decorate the surface.

Running winged animal, bridle ornament (with a loop on the back). Bronze, length 13.5 cm. (5⅝₁₆ in.).

Scythian, end of the 4th century B.C. Krasnodar region, Elizavetinskaya kurgan. Excavations of N. I. Veselovsky, 1917. Hermitage, Ku 1917, 1/173.

Artamonov, *Splendor,* pl. 138.

87

Three animal heads, cheekpiece fragment. Bronze, height 8.3 cm. (3¼ in.).

Scythian, end of the 4th century B.C. Krasnodar region, Elizavetinskaya kurgan. Excavations of N. I. Veselovsky, 1917. Hermitage, Ku 1917, 1/251.

Artamonov, *Splendor,* pl. 143.

87

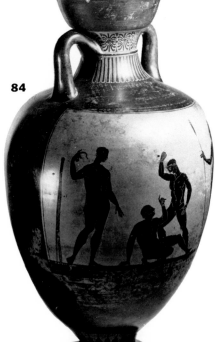

84

113

88

Targitaus (the Scythian Heracles) struggling with a monster, chariot finial. Bronze, height 16.3 cm. (6⁷⁄₁₆ in.).

Scythian, 4th century B.C. Ukrainian SSR, Dnepropetrovsk region, Slonovskaya Bliznitsa kurgan. Excavations of I. E. Zabelin, 1861. Hermitage, Dn 1861, 1/2.

B. N. Grakov, "Skifsky Gerakl," *KSIIMK* (1950), issue 34, p. 14, fig. 2.

89

Winged goddess (possibly the Scythian goddess Artimpasa), chariot finial. Bronze, height 15.7 cm. (6³⁄₁₆ in.).

Scythian, 4th–beginning of the 3rd century B.C. Ukrainian SSR, Dnepropetrovsk region, Alexandropol kurgan. Chance find, 1851. Hermitage, Dn 1851, 1/15.

Artamonov, *Splendor,* pl. 189.

90

Crescent-shaped finial decorated with three small birds (two holding bells). Bronze, height 28.9 cm. (11⅜ in.).

Scythian, 4th–beginning of the 3rd century B.C. Ukrainian SSR, Dnepropetrovsk region, Alexandropol kurgan. Chance find, 1851. Hermitage, Dn 1851, 1/17.

Artamonov, *Splendor,* pl. 191.

91

Walking griffin in an openwork frame hung with two bells, finial. Bronze, height 15.5 cm. (6⅛ in.).

Ukrainian SSR, Dnepropetrovsk region, Alexandropol kurgan. Hermitage, Dn 1853, 1/3.

Artamonov, *Splendor,* pl. 190.

92

Ketos seizing an animal, finial. Bronze, height 13.3 cm. (5¼ in.).

Ukrainian SSR, Dnepropetrovsk region, Krasnokutsk kurgan. Hermitage, Dn 1860, 1/19.

Artamonov, *Splendor,* fig. 123.

88

89

Objects from the Siberian collection of Peter I

93 (Color plate 21)

In this gold plaque representing a lion-griffin attacking a horse, the artist has ingeniously filled the P-shape demanded by the plaque's use as a scabbard mounting with the two S-forms of the struggling animals. A further attempt at introducing a strict geometrical structure into this seemingly chaotic design was made by the regular distribution of round and flame-shaped insets of colored stones, now fallen out.

Lion-griffin attacking a horse, plaque. Gold, length 19.3 cm. (7⅝ in.).

Scytho-Siberian animal style, 5th–4th century B.C. Siberian collection of Peter I. Hermitage, Si 1727, 1/6.

S.I. Rudenko, *Sibirkskaya kollektsiya Petra I* (Moscow-Leningrad, 1966), pl. VIII, 8.

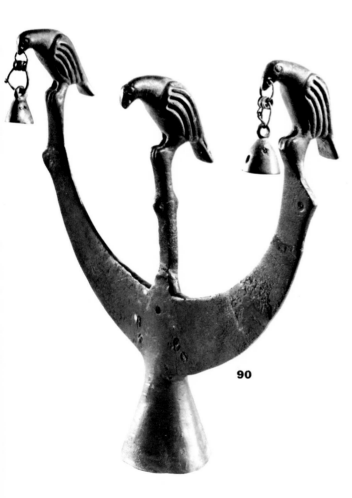

90

94 (Color plate 21)

Here a tiger and an animal monster defying zoological classification are fiercely locked in combat. Of particular artistic interest is the deliberate contrast of realistically seen and monstrously imagined animals, of free-flowing forms and strict repetitive designs (such as the three aligned paws of the tiger or the five tiny griffins' heads forming the monster's mane and tip of its tail).

Horned predatory animal attacking a tiger, plaque. Gold, length 16.8 cm. (6⅝ in.).

Scytho-Siberian animal style, 4th–3rd century B.C. Siberian collection of Peter I. Hermitage, Si 1727, 1/11.

Rudenko, *Sibirskaya kollektsiya,* pl. VI, 4.

95 (Color plate 21)

Human figures are rare enough in the nomads' art to make this plaque worthy of special notice, but its subject is of extraordinary interest in the history of world literature. The warrior lying under a tree with his head in a woman's lap is a motif still living in a Hungarian folk ballad (the Hungarians are ethnically and linguistically descendants of steppe nomads that came to Central Europe in the early Middle Ages), but also featured in the 10th-century German heroic epic *Waltharius,* in Wolfram von Eschenbach's *Parzival* (about 1200), and in the Arthurian story of *Sir Balin and Sir Balan* (mid-13th century). It is of special interest that in the three latter stories this motif is connected with a hero distinguished by carrying two swords. This plaque is one of a pair (its companion piece, a mirror image, is not in this exhibition): they were probably made for a pair of matching swords to be worn by a warrior on either hip–which is specifically described in *Waltharius* as a Hunnish custom.

Warrior resting (probably a scene from a legend), plaque. Gold, length 16.2 cm. (6⅜ in.).

Siberian collection of Peter I. Hermitage, Si 1727, 1/161.

Rudenko, *Sibirskaya kollektsiya,* pl. VII, 1.

96 (Color plate 22)

Animal fighting a snake, plaque. Gold, length 14.5 cm. (5¹¹⁄₁₆ in.).

4th–3rd century B.C. Siberian collection of Peter I. Hermitage, Si 1727, 1/7.

Rudenko, *Sibirskaya kollektsiya,* pl. IX, 2.

97 (Color plate 22)

The horizontal fluting and zoomorphic handles of this cup are signs of Iranian influence. The shape of the vessel, however, is not typical of Near Eastern works, and the exaggerated stylization of the animals' rib cage appears on many objects from Siberia.

Cup with handles in the form of sculptured predatory animals. Gold, height 10.2 cm. (4 in.).

Achaemenid, 5th–4th century B.C. Siberian collection of Peter I. Acquired from M. P. Gagarin, 1716. Hermitage, Si 1727, 1/71.

M. I. Artamonov, *Sokrovishcha sakov* (Moscow, 1973), pl. 216, fig. 288.

98

This handle is in the shape of an exquisitely and naturalistically modeled fallow deer. Although found in Siberia, it is of Iranian manufacture. The spots on the body and the horns (now missing) were gilded. The bent knees would originally have rested on the vessel's rim.

Leaping fallow deer, handle from a silver vase. Silver gilt, height 16 cm. (6¼ in.).

Iranian, 4th–3rd century B.C. South Altai, near Bukhtarma. Acquired from G. F. Miller, 1735. Hermitage, S 273.

Artamonov, *Sokrovishcha sakov,* p. 216.

99 (Color plate 22)

This plaque depicts a fantastic creature–an eagle or griffin–clutching a contorted goat in its talons. Note the explicit and different ways the texture of the creature's body is delineated: parts are covered with cloisons that originally contained colored insets to simulate scales. The captured animal also has numerous areas for inlay, with a surviving bit of black glass in his eye. Remnants of light blue and cherry red enamel are reminders of the magnificent colors with which this dazzling ornament once glowed. Power and vitality radiate from this work of art: imagine it bedecking a warrior's headdress, with real plumes flying atop the griffin's tail, and the polychrome inlays and cloisonné glittering against the shining gold.

Eagle or griffin holding a goat, possibly a headband ornament. Gold, height 15.4 cm. (6¹⁄₁₆ in.), width 16 cm. (6⁵⁄₁₆ in.), weight 209.78 gr.

Eastern Iran or Central Asia, 4th–3rd century B.C. Siberian collection of Peter I. Acquired from M. P. Gagarin, 1716. Hermitage, Si 1727, 1/31.

Artamonov, *Sokrovishcha sakov,* pp. 189-190, fig. 241.

Altai culture

6th–3rd centuries B.C.

The northern nomads' textiles and woodcarvings are as strikingly characteristic a part of their art as the famous Siberian gold treasure of Peter the Great (see nos. 93-99). More perishable than the metal objects, which were found in many places, these have not been known to any extent in the modern world until five kurgans (the Russian term for a burial mound) near the hamlet of Pazyryk in the central Altai Mountains of Siberia were opened by Soviet scientists in the second quarter of this century. Here–and in similar burials nearby–frozen in the ice resulting from a combination of long, cold winters, the deep frost level of this mountainous terrain, and the fortuitous (for us) hacking open of the burial chambers by early grave robbers (which permitted the entry of a great deal of quickly frozen moisture), was preserved a record of the life of a tribe of highly civilized nomads of the 5th to 4th century B.C., who were in touch with Achaemenid Persia on the west and feudal China (Chou period, about 1027–256 B.C.) on the east.

Wood rarely survives in the climates of Near Eastern and Central Asian countries, therefore the examples from the Altai are particularly valuable. The beveled carving of the surface is distinctive, and this treatment was deliberately reproduced by the goldworkers who made some of the large animal figures found in the Scythian tombs in the Black Sea region (see nos. 18, 28, 77). Many of the wooden pieces were covered with gold leaf in order to give the appearance of that precious metal.

98

102

100 (Color plate 24)

The figural carving on this object shows a feline face with a ferocious teeth-baring grin and curiously spiral ears, over an interlocked S-shape ending in a couple of curly-beaked birds' heads. The symmetry of the composition is subtly enlivened by the inward-turning scroll of the lower loop.

Tiger, harness ornament. Wood, leather, and bronze, length 22.5 cm. (8⅞ in.).

Altai nomadic, 6th century B.C. Altai, Tuekta, kurgan 1. Excavations of S. I. Rudenko, 1954. Hermitage, 2179/148.

S. I. Rudenko, *Kultura naseleniya Tsentralnogo Altaya v skifskoe vremya* (Moscow-Leningrad, 1960), pl. LXVII.

101

Eagle, harness ornament. Wood, height 4.5 cm. (1¾ in.).

Altai nomadic, 6th century B.C. Altai, Tuekta, kurgan 1. Excavations of S. I. Rudenko, 1954. Hermitage, 2179/120.

Rudenko, *Kultura Tsentralnogo Altaya,* p. 286, fig. 145a, pl. XCVII.

102

Panther's head, harness ornament. Wood, height 4.5 cm. (1¾ in.).

Altai nomadic, 6th century B.C. Altai, Tuekta, kurgan 1. Excavations of S. I. Rudenko, 1954. Hermitage, 2179/187.

Rudenko, *Kultura Tsentralnogo Altaya,* p. 289, fig. 148l, pl. CII.

103

Wolf's head, harness ornament. Wood, length 12.2 cm. (4¹³⁄₁₆ in.).

Altai nomadic, 6th century B.C. Altai, Tuekta, kurgan 1. Excavations of S. I. Rudenko, 1954. Hermitage, 2179/198.

Rudenko, *Kultura Tsentralnogo Altaya,* p. 279, fig. 143g, pl. XCIV.

104

Elk's head, harness plaque. Wood, 11.2 cm. (4⁵⁄₁₆ in.).

Altai nomadic, 6th century B.C. Altai, Tuekta, kurgan 1. Excavations of S. I. Rudenko, 1954. Hermitage, 2179/205.

Rudenko, *Kultura Tsentralnogo Altaya,* p. 265, fig. 136z, pl. XCII.

105

Two elks' heads, harness plaque. Wood, height 8.8 cm. (3⁷⁄₁₆ in.).

Altai nomadic, 6th century B.C. Altai, Tuekta, kurgan 1. Excavations of S. I. Rudenko, 1954. Hermitage, 2179/227.

Rudenko, *Kultura Tsentralnogo Altaya,* p. 265, fig. 136g, pl. XCI.

106

Three elks' heads, harness plaque. Wood, height 8.8 cm. (3⁷⁄₁₆ in.).

Altai nomadic, 6th century B.C. Altai, Tuekta, kurgan 1. Excavations of S. I. Rudenko, 1954. Hermitage, 2179/245.

Rudenko, *Kultura Tsentralnogo Altaya,* p. 255, fig. 131v, pl. XCI.

107 (Color plate 24)

On this roundel, the foreparts of two griffins swirl around the central boss. The head of a griffin is differentiated from that of an eagle by having pointed ears and a jagged, sometimes finlike crest down its neck.

Roundel decorated with two griffins. Wood, diameter 12.7 cm. (5 in.).

Altai nomadic, 6th century B.C. Altai, Tuekta, kurgan 1. Excavations of S. I. Rudenko, 1954. Hermitage, 2179/79.

Rudenko, *Kultura Tsentralnogo Altaya,* pl. CI.

108

Two griffins' heads, harness plaque. Wood, height 12 cm. (4¾ in.).

Altai nomadic, 6th century B.C. Altai, Tuekta, kurgan 1. Excavations of S. I. Rudenko, 1954. Hermitage, 2179/28.

Rudenko, *Kultura Tsentralnogo Altaya,* pl. CI.

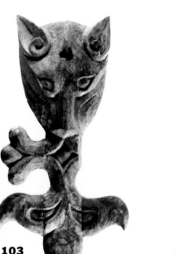

103

108

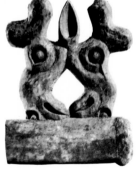

104

105

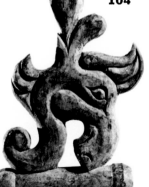

106

109

Griffin's head on palmette-shaped plaque, harness ornament. Wood, height 7 cm. (2¾ in.).

Altai nomadic, 6th century B.C. Altai, Tuekta, kurgan 1. Excavations of S. I. Rudenko, 1954. Hermitage, 2179/96.

Rudenko, *Kultura Tsentralnogo Altaya,* pl. XCIX.

110

Griffin's head, harness ornament. Wood, 5.5 cm. (2⅛ in.).

Altai nomadic, 6th century B.C. Altai, Tuekta, kurgan 1. Excavations of S. I. Rudenko, 1954. Hermitage, 2179/109.

Rudenko, *Kultura Tsentralnogo Altaya,* pl. XCIX.

111

In Siberian art, only the head of a bird of prey is usually shown. In this example, the depiction of the whole bird may indicate foreign influence.

Eagle, saddle ornament. Wood, height 14.5 cm. (5¹¹⁄₁₆ in.).

Altai nomadic, 6th century B.C. Altai, Bashadar, kurgan 2. Excavations of S. I. Rudenko, 1950. Hermitage, 1793/347.

Rudenko, *Kultura Tsentralnogo Altaya,* p. 286, fig. 145d, pl. I.

112 (Color plate 24)

Complete saddle covers like this are rarely found, even though a great number must once have been made. They were used over two pillows of finely tanned leather and felt stuffed with reindeer hair, placed, in turn, over a square of felt on the horse's back. Chest, belly, and tail straps held them in position. The griffins attacking mountain goats, in felt appliqué outlined in cords, are striking examples of the animal combat theme found in many Near Eastern civilizations; the northern nomads probably adopted it from the Achaemenids of Iran, on the western borders of their grazing territory. The nomadic version, frequent in all their arts, pictures with remarkable impact the ferocity of the attacking animals and the helplessness of the attacked, shown in a curiously contorted position. The pendants appear to be a light-hearted adaptation of an important eastern motif: in China, the *t'ao-t'ieh* mask with two confronting dragons forming the face of a monster had been an ornament of cosmic import for centuries. In the nomadic version, horned animals, back to back, form an animal mask from whose mouth is suspended a flower.

Saddle cover decorated with griffins attacking mountain goats. Felt, leather, fur, hair, and gold, length 119 cm. (46⅞ in.).

Altai nomadic, 5th century B.C. Altai, Pazyryk, kurgan 1. Excavations of M. P. Gryaznov, 1929. Hermitage, 1295/150.

S. I. Rudenko, *Kultura naseleniya Gornogo Altaya v skifskoe vremya* (Moscow-Leningrad, 1953), pl. XXVII; S. I. Rudenko, *Drevneyshie v mire khudozhestvennye kovry i tkani* (Moscow, 1968), p. 25, fig. 13.

113 (Color plate 23)

This magnificently antlered elk in a sort of flying gallop must have come from a saddle cover like no. 112. The exuberant, stylized shapes on the animal's body are derived from a traditional, more restrained Iranian treatment.

Elk, fragment of a saddle cover. Felt, length 47 cm. (18½ in.).

Altai nomadic, 5th century B.C. Altai, Pazyryk, kurgan 2. Excavations of S. I. Rudenko, 1947. Hermitage, 1684/326.

Rudenko, *Kultura Gornogo Altaya,* pl. CIX, 1.

114

Here we see a northern nomadic interpretation of what are probably plant and flower forms, crowded in a mosaic of felt shapes with columns in alternating repeat. The design incorporates some forms that are vaguely reminiscent of Near Eastern lotus and bud patterns.

Fragment of a hanging bordered with flower and lotus buds. Felt, length 47 cm. (18½ in.).

Altai nomadic, 5th century B.C. Altai, Pazyryk, kurgan 2. Excavations of S. I. Rudenko, 1947. Hermitage, 1684/262.

Rudenko, *Drevneyshie kovry i tkani,* p. 69, fig. 55.

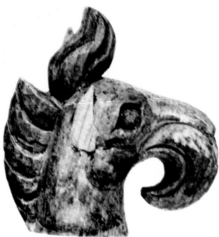

110

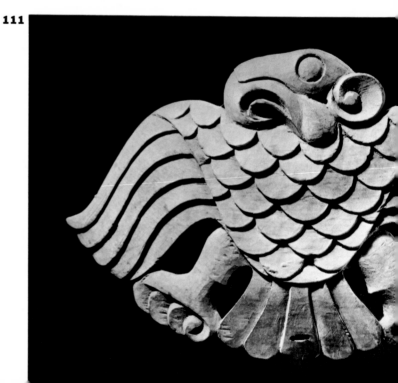

111

115 (Color plate 23)

The felt lions' heads are applied as decoration in the same fashion as the better-known gold plaques that were sewn onto garments or attached to cloth and leather hangings. Small gold lion heads of closely similar design have been found in Iran. The lion is unknown in the Altai region and its presence on this piece indicates the influence of Iranian works.

Hanging decorated with lions' heads. Felt, length 135 cm. (53⅛ in.).

Altai nomadic, 5th century B.C. Altai, Pazyryk, kurgan 1. Excavations of M. P. Gryaznov, 1929. Hermitage, 1295/52.

Rudenko, *Drevneyshie kovry i tkani,* p. 69, fig. 52.

116

This piece, a horse's chest strap, is made of wool and linen tapestry with roaring lions in soft brown, black, and white, mounted on felt and then on the leather strap. The formal, decorated animals and the sawtooth borders suggest Achaemenid Persia as a source. The weave, itself an early Near Eastern specialty, is very fine (about 50 warps, 250 wefts per running inch). Here the nomads are using material from their neighbors on the west to decorate their treasured horses.

Horse's breastband covered with an Iranian textile decorated with striding lions. Wool, linen, moss, and gold, width 8 cm. (3⅛ in.).

Altai nomadic, 5th-4th century B.C. Altai, Pazyryk, kurgan 5. Excavations of S. I. Rudenko, 1949. Hermitage, 1687/100.

Rudenko, *Kultura Gornogo Altaya,* p. 351, pl. CXVII, fig. 191.

117 (Color plate 23)

This saddle blanket comes from the most richly caparisoned of 9 noble horses stretched out in full regalia in the horse burial of kurgan 5 at Pazyryk. A rectangle of fine, embroidered Chinese silk—one of the earliest known—has been mounted on felt by its nomadic owners. The secret of sericulture and the resulting exquisitely fine fabrics and embroideries were a much-sought-after Chinese specialty until well into the Christian era. The ornament here is typical of the Ch'u state, centered around Hunan province in southern China in the late Chou and Han periods. This sophisticated southern civilization was known for its silks, lacquers, and inlaid bronzes, all richly and elegantly decorated. Silk was not exported until the Han dynasty (206 B.C.– A.D. 220), so this embroidery was probably of the sort recorded in Chinese annals as a "gift" (Chinese term) or "tribute" (nomad term).

Saddle blanket *(shabrak)* covered with Chinese silk. Wool, silk, gold, and leather, width 64 cm. (25³⁄₁₆ in.).

Altai nomadic, 5th-4th century B.C. Altai, Pazyryk, kurgan 5. Excavations of S. I. Rudenko, 1949. Hermitage, 1687/101.

Rudenko, *Kultura Gornogo Altaya,* p. 214, pl. CXVIII.

118 (Color plate 25)

Cut from felt and padded–probably with reindeer hair–this swan has the sculptural quality of the other northern nomadic arts of woodcarving and metalworking. The masterly handling of felt is characteristic of these people. This ancient non-woven fabric was made by stirring together a mass of wool fibers, flattening them, and applying pressure, moisture, and heat to pack and firm the resulting fabric. Various kinds of animal fiber were used for different grades of felt; very fine felt made of domesticated sheep wool, for instance, was found at Pazyryk. Though felt is the characteristic indigenous fabric of Central Asia, felt objects sometimes reflect influences from civilizations on the nomads' eastern and western boundaries. This swan suggests Chinese influence or a Chinese prototype, recalling the Chinese minor princesses who were married off to nomadic chieftains in order to secure peace on China's western border.

Swan. Felt, length 35 cm. (13¾ in.).

Altai nomadic, 5th–4th century B.C. Altai, Pazyryk, kurgan 5. Excavations of S. I. Rudenko, 1949. Hermitage, 1687/262.

Rudenko, *Kultura Gornogo Altaya,* pl. CVIII.

114

116

119,120

These figures and the two following are rendered in striking silhouette, the curvilinear designs within the body of the cock increasing the decorative effect. The elk is an animal one might expect to find in the art of the Altai, but the cock is an indication of foreign, probably Iranian influence.

Elks, ornaments from a log sarcophagus. Leather, lengths 29 cm. (11⅜ in.).

Altai nomadic, 5th century B.C. Altai, Pazyryk, kurgan 2. Excavations of S. I. Rudenko, 1947. Hermitage, 1684/285, 283.

Rudenko, *Kultura Gornogo Altaya,* p. 46, fig. 18.

121,122

Roosters, jug ornaments. Leather, heights 13.7 cm. (5⅜ in.).

Altai nomadic, 5th century B.C. Altai, Pazyryk, kurgan 2. Excavations of S. I. Rudenko, 1947. Hermitage, 1684/56,57.

Rudenko, *Kultura Gornogo Altaya,* p. 92, fig. 44.

123

Belt fragment decorated with roosters. Leather, length 53 cm. (20⅞ in.).

Altai nomadic, 5th century B.C. Altai, Pazyryk, kurgan 2. Excavations of S. I. Rudenko, 1947. Hermitage, 1684/241.

Rudenko, *Kultura Gornogo Altaya,* p. 125, fig. 71.

124

Flagon with applied ornament. Leather, height 16.5 cm. (6½ in.).

Altai nomadic, 5th century B.C. Altai, Pazyryk, kurgan 2. Excavations of S. I. Rudenko, 1947. Hermitage, 1684/87.

Rudenko, *Kultura Gornogo Altaya,* pl. XXIII.

125

Woman's boot. Leather, textile, tin (or pewter), gold, and pyrites, height 36 cm. (14⅛ in.).

Altai nomadic, 5th century B.C. Altai, Pazyryk, kurgan 2. Excavations of S. I. Rudenko, 1947. Hermitage, 1684/218.

Rudenko, *Kultura Gornogo Altaya,* pl. XXV, 2.

126

A theme much illustrated in nomadic art both in Siberia and around the Black Sea is that of a griffin slaying a stag. This superb example shows an abbreviated form of this subject, in which the heads of these animals stand for the whole.

Griffin holding a stag's head, finial. Wood and leather, height 35 cm. (13¾ in.).

Altai nomadic, 5th century B.C. Altai, Pazyryk, kurgan 2. Excavations of S. I. Rudenko, 1947. Hermitage, 1684/170.

Rudenko, *Kultura Gornogo Altaya,* pl. LXXXIII, 1.

127

This wood and leather pole top, one of four, originally was covered with gold leaf to suggest a metal ornament.

Stag, finial. Wood and leather, height 11.5 cm. (4½ in.).

Altai nomadic, 5th century, B.C. Altai, Pazyryk, kurgan 2. Excavations of S. I. Rudenko, 1947. Hermitage, 1684/154.

Rudenko, *Drevneyshie kovry i tkani,* p. 28, fig. 15.

128

Goat's head and two geese, bridle frontlet. Horn, height 20.6 cm. (8⅛ in.).

Altai nomadic, 5th century. Altai, Pazyryk, kurgan 2. Excavations of S. I. Rudenko, 1947. Hermitage, 1684/353.

Rudenko, *Kultura Gornogo Altaya,* pl. C, 1.

119

122

128

125

123

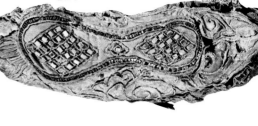

129

Leather bridle ornamented with wooden plaques of mountain rams and a springing ram cheekpiece. Wood, leather, and gold, length 51 cm. (20 in.).

Altai nomadic, 5th century B.C. Altai, Pazyryk, kurgan 1. Excavations of M. P. Gryaznov, 1929. Hermitage, 1295/189.

Rudenko, *Kultura Gornogo Altaya,* pl. XXXIV.

130

Leather bridle ornamented with wooden plaques of animals. Wood and leather, length 50 cm. (19¹¹⁄₁₆ in.).

Altai nomadic, 5th century B.C. Altai, Pazyryk, kurgan 1. Excavations of M. P. Gryaznov, 1929. Hermitage, 1295/146.

Rudenko, *Kultura Gornogo Altaya,* pl. XXXII.

131

Recumbent tiger, bridle plaque. Wood, length 3.3 cm. (1¼ in.).

Altai nomadic, 5th–4th century B.C. Altai, Pazyryk, kurgan 4. Excavations of S. I. Rudenko, 1948. Hermitage, 1686/68.

Rudenko, *Kultura Gornogo Altaya,* p. 203, pl. LXIII, fig. 124.

132

Recumbent tiger, bridle plaque. Wood, length 3.3 cm. (1¼ in.).

Altai nomadic, 5th–4th century B.C. Altai, Pazyryk, kurgan 4. Excavations of S. I. Rudenko, 1948. Hermitage, 1686/69.

Rudenko, *Kultura Gornogo Altaya,* pl. LXIII.

133

Bearded man, bridle plaque. Wood, height 11 cm. (4⅜ in.).

Altai nomadic, 5th century B.C. Altai, Pazyryk, kurgan 1. Excavations of M. P. Gryaznov, 1929. Hermitage, 1295/392.

Rudenko, *Kultura Gornogo Altaya,* pl. XLIV.

134,135 (Color plate 25)

The expressively raised bridge of the nose and the heavy nostrils and lips indicate that these rather naturalistically carved wooden animal heads are those of elks. Traces of red paint are still visible; their antlers, however, are lost. The elk figures prominently in the art of the northern nomads; a possible reference to this might be Tacitus's mention of the twin gods Alci ("elks") in the land of the Naharvali, on the plains of what is now Poland.

Elks' heads, bridle ornaments. Wood, lengths 9.9, 9.6 cm. (3⅞, 3¾ in.).

Altai nomadic, 5th–4th century B.C. Altai, Pazyryk, kurgan 3. Excavations of S. I. Rudenko, 1948. Hermitage, 1685/146,147.

Rudenko, *Kultura Gornogo Altaya,* pl. LII.

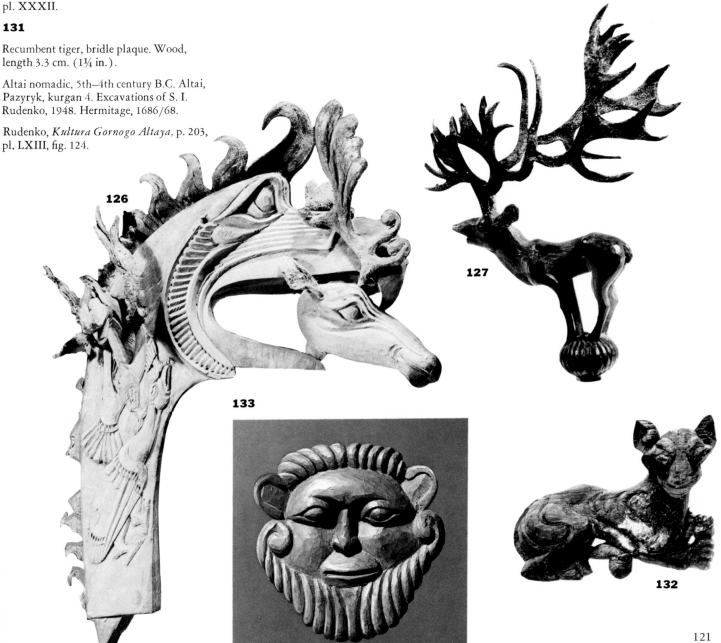

126

127

133

132

136 (Color plate 25)

Cheekpieces of horses' bridles were often of wood or staghorn, with terminals carved to resemble the heads of fantastic animals. At one end of this piece is a creature with feline fangs and the horns and ears of a mountain goat, and at the other appears a bird of prey with an exaggeratedly curved beak and a curled crest.

Cheekpiece decorated with heads. Wood, length 18 cm. (7⅛ in.).

Altai nomadic, 5th–4th century B.C. Altai, Pazyryk, kurgan 3. Excavations of S. I. Rudenko, 1948. Hermitage, 1685/109.

Rudenko, *Kultura Gornogo Altaya,* pl. LVI, 3.

137

Fantastic bird's head, from a bridle frontlet. Wood, leather, and gold, height 15 cm. (5¹⁵⁄₁₆ in.).

Altai nomadic, 5th–4th century B.C. Altai, Pazyryk, kurgan 3. Excavations of S. I. Rudenko, 1948. Hermitage, 1685/396.

Rudenko, *Kultura Gornogo Altaya,* pl. LXXII, 1.

138

Griffin's head, from a bridle frontlet. Wood, leather, and gold, height 21.5 cm. (8½ in.).

Altai nomadic, 5th–4th century B.C. Altai, Pazyryk, kurgan 3. Excavations of S. I. Rudenko, 1948. Hermitage, 1685/397.

Rudenko, *Kultura Gornogo Altaya,* pl. LXXII, 2.

139

Mountain ram, harness plaque. Wood and leather, height 10.4 cm. (4⅛ in.).

Altai nomadic, 5th–4th century B.C. Altai, Pazyryk, kurgan 3. Excavations of S. I. Rudenko, 1948. Hermitage, 1685/151.

Rudenko, *Kultura Gornogo Altaya,* pl. LI.

140 (Color plate 25)

At first glance, the ornament on this plaque seems to be purely geometrical, but on closer examination it turns out to consist of two elks' heads facing outward. Their stylization into sweeping curves emphasized by parallel incised lines results in a complex, highly pleasing pattern.

Elks' heads, saddle plaque. Horn, length 13 cm. (5⅛ in.).

Altai nomadic, 5th–4th century B.C. Altai, Pazyryk, kurgan 3. Excavations of S. I. Rudenko, 1947. Hermitage, 1685/258.

Rudenko, *Kultura Gornogo Altaya,* pl. XVIII, 1.

141

Stylized tiger's face, saddle plaque. Horn, length 12.5 cm. (4⅞ in.).

Altai nomadic, 5th–4th century B.C. Altai, Pazyryk, kurgan 3. Excavations of S. I. Rudenko, 1948. Hermitage, 1685/262.

Rudenko, *Kultura Gornogo Altaya,* Pl. XVIII, 2.

142

This cauldron is unusual in design and shape. The three separate legs are in the form of the foreparts of rams and the feet of camels.

Three-legged cauldron with sculptured heads of rams on the legs. Bronze, height 62 cm. (24⅜ in.).

Altai nomadic, 5th–3rd centuries B.C. Kargalinka river near Alma-Ata. Chance find, 1893. Hermitage, 1654/1.

Smirnova, Domansky, *Drevnee iskusstvo,* p. 176, pl. 68.

139

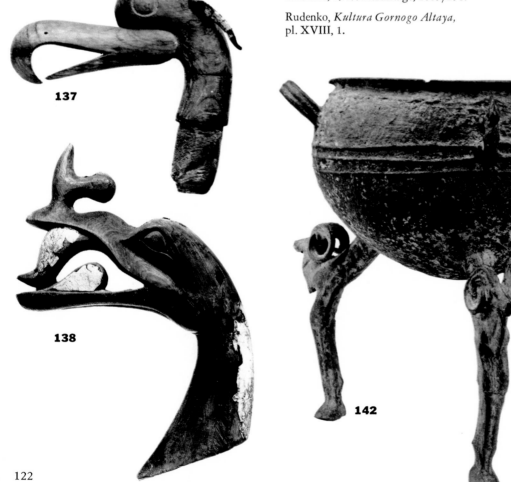

137

138

142

141

The Culture of Siberia

143

Stag, finial. Bronze, height 11 cm. (4¼ in.).

Altai nomadic, 7th–6th century B.C. Location of find unknown. Paskevich Collection. Hermitage, 1668/1.

Artamonov, *Sokrovishcha sakov,* p. 105, fig. 142.

144 (Color plate 26)

The extreme simplification of the animal's body and the pose with feet drawn together at the base are hallmarks of the "animal style" of Siberia and Mongolia.

Mountain goat, finial, probably from a pole of a funerary couch. Bronze, height 18.8 cm. (7⅜ in.).

Altai nomadic, 6th century B.C. Chance find. Bought in the town of Krasnoyarsk by G. F. Miller, 1735. Hermitage, 1121/7.

Smirnova, Domansky, *Drevnee iskusstvo,* p. 65.

145

Battle axe with a predatory animal on the butt end. Bronze, length 18.5 cm. (7¼ in.).

Altai nomadic, 6th–5th century B.C. Krasnoyarsk region, Upper Pit river. I. A. Lopatin Collection. Hermitage, 5531/189.

M. P. Gryaznov, *Southern Siberia* (Geneva, 1969), pl. 38.

146

The ring-shaped paws and curled body of the feline on the handle of this knife are similar to the stylizations of Scythian animals in the area of the Black Sea coast.

Knife with a predatory animal and four stags on the handle. Bronze, length 28.7 cm. (11⁵⁄₁₆ in.).

Altai nomadic, 6th century B.C. Tuva, Turan region. Chance find. Purchase, S. A. Teploukhov, 1927. Hermitage, 5130/2.

Gryaznov, *Southern Siberia,* pl. 31.

147

Vessel. Earthenware, height 14 cm. (5½ in.).

Tagar culture, 6th century B.C. Minusinsk region, Turan burial 1, kurgan 3. Excavations of A.D. Grach, 1963. Hermitage, 2463/33.

Gryaznov, *Southern Siberia,* pl. 42.

148

Bronzes of the second half of the first millennium B.C. from the Minusinsk region illustrate the continuation of older forms developed there, such as knives with inward-curving blades and handles terminating in stylized animals. They were clearly influenced by bronzes of the Ordos region in China.

Knife with a mountain goat on the handle. Bronze, length 18.8 cm. (7⅜ in.).

Altai nomadic, 6th century B.C. Minusinsk region, Beyskoye village. Purchase, 1924. Hermitage, 1667/1.

G. Borovka, *Scythian Art* (London, 1928), pl. 39e.

149

Knife with a wild boar and two fish on the handle. Bronze, length 19.4 cm. (7⅝ in.).

Altai nomadic, 6th–5th century B.C. Minusinsk region, Koryakovo village. Chance find. I. A. Lopatin Collection. Hermitage, 5531/926.

V. V. Radlov, *Sibirskie drevnosti* 1 (St. Petersburg, 1888), no. 1, pl. IV, 13.

150

Stag, plaque. Bronze, length 6.8 cm. (2¹¹⁄₁₆ in.).

Altai nomadic, 5th century B.C. Minusinsk region, Maliy Talek village. Purchase, 1937. Hermitage, 1293/198.

Unpublished.

151

Cheekpiece decorated with birds' heads. Bronze, length 13.8 cm. (5⅛ in.).

Altai nomadic, 5th–4th century B.C. Minusinsk region. Chance find, 1863. V. V. Radlov Collection. Hermitage, 1123/47.

Artamonov, *Sokrovishcha sakov,* p. 92, fig. 117.

152

Dagger with bird's heads on the hilt and a wolf on the guard. Bronze, length 26 cm. (10¼ in.).

Altai nomadic, 5th–3rd centuries B.C. Minusinsk region. Chance find. Collection of V. V. Radlov, 1863. Hermitage, 1123/56.

Gryaznov, *Southern Siberia,* pl. 28.

146

148

149

145

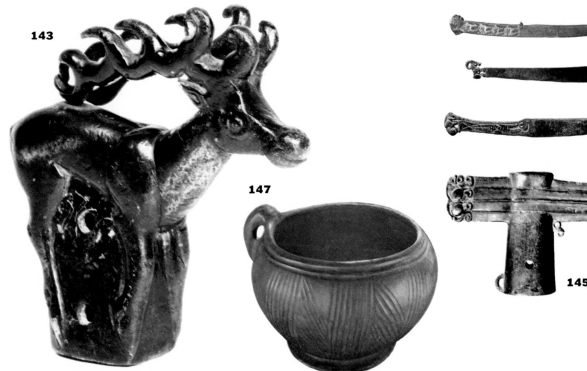

143

147

153

Dagger with mountain goats' heads on the hilt and figures of tigers on the guard. Iron, length 30.2 cm. (11⅞ in.).

Altai nomadic, 5th–3rd centuries B.C. Environs of the town of Minusinsk. Chance find, 1914. Hermitage, 1669/1.

S. V. Kiselev, *Drevnyaya istoriya Yuzhnoy Sibiri* (Moscow, 1951), p. 237, pl. XXII, 3.

154

Cheekpiece with predatory animals' heads at the ends. Bronze, length 14 cm. (5½ in.).

Altai nomadic, 5th–3rd centuries B.C. Minusinsk region, Abakanskoye village. I. A. Lopatin Collection. Hermitage, 5531/305.

Gryaznov, *Southern Siberia*, pl. 34.

155

Tiger holding a ram's head, plaque. Bronze, length 7.7 cm. (3 in.).

Altai nomadic, 5th–3rd centuries B.C. Minusinsk region, Askyz village. I. A. Lopatin Collection. Hermitage, 5531/1396.

Artamonov, *Sokrovishcha sakov*, p. 109, fig. 149.

156

Onager, harness ornament. Bronze, length 5 cm. (2 in.).

Altai nomadic, 5th–3rd centuries B.C. Minusinsk region. Chance find. Purchase, 1913. I. P. Tovostine Collection. Hermitage, 3975/316.

Artamonov, *Sokrovishcha sakov*, p. 107, fig. 144.

157

Torque with tigers at the ends. Bronze, diameter 17.5 cm. (6⅞ in.).

Altai nomadic, 5th–3rd centuries B.C. Siberia. Stroganov Collection. Hermitage, 1135/11.

Rudenko, *Sibirskaya kollektsiya*, p. 17, fig. 10.

158

Pendant decorated with a human face. Bone, height 4.4 cm. (1¾ in.).

Tuva culture of the Scythian period, 5th–3rd centuries B.C. Tuva, Sagly-Bazhi burial 2, kurgan 19. Excavations of A.D. Grach, 1961. Hermitage, 2351/207.

Unpublished.

159

Mirror with fighting tigers on the handle. Bronze, diameter 6.2 cm. (2⁷⁄₁₆ in.).

Altai nomadic, 5th–3rd centuries B.C. Tuva, Sagly-Bazhi burial 2, kurgan 23. Excavations of A.D. Grach, 1961. Hermitage, 2351/286.

A.D. Grach, "Mogilnik Sagly-Bazhi II i voprosy arkheologii Tuvy skifskogo vremeni," *SA* (1967), no. 3, p. 226, fig. 10; Artamonov, *Sokrovishcha sakov*, p. 81, fig. 104.

160 (Color plate 26)

Plaques such as this, of characteristic P-shape, have been interpreted as belt buckles, dress appliqués, or mounts for sword scabbards. This one is especially interesting in that it depicts a horse; in spite of the dependence of the nomads' culture on their domesticated animals, most of the creatures represented in their art are wild species.

Horse, plaque. Bone, length 11 cm. (4¼ in.).

Altai nomadic, 5th–3rd centuries B.C. Tuva, Sagly-Bazhi burial 2, kurgan 23. Excavations of A.D. Grach, 1961. Hermitage, 2351/268.

Grach, *SA* (1967), no. 3, p. 229, fig. 12.

161

Plaque decorated with mountain rams. Bone, length 7.5 cm. (3 in.).

Altai nomadic, 5th–3rd centuries B.C. Tuva, Sagli-Bazhi burial 2, kurgan 18. Excavation of A.D. Grach, 1961. Hermitage, 2351/183.

Artamonov, *Sokrovishcha sakov*, p. 81, fig. 107.

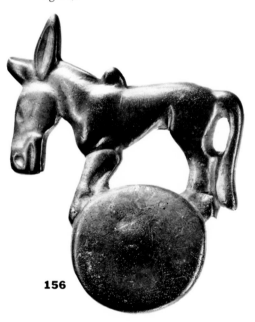

156

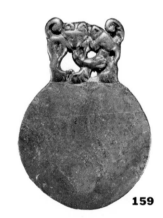

159

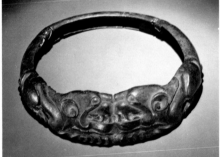

157

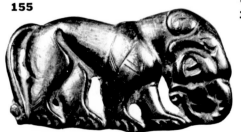

155

162

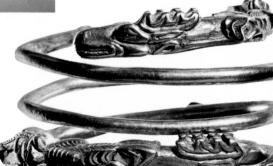

Sarmatian art

1st century B.C.–1st century A.D.

162

The incorporation of elaborate animal motifs into a restricted space is particularly common in Sarmatian art. The adjustment of the animals' shape to fit the surface of the piece they decorate has resulted in a distortion that makes them almost unrecognizable.

Spiral bracelet decorated with panthers attacking elk at the ends. Gold, diameter 8.4 cm. (3⅝ in.).

Sarmatian, 1st century B.C.–1st century A.D. Volga river region, Vezkhneye Pogromnoye village, kurgan 1, burial 2. Excavations of V. P. Shilov, 1954. Hermitage, 1953/1.

Smirnova, Domansky, *Drevnee iskusstvo,* no. 70, p. 177.

163

The "invisibility" of the animals on this cosmetic bottle is increased by the extensive use of colored inlays, which form a pattern quite apart from the shape of the animals' bodies.

Cosmetic bottle, suspended from a chain, decorated with reliefs of dragons and birds' heads. Gold, length 13.5 cm. (5⅝ in.), width 2.1 cm. (1³⁄₁₆ in.).

Sarmatian, beginning of 1st century A.D. Rostov region, territory of the town of Novocherkassk, Khokhlach kurgan. Chance find, 1864. Hermitage, 2213/12.

I. Tolstoy, N. Kondakov, *Russkie drevnosti v pamyatnikakh iskusstva* (St. Petersburg, 1890), issue 3, p. 140, fig. 164.

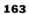

163

164

Torque composed of two relief bands of fantastic animals. Gold, with inlay of turquoise, coral, and glass, diameter 17.8 cm. (7 in.), height 6.3 cm. (2½ in.).

Sarmatian, beginning of the 1st century A.D. Rostov region, territory of the town of Novocherkassk, Khokhlach kurgan. Chance find, 1864. Hermitage, 2213/1.

Smirnova, Domansky, *Drevnee iskusstvo,* no. 72, fig. 178.

165

Cauldron with horse-shaped handles. Bronze, height 24.8 cm. (9¾ in.).

Sarmatian, 1st century A.D. Odessa region, burial near Troyany village. Chance find, 1914. Hermitage, 1095/2.

Kultura drevnikh narodov Vostochnoy Evropy. Putevoditel. (Leningrad, 1969), p. 30.

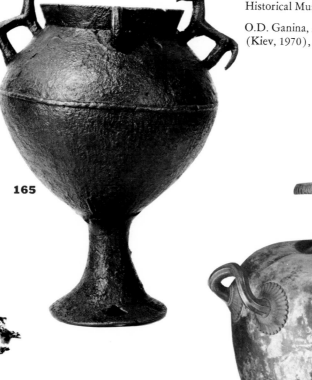

165

Kiev State Historical Museum

166

Recumbent stags, 29 plaques from a woman's headdress. Gold, lengths 4.3 cm. (1¹¹⁄₁₆ in.).

6th century B.C. Cherkassy region, kurgan near Sinyavka village. Kiev Historical Museum, DM 6307, 6361-6377.

167

Bronze hydriai of this type have been found in many parts of the ancient world. The foot and the handles are cast; the rest of the body is hammered from sheet metal. The attachment of the vertical handle is in the shape of a frontal siren, whose unusually big feathers on the body are very close to those on a handle from Torone. There are silver studs in the center of each volute.

Hydria. Bronze, height 44 cm. (17⁵⁄₁₆ in.), capacity 20.5 liters.

Greek, 5th century B.C. Cherkassy district, kurgan near Peschanoye village. Kiev Historical Museum, B 41-429.

O.D. Ganina, *Antichni bronzi z Pishanogo* (Kiev, 1970), figs. 1, 10, 42, 44, pp. 84-85.

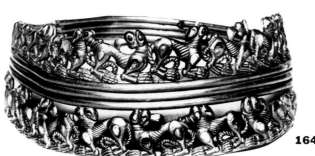

164

167

168

This bowl is decorated by a relief plaque showing a griffin felling a horse near a tree trunk. Although the shape of the bowl is thoroughly Greek, the decoration caters to local taste, and the animal group is in keeping with the Scythian repertory.

Large bowl on a ring base. Bronze, height 12.5 cm. (4⅞ in.), diameter 44.5 cm. (17½ in.), capacity 12.5 liters.

4th century B.C. Cherkassy district, Peschanoye village. Kiev Historical Museum, B 41-439.

Ganina, *Antichni bronzi z Pishanogo*, figs. 3, 26, 27, p. 91.

169

Bridle ornaments: chanfron decorated with the figure of a lion, 2 pendelocks, 6 hemispherical plaques, and 2 cheekpieces. Gold.

4th century B.C. Dnepropetrovsk district, Tolstaya Mogila kurgan. Kiev Historical Museum, AZ 2520-29.

170 (Color plate 30)

This scabbard, like the one from Chertomlyk (no. 68), combines a Scythian shape and decoration devised by a Greek. The part near the hilt is decorated with two confronted cocks, the "flap" with a splendid horned lion-griffin. The sheath portrays animal combat: an eagle-griffin has brought down a stag; a lion and griffin attack a wild horse; a panther pursues a stag; and a panther confronts a lion.

Scabbard decorated with fighting animals and mythological creatures. Gold, length 64.5 cm. (25⅜ in.), width 18.6 cm. (7⁵⁄₁₆ in.), weight 73.25 gr.

4th century B.C. Dnepropetrovsk district, near the town of Ordzhonikidze, Tolstaya Mogila kurgan. Kiev Historical Museum, AZS 2493.

171 (Cover, color plates 31-33)

Of all the superb works in gold that have been found in South Russia, this great pectoral is easily the most splendid. The artist has contrasted scenes from the home life of the Scythians with the wildness outside the encampments. In the upper register, calves and foals are suckling; two Scythians sew a shirt cut out of an animal skin; a third milks a ewe; and a fourth, shown in daring three-quarter frontal view, closes an amphora. This scene is framed by a kid, a goat, and a bird on each side, and also includes a pig. The center of the lower band is given over to three pairs of griffins attacking horses. These groups are flanked by lions and panthers attacking a deer on the left and a boar on the right. In the tapering ends of this zone, hounds course hares and grasshoppers confront each other. The middle zone is richly decorated with floral ornaments, on which four birds perch. The 48 figures were individually cast and soldered onto the frame.

Pectoral with scenes of Scythians tending their livestock, animals struggling with mythological creatures, and floral ornament. Gold, diameter 30.6 cm. (12 in.), weight 1150 gr.

Greek workmanship, executed for the Scythians, 4th century B.C. Dnepropetrovsk district, near the town of Ordzhonikidze, Tolstaya Mogila kurgan. Kiev Historical Museum, AZS 2494.

B. N. Mozolevskii, "Kurgan Tolstaya Mogila bliz g. Ordzhonikidze na Ukraine," *SA* (1972), no. 3, pp. 268-308; Renate Rolle, "Die Ausgrabung des skythischen Fürstengrabes 'Tolstaja mogila' bei Ordzonikidze," *Antike Welt* 4 (1973), pp. 48-52.

168

172 (Color plate 29)

Scythians are shown here in their full panoply, with the characteristic gorytus (a quiver holding the bow as well as arrows), shield, and bow. The pattern on the rim and the careful rendering of features betray Greek workmanship. The three-quarter view is typical of classic Greek art of the 4th century B.C.

Drinking cup (skyphos) showing Scythian warriors resting. Silver gilt, height 9.2 cm. (3⅝ in.), diameter 10.3 cm. (4¹/₁₆ in.), weight 24.29 gr.

Greek workmanship, executed for the Scythians, 4th century B.C. Zaporozhe district, Balki village. Gaimanova Mogila kurgan. Kiev Historical Museum, AZS 2358.

173

Plaque decorated with a recumbent griffin. Gold, 2.95 x 2.4 cm. (1³/₁₆ x ¹⁵/₁₆ in.).

Kherson district, near the Sovkhoz, Blyukher kurgan. Kiev Historical Museum, AZ 2404.

174

Wild boar, plaque. Gold, 9 x 4.6 cm. (3½ x 1¹³/₁₆ in.).

4th century B.C. Kherson district, kurgan near Arkhangelskaya village. Kiev Historical Museum, AZ 2325.

175

Recumbent panther, plaque. Gold, length 8 cm. (3⅛ in.).

4th century B.C. Kherson district, kurgan near Arkhangelskaya village. Kiev Historical Museum, AZ 2326.

176

Dog, plaque. Gold, length 9.45 cm. (3¾ in.).

4th century B.C. Kherson district, kurgan near Arkhangelskaya village. Kiev Historical Museum, AZ 2327.

177

Woman with raised arms sitting on a ram, pendant. Gold, height 8.3 cm. (3¼ in.).

4th century B.C. Kherson district, kurgan near Lyubimovka village. Kiev Historical Museum, AZ 2312.

178 (Color plate 30)

This unusual ornament shows a spider in combat with an insect, conforming to the Scythian notion of constant battle pervading even the insect kingdom.

Insect and spider, openwork plaque. Gold, length 4.2 cm. (1⅝ in.).

4th century B.C. Zaporozhe district, kurgan near the town of Melitopol. Kiev Historical Museum, AZS 1329.

179

The situla is a wine bucket with two swinging handles that lie flat on the rim when not carried. On one side this example has a pouring spout in the shape of a lion's head, cast in one piece with the rings that hold the handles. Opposite the lion's head is a frontal bust of Athena.

Situla. Bronze, height 23 cm. (9¹/₁₆ in.), capacity 5.5 liters.

Greek, 4th century B.C. Kiev Historical Museum, BB 41-431.

Ganina, *Antichni bronzi z Pishanogo,* cover, figs. 2, 19-22,30, p. 90.

180

Plaque with the representation of a bearded Scythian.

Kurgan near Krasno Perekopsk. Kiev Historical Museum.

181

Bronze brazier.

Gaimanova Mogila kurgan. Kiev Historical Museum.

182

Oinochoe.

Gaimanova Mogila kurgan. Kiev Historical Museum.

183 (Color plate 27)

The combination of two different heads joined back to back occurs in Scythian art for the first time in the second kurgan of the Seven Brothers, where the two are the head of Athena and of a lion; a comparison with Athenian coins allows a date of about 440 B.C. Here the head of a lion is joined to that of a youth, almost as if the artist remembered the common Greek motif of Heracles wearing the lion skin. The type persists until about 370 B.C.

Heads of a youth and a lion. Gold, diameter 2.4 cm. (¹⁵/₁₆ in.).

Kherson region, near Nizhniye Sirogozy village, Oguz kurgan. Kiev Historical Museum, DM 6264.

184 (Color plate 28)

Lion. Silver gilt, length 9.5 cm. (3¾ in.), height 6.3 cm. (2½ in.), weight 36.38 gr.

6th–7th century A.D. Cherkassy district, treasure trove near Martynovka village.

Kiev Historical Museum, AZS 81.

185 (Color plate 28)

Human figures are quite rare in the art of the steppes, in contrast to the overwhelming number of animals. Though severely simplified, this man's dress can be recognized as that of a horse nomad, and his posture–arms akimbo and knees bent–suggests a dance step still surviving in Russian folk dance.

Dancing man. Silver gilt, height 8.6 cm. (3⅜ in.), width 5.2 cm. (2¹/₁₆ in.), weight 24.4 gr.

6th–7th century A.D. Cherkassy district, treasure trove near Martynovka village. Kiev Historical Museum, AZS 84.

180

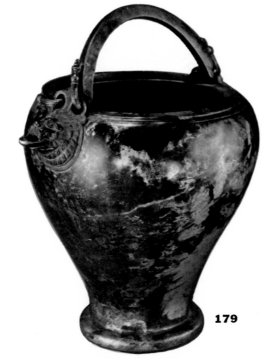

179

Rostov-on-Don Art Museum

186

The gorytus–typically Scythian–is a combination of quiver and bow-case, and like the many scabbards made for the Scythians, it was often covered with gold. At least four have been found, all decorated with the same subjects: one from Chertomlyk, another from near Ilyintsy (both now in Leningrad), a third, illustrated here, in Kiev, and the fourth from an estuary of the Don, now in Rostov–on–Don. The animals in fighting groups are familiar from other objects made to Scythian taste, but the two friezes with figures are taken from Greek mythology and probably represent Achilles among the daughters of King Lykomedes on the island of Skyros.

Gorytus with relief decoration. Gold, length 36 cm. (14⅛ in.), width 25 cm. (9¹³⁄₁₆ in.).

Greek workmanship, executed for the Scythians. Late 5th–early 4th century B.C. Rostov-on-Don Art Museum.

V.P. Shilov, *SA* (1961), p. 161, fig. 13.

State Historical Museum, Moscow

187

Harness plaque decorated with four predatory bird's heads. Bronze, length 2.5 cm. (1 in.).

Culture of the Sakas, 7th–5th centuries B.C. Historical Museum, Moscow, 101908.

188

Bird's head, harness plaque. Bronze, length 7 cm. (2¾ in.).

Culture of the Sakas, 7th–5th centuries B.C. Historical Museum, Moscow, 101908.

189

Boar's head, harness plaque. Bronze, length 4 cm. (1⁹⁄₁₆ in.).

Culture of the Sakas, 7th–5th centuries B.C. Historical Museum, Moscow, 101908.

190

Camel's head, frontlet. Bronze, length 3 cm. (1³⁄₁₆ in.).

Culture of the Sakas, 7th–5th centuries B.C. Historical Museum, Moscow, 101908.

191

Harness plaque decorated with a panther's head. Bronze, 6 x 5 cm. (2⅜ x 2 in.).

Culture of the Sakas, 7th–5th centuries B.C. Historical Museum, Moscow, 101908.

192

Bird, harness buckle. Bronze, length 5 cm. (2 in.).

Culture of the Sakas, 7th–5th centuries B.C. Historical Museum, Moscow, 101908.

193

Buckle from a saddle girth decorated with a recumbent lion. Bronze, diameter 10 cm. (3¹⁵⁄₁₆ in.).

Culture of the Sakas, 7th–5th centuries B.C. Historical Museum, Moscow, 101908.

194

Spoon decorated with stylized representation of animals. Bone, length 10.4 cm. (3¹⁵⁄₁₆ in.)

Sauromatian culture, 6th century B.C. Orenburg district, Bis Oba. Historical Museum, Moscow, 70172.

195

Recumbent stag, plaque. Bronze, length 6.5 cm. (2⁹⁄₁₆ in.).

Tagar culture, 5th–3rd centuries B.C. Historical Museum, Moscow, 36855.

196

Sepulchral monument. Limestone, height 146 cm. (57½ in.).

Scythian, 4th–3rd century B.C. Rostov region, Elizavetovskaya village. Historical Museum, Moscow, 48214.

197

Hollow torque with inlaid animal heads at the ends. Gold and turquoise, length 24.4 cm (8¹⁄₁₆ in.).

Sauromatian culture, 2nd century B.C. Voronezh district. Chance find. Historical Museum, Moscow, 80330.

IAK	*Izvestiya Arkheologicheskoy Komissii*
KSIIMK	*Kratiye soobshcheniya Instituta Istorii Materyalnoy Kultury*
MAK	*Materialy po arkheologii Kavkaza*
MAR	*Materialy po arkheologii Rossii*
OAK	*Otchet Arkheologicheskoy Komissii*
SA	*Sovetskaya arkheologiya*

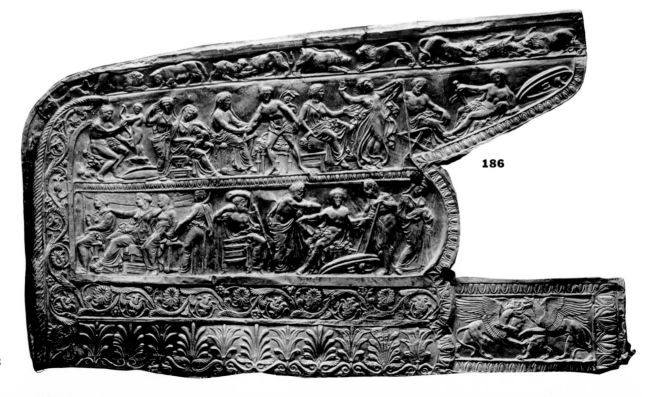

186

Herodotus: On The Scythians

Herodotus, the "Father of History," was born in Halicarnassus, a town in Asia Minor, in the eighties of the fifth century B.C. He lived on Samos and in Athens (where he was admitted into the circle of Pericles and became friends with Sophocles), and died in the Greek colony of Thurii in Italy around 430 B.C.

His grandiose history of the decisive event of his century, the Persian Wars, includes a rich variety of information on the customs, cultures, and geography of the ancient world. As he collected information for his book, his many travels led him to Egypt and Libya, the coasts of Syria and Cyprus, Mesopotamia, Asia Minor, Southern Italy and Sicily, the islands of the Aegean, Macedonia, Thrace, and the Black Sea. His account of the Scythians —who had humiliated the Persian army sent out to subdue them—was based in part on his voyage by ship along the shore of the Black Sea, and on first-hand information gathered in Olbia, the Greek settlement and trading post on the fringes of Scythian territory; he must also have made several excursions on land. The value of his narrative lies in his skillful combination of personal observations with stories told him by others, as well as information already compiled by other historians and geographers whose works are now mostly lost. Incredible as some of his stories of Scythian customs may seem, many of them have been borne out by modern archaeology, and his account remains the basis for present-day knowledge of the Scythian people.

1. After the taking of Babylon, an expedition was led by Darius into Scythia.[1] Asia abounding in men, and vast sums flowing into the treasury, the desire seized him to exact vengeance from the Scyths, who had once in days gone by invaded Media, defeated those who met them in the field, and so begun the quarrel. During the space of twenty-eight years, as I have before mentioned, the Scyths continued lords of the whole of Upper Asia. They entered Asia in pursuit of the Cimmerians, and overthrew the empire of the Medes, who till they came possessed the sovereignty. On their return to their homes after the long absence of twenty-eight years, a task awaited them little less troublesome than their struggle with the Medes. They found an army of no small size prepared to oppose their entrance. For the Scythian women, when they saw that time went·on, and their husbands did not come back, had intermarried with their slaves.

2. Now the Scythians blind all their slaves, to use them in preparing their milk. The plan they follow is to thrust tubes made of bone, not unlike our musical pipes, up the vulva of the mare, and then to blow into the tubes with their mouths, some milking while the others blow. They say that they do this because when the veins of the animal are full of air, the udder is forced down. The milk thus

[1]The date of Darius' campaign seems to be 512 B.C. Although chapters 1-144 have little to do with Herodotus' main subject, they are important as the earliest study we possess of an uncivilised people.

Selections from The Persian Wars *(book IV) by Herodotus. From "The Greek Historians," edited by Francis R. B. Godolphin. Copyright 1942 and renewed 1970 by Random House, Inc. Reprinted by permission of the publisher.*

obtained is poured into deep wooden casks, about which the blind slaves are placed, and then the milk is stirred round. That which rises to the top is drawn off, and considered the best part; the under portion is of less account. Such is the reason why the Scythians blind all those whom they take in war; it arises from their not being tillers of the ground, but a pastoral race.

3. When therefore the children sprung from these slaves and the Scythian women, grew to manhood, and understood the circumstances of their birth, they resolved to oppose the army which was returning to Media. And first of all, they cut off a tract of country from the rest of

Scythia by digging a broad dyke from the Tauric mountains to the vast lake of the Maeotis. Afterwards, when the Scythians tried to force an entrance, they marched out and engaged them. Many battles were fought, and the Scythians gained no advantage, until at last one of them thus addressed the remainder, "What are we doing, Scythians? We are fighting our slaves, diminishing our own number when we fall, and the number of those that belong to us when they fall by our hands. Take my advice —lay spear and bow aside, and let each man fetch his horse-whip, and go boldly up to them. So long as they see us with arms in our hands, they imagine themselves our equals in birth and bravery; but let them behold us with no other weapon but the whip, and they will feel that they are our slaves, and flee before us."

Cat. no. 69

4. The Scythians followed this counsel, and the slaves were so astounded, that they forgot to fight, and immediately ran away. Such was the mode in which the Scythians, after being for a time the lords of Asia, and being forced to quit it by the Medes, returned and settled in their own country. This inroad of theirs it was that Darius was anxious to avenge, and such was the purpose for which he was now collecting an army to invade them.

5. According to the account which the Scythians themselves give, they are the youngest of all nations. Their tradition is as follows. A certain Targitaus was the first man who ever lived in their country, which before his time was a desert without inhabitants. He was a child—I do not believe the tale, but it is told nevertheless—of Zeus and a daughter of the Borysthenes. Targitaus, thus descended, begat three sons, Leipoxais, Arpoxais, and

Colaxais, who was the youngest born of the three. While they still ruled the land, there fell from the sky four implements, all of gold,—a plough, a yoke, a battle-axe, and a drinking-cup. The eldest of the brothers perceived them first, and approached to pick them up; as he came near, the gold took fire, and blazed. He therefore went his way, and the second coming forward made the attempt, but the same thing happened again. The gold rejected both the eldest and the second brother. Last of all the youngest brother approached, and immediately the flames were extinguished; so he picked up the gold, and carried it to his home. Then the two elder agreed together, and made the whole kingdom over to the youngest born.

6. From Leipoxais sprang the Scythians of the race called Auchatae; from Arpoxais, the middle brother, those known as the Catiari and Traspians; from Colaxais, the youngest, the Royal Scythians, or Paralatae. All together they are named Scoloti, after one of their kings: the Greeks, however, call them Scythians.

7. Such is the account which the Scythians give of their origin. They add that from the time of Targitaus, their first king, to the invasion of their country by Darius, is a period of 1,000 years, neither less nor more. The Royal Scythians guard the sacred gold with most especial care, and year by year offer great sacrifices in its honour. At this feast, if the man who has the custody of the gold should fall asleep in the open air, he is sure (the Scythians say) not to outlive the year. His pay therefore is as much land as he can ride round on horseback in a day. As the extent of Scythia is very great, Colaxais gave each of his three sons a separate kingdom, one of which was of ampler size than the other two: in this the gold was preserved. Above, to the northward of the farthest dwellers in Scythia, the country is said to be concealed from sight and made impassable by reason of the feathers which are shed abroad abundantly. The earth and air are alike full of them, and this it is which prevents the eye from obtaining any view of the region.[2]

8. Such is the account which the Scythians give of themselves, and of the country which lies above them. The Greeks who dwell about the Pontus tell a different story. According to them, Heracles, when he was carrying off the cows of Geryon, arrived in the region which is now inhabited by the Scyths, but which was then a desert. Geryon lived outside the Pontus, in an island called by the Greeks Erytheia, near Gades,[3] which is beyond the Pillars of Heracles upon the Ocean. Now some

[2] Herodotus explains (iv. 31) that the so-called feathers are snow-flakes.

[3] The modern Cadiz.

say that the Ocean begins in the east, and runs the whole way round the world; but they give no proof that this is really so.[4] Heracles came from thence into the region now called Scythia, and being overtaken by storm and frost, drew his lion's skin about him, and fell fast asleep. While he slept, his mares, which he had loosed from his chariot to graze, by some wonderful chance disappeared.

9. On waking, he went in quest of them, and, after wandering over the whole country, came at last to the district called the Woodland, where he found in a cave a strange being, between a maiden and a serpent, whose form from the buttocks upwards was like that of a woman, while all below was like a snake. He looked at her wonderingly; but nevertheless inquired, whether she had chanced to see his strayed mares anywhere. She answered him, "Yes, and they were now in her keeping; but never would she consent to give them back, before he had intercourse with her." So Heracles, to get his mares back, agreed; but afterwards she put him off and delayed restoring the mares, since she wished to keep him with her as long as possible. He, on the other hand, was only anxious to secure them and to get away. At last, when she gave them up, she said to him, "When your mares strayed hither, it was I who saved them for you; now you have paid a reward; for I bear in my womb three sons of yours. Tell me therefore when your sons grow up, what must I do with them? Would you wish that I should settle them here in this land, whereof I am mistress, or shall I send them to you?" Thus questioned, they say, Heracles answered, "When the lads have grown to manhood, do thus, and assuredly you will not err. Watch them, and when you see one of them bend this bow as I now bend it, and gird himself with this girdle thus, choose him to remain in the land. Those who fail in the trial, send away. Thus you will at once please yourself and obey me."

10. Hereupon he strung one of his bows—up to that time he had carried two—and showed her how to fasten the belt. Then he gave both bow and belt into her hands. Now the belt had a golden goblet attached to its clasp. So after he had given them to her, he went his way; and the woman, when her children grew to manhood, first gave them severally their names. One she called Agathyrsus, one Gelonus, and the other, who was the youngest Scythes. Then she remembered the instructions she had received from Heracles, and, in obedience to his orders, she put her sons to the test. Two of them, Agathyrsus

and Gelonus, proving unequal to the task enjoined, their mother sent them out of the land; Scythes, the youngest, succeeded, and so he was allowed to remain. From Scythes, the son of Heracles, were descended the after kings of Scythia; and from the circumstance of the goblet which hung from the belt, the Scythians to this day wear goblets at their girdles. This was the only thing which the mother of Scythes did for him. Such is the tale told by the Greeks who dwell around the Pontus.

11. There is also another different story, now to be related, in which I am more inclined to put faith than in any other. It is that the wandering Scythians once dwelt in Asia, and there warred with the Massagetae, but with ill success; they therefore quitted their homes, crossed the Araxes,[5] and entered the land of Cimmeria. For the land which is now inhabited by the Scyths was formerly the country of the Cimmerians. On their coming, the natives, who heard how numerous the invading army was, held a council. At this meeting opinion was divided, and both parties stiffly maintained their own view, but the counsel of the Royal tribe was the braver. For the others urged that the best thing to be done was to leave the country and avoid a contest with so vast a host; but the Royal tribe advised remaining and fighting for the soil to the last. As neither party chose to give way, the one determined to retire without a blow and yield their lands to the invaders; but the other, remembering the good things which they had enjoyed in their homes, and picturing to themselves the evils which they had to expect if they gave them up, resolved not to flee, but rather to die and at least be buried in their fatherland. Having thus decided, they drew apart in two bodies, the one as numerous as the other, and fought together. All of the Royal tribe were slain, and the people buried them near the river Tyras, where their grave is still to be seen. Then the rest of the Cimmerians departed, and the Scythians, on their coming, took possession of a deserted land.

12. Scythia still retains traces of the Cimmerians; there are Cimmerian walls, and a Cimmerian ferry, also a tract called Cimmeria,[6] and a Cimmerian Bosporus. It appears likewise that the Cimmerians, when they fled into Asia to escape the Scyths, made a settlement in the peninsula where the Greek city of Sinope was afterwards built. The Scyths, it is plain, pursued them, and missing their road, poured into Media. For the Cimmerians kept the line which led along the sea-shore, but the Scyths in their pursuit held the Caucasus upon their right, thus proceeding inland, and falling upon Media. This account is one which is common both to Greeks and barbarians.

[4] Herodotus considered that the eastern and northern boundaries of the earth were unknown, and that the general belief that the sea encompassed the land was a pure conjecture resting on no certain data.

[5] It seems that the Araxes here represents the Volga.

[6] The Cimmerians have given their name to the Crimea.

13. Aristeas also, son of Caystrobius, a native of Proconnesus,[7] says in the course of his poem, that inspired by Phoebus, he went as far as the Issedones. Above them dwelt the Arimaspi, men with one eye; still further, the gold-guarding griffins; and beyond these, the Hyperboreans, who extended to the sea. Except the Hyperboreans, all these nations, beginning with the Arimaspi, were continually encroaching upon their neighbours. Hence it came to pass that the Arimaspi drove the Issedonians from their country, while the Issedonians dispossessed the Scyths; and the Scyths, pressing upon the Cimmerians, who dwelt on the shores of the Southern sea,[8] forced them to leave their land. Thus even Aristeas does not agree in his account of this region with the Scythians.

16. With regard to the regions which lie above the country whereof this portion of my history treats, there is no one who possesses any exact knowledge. Not a single person can I find who professes to be acquainted with them by actual observation. Even Aristeas, the traveller of whom I lately spoke, does not claim—and he is writing poetry—to have reached any farther than the Issedonians. What he relates concerning the regions beyond is, he confesses, mere hearsay, being the account which the Issedonians gave him of those countries. However, I shall proceed to mention all that I have learnt of these parts by the most exact inquiries which I have been able to make concerning them.

17. Above the trading-port of the Borysthenites, which is situated in the very centre of the whole sea-coast of Scythia, the first people who inhabit the land are the Callippidae, a Graeco-Scythic race. Next to them, as you go inland, dwell the people called the Alazonians. These two nations in other respects resemble the Scythians in their usages, but sow and eat corn, also onions, garlic, lentils, and millet. Beyond the Alazonians reside Scythian cultivators, who grow corn, not for their own use, but for sale.[9] Still higher up are the Neuri. Northwards of the Neuri the continent, as far as it is known to us, is uninhabited. These are the nations along the course of the river Hypanis, west of the Borysthenes.

18. Across the Borysthenes, the first country after you leave the coast is the Woodland. Above this dwell the Scythian Husbandmen, who the Greeks living near the Hypanis call Borysthenites, while they call themselves Olbiopolites. These Husbandmen extend eastward a distance of three days' journey to a river bearing the name of Panticapes,[10] while northward the country is theirs for eleven days' sail up the course of the Borysthenes. Further inland there is a vast tract which is uninhabited. Above this desolate region dwell the Cannibals, who are a people apart, much unlike the Scythians. Above them the country becomes an utter desert; not a single tribe, so far as we know, inhabits it.

19. Crossing the Panticapes, and proceeding eastward of the Husbandmen, we come upon the wandering Scythians, who neither plough nor sow. Their country, and the whole of this region, except the Woodlands, is quite bare of trees. They extend towards the east a distance of fourteen days' journey, occupying a tract which reaches to the river Gerrhus.

20. On the opposite side of the Gerrhus is the Royal district, as it is called: here dwells the largest and bravest of the Scythian tribes, which looks upon all the other tribes in the light of slaves. Its country reaches on the south to Taurica, on the east to the trench dug by the sons of the blind slaves, the mart upon Lake Maeotis, called the Cliffs, and in part to the river Tanais.[11] North of the country of the Royal Scythians are the Blackcloaks, a people of a quite different race from the Scythians. Beyond them lie marshes and a region without inhabitants, so far as our knowledge reaches.

21. When one crosses the Tanais, one is no longer in Scythia; the first region on crossing is that of the Sauromatae, who, beginning at the upper end of Lake Maeotis, stretch northward a distance of fifteen days' journey, inhabiting a country which is entirely bare of trees, whether wild or cultivated. Above them, possessing the second region, dwell the Budini, whose territory is thickly wooded with trees of every kind.

22. Beyond the Budini, as one goes northward, first there is a desert, seven days' journey across; after which, if one inclines somewhat to the east, the Thyssagetae are reached, a numerous nation quite distinct from any other, and living by the chase. Adjoining them, and within the limits of the same region, are the people who bear the

[7] Proconnesus is the island now called Marmora, which gives its modern appellation to the Sea of Marmora.

[8] That is, the Euxine, in contradistinction from the Northern Sea, on the shores of which dwelt the Hyperboreans, according to Aristeas.

[9] The corn-trade of the Scythians appears to have been chiefly with the Greeks. Its extent is indicated in Herodotus by his assignment of the whole country west, and a portion of that east, of the Borysthenes to Scythian husbandmen, who raised corn only for sale.

[10] Here the description of Herodotus, which has been hitherto excellent, begins to fail.

[11] Now the Don.

name of Iyrcae; they also support themselves by hunting, which they practice in the following manner. The hunter climbs a tree, the whole country abounding in wood, and there sets himself in ambush; he has a dog at hand, and a horse, trained to lie down upon its belly, and thus make itself low; the hunter keeps watch, and when he sees his game, lets fly an arrow; then mounting his horse, he gives the beast chase, his dog following hard all the while. Beyond these people, a little to the east, dwells a distinct tribe of Scyths, who revolted once from the Royal Scythians, and migrated into these parts.

23. As far as their country, the tract of land whereof I have been speaking is all a smooth plain, and the soil deep; beyond you enter on a region which is rugged and stony. Passing over a great extent of this rough country, you come to a people dwelling at the foot of lofty mountains, who are said to be all—both men and women—bald from their birth, to have flat noses, and very long chins. These people speak a language of their own, but the dress which they wear is the same as the Scythian. They live on the fruit of a certain tree, the name of which is Ponticum; in size it is about equal to our fig-tree, and it bears a fruit like a bean, with a stone inside. When the fruit is ripe, they strain it through cloths; the juice which runs off is black and thick, and is called by the natives "aschy." They lap this up with their tongues, and also mix it with milk for a drink; while they make the lees, which are solid, into cakes, and eat them instead of meat; for they have but few sheep in their country, in which there is no good pasturage. Each of them dwells under a tree, and they cover the tree in winter with a cloth of thick white felt, but take off the covering in the summer-time. No one harms these people, for they are looked upon as sacred,— they do not even possess any warlike weapons. When their neighbours fall out, they make up the quarrel; and when one flies to them for refuge, he is safe from all hurt. They are called the Argippaeans.

24. Up to this point the territory of which we are speaking is very completely explored, and all the nations between the coast and the bald-headed men are well known to us. For some of the Scythians are accustomed to penetrate as far, of whom inquiry may easily be made, and Greeks also go there from the trading-stations on the Borysthenes, and from the other trading-stations along the Euxine. The Scythians who make this journey communicate with the inhabitants by means of seven interpreters and seven languages.

25. Thus far therefore the land is known; but beyond the bald-headed men lies a region of which no one can give any exact account. Lofty and precipitous mountains, which are never crossed, bar further progress. The bald

men say, but it does not seem to me credible, that the people who live in these mountains have feet like goats; and that after passing them you find another race of men, who sleep during one half of the year. This latter statement appears to me quite unworthy of credit. The region east of the bald-headed men is well known to be inhabited by the Issedonians, but the tract that lies to the north of these two nations is entirely unknown, except by the accounts which they give of it.

26. The Issedonians are said to have the following customs. When a man's father dies, all the near relatives bring sheep to the house; which are sacrificed, and their flesh cut in pieces, while at the same time the dead body undergoes the like treatment. The two sorts of flesh are afterwards mixed together, and the whole is served up at a banquet. The head of the dead man is treated differently: it is stripped bare, cleansed, and set in gold. It then becomes an ornament on which they pride themselves, and is brought out year by year at the great festival which sons keep in honour of their fathers' death, just as the Greeks keep their feast of the dead. In other respects the Issedonians are reputed to be observers of justice: and it is to be remarked that their women have equal authority with the men. Thus our knowledge extends as far as this nation.

27. The regions beyond are known only from the accounts of the Issedonians, by whom the stories are told of the one-eyed race of men and the gold-guarding griffins. These stories are received by the Scythians from the Issedonians, and by them passed on to us Greeks: whence it arises that we give the one-eyed race the Scythian name of Arimaspi, arima being the Scythic word for one, and spu for the eye.

28. The whole district whereof we have here discoursed has winters of exceeding rigour. During eight months the frost is so intense, that water poured upon the ground does not form mud, but if a fire be lighted on it mud is produced. The sea freezes, and the Cimmerian Bosporus is frozen over. At that season the Scythians who dwell inside the trench make warlike expeditions upon the ice, and even drive their waggons across to the country of the Sindians. Such is the intensity of the cold during eight months out of the twelve, and even in the remaining four the climate is still cool. The character of the winter likewise is unlike that of the same season in any other country; for at that time, when the rains ought to fall, in Scythia there is scarcely any rain worth mentioning, while in summer it never gives over raining; and thunder, which elsewhere is frequent then, in Scythia is unknown in that part of the year, coming only in summer, when it is very heavy. Thunder in the wintertime

is there accounted a prodigy; as also are earthquakes, whether they happen in winter or summer. Horses bear the winter well, cold as it is, but mules and asses are quite unable to bear it; whereas in other countries mules and asses are found to endure the cold, while horses, if they stand still, are frost-bitten.

31. With respect to the feathers which are said by the Scythians to fill the air, and to prevent persons from penetrating into the remoter parts of the continent, or even having any view of those regions, my opinion is, that in the countries above Scythia it always snows, less, of course, in the summer than in the wintertime. Now snow when it falls looks like feathers, as every one is aware who has seen it come down close to him. These northern regions, therefore, are uninhabitable by reason of the severity of the winter; and the Scythians, with their neighbours, call the snow-flakes feathers because, I think, of the likeness which they bear to them. I have now related what is said of the most distant parts of this continent whereof any account is given.

46. The Euxine sea, where Darius now went to war, has nations dwelling around it, with the one exception of the Scythians, more unpolished than those of any other region that we know of. For, setting aside Anacharsis and the Scythian people, there is not within this region a single nation which can be put forward as having any claims to wisdom, or which has produced a single person of any high repute. The Scythians indeed have in one respect, and that the very most important of all those that fall under man's control, shown themselves wiser than any nation upon the face of the earth. Their customs otherwise are not such as I admire. The one thing of which I speak, is the contrivance whereby they make it impossible for the enemy who invades them to escape destruction, while they themselves are entirely out of his reach, unless it please them to engage with him. Having neither cities nor forts, and carrying their dwellings with them wherever they go; accustomed, moreover, one and all of them, to shoot from horseback; and living not by husbandry but on their cattle, their waggons the only houses that they possess, how can they fail of being unconquerable, and unassailable even?

47. The nature of their country, and the rivers by which it is intersected, greatly favour this mode of resisting attacks. For the land is level, well-watered, and abounding in pasture; while the rivers which traverse it are almost equal in number to the canals of Egypt. Of these I shall only mention the most famous and such as are navigable to some distance from the sea. They are, the Ister, which has five mouths; the Tyras, the Hypanis, the Borysthenes, the Panticapes, the Hypacyris, the Gerrhus, and the Tanais. The courses of these streams I shall now proceed to describe.

48. The Ister is of all the rivers with which we are acquainted the mightiest. It never varies in height, but continues at the same level summer and winter. Counting from the west it is the first of the Scythian rivers, and the reason of its being the greatest is, that it receives the waters of several tributaries. Now the tributaries which swell its flood are the following: first, on the side of Scythia, these five—the stream called by the Scythians Porata, and by the Greeks Pyretus, the Tiarantus, the Ararus, the Naparis, and the Ordessus. The first-mentioned is a great stream, and is the easternmost of the tributaries. The Tiarantus is of less volume, and more to the west. The Ararus, Naparis, and Ordessus fall into the Ister between these two. All the above-mentioned are genuine Scythian rivers, and go to swell the current of the Ister.

49. From the country of the Agathyrsi comes down another river, the Maris, which empties itself into the same; and from the heights of Haemus descend with a northern course three large streams, the Atlas, the Auras, and the Tibisis, and pour their waters into it. Thrace gives it three tributaries, the Athrys, the Noes, and the Artanes, which all pass through the country of the Crobyzian Thracians. Another tributary is furnished by Paeonia, namely the Scius; this river, rising near Mount Rhodope, forces its way through the chain of Haemus, and so reaches the Ister. From Illyria comes another stream, the Angrus, which has a course from south to north, and after watering the Triballian plain, falls into the Brongus, which falls into the Ister. So the Ister is augmented by these two streams, both considerable. Besides all these, the Ister receives also the waters of the Carpis and the Alpis, two rivers running in a northly direction from the country above the Umbrians. For the Ister flows through the whole extent of Europe, rising in the country of the Celts[19] (the most westerly of all the nations of Europe, excepting the Cynetians), and

[19] As Herodotus plunges deeper into the European continent, his knowledge is less and less exact. He knows that the Danube receives two great tributaries from the south in the upper part of its course, but he conceives the rivers, of which he had heard the Umbrians tell as running northwards from the Alps above their country, to be identical with the great tributaries whereof the dwellers on the middle Danube spoke. The length of the Nile is 4,000 miles; of the Danube, 1,760 miles.

thence running across the continent till it reaches Scythia, whereof it washes the flanks.

50. All these streams, then, and many others, add their waters to swell the flood of the Ister, which thus increased becomes the mightiest of rivers; for undoubtedly if we compare the stream of the Nile with the single stream of the Ister, we must give the preference to the Nile, of which no tributary river, nor even rivulet, augments the volume. The Ister remains at the same level both summer and winter—owing to the following reasons, as I believe. During the winter it runs at its natural height, or a very little higher, because in those countries there is scarcely any rain in winter, but constant snow. When summer comes, this snow, which is of great depth, begins to melt, and flows into the Ister, which is swelled at that season, not only by this cause but also by the rains, which are heavy and frequent at that part of the year. Thus the various streams which go to form the Ister, are higher in summer than in winter, and just so much higher as the sun's power and attraction are greater; so that these two causes counteract each other, and the effect is to produce a balance, whereby the Ister remains always at the same level.

51. This, then, is one of the great Scythian rivers; the next to it is the Tyras, which rises from a great lake separating Scythia from the land of the Neuri, and runs with a southerly course to the sea. Greeks dwell at the mouth of the river, who are called Tyritae.

52. The third river is the Hypanis. This stream rises within the limits of Scythia, and has its source in another vast lake, around which wild white horses graze. The lake is called, properly enough, the Mother of the Hypanis. The Hypanis, rising here, during the distance of five days' navigation is a shallow stream, and the water sweet and pure; thence, however, to the sea, which is a distance of four days, it is exceedingly bitter. This change is caused by its receiving into it at that point a brook the waters of which are so bitter that, although it is but a tiny rivulet, it nevertheless taints the entire Hypanis, which is a large stream among those of the second order. The source of this bitter spring is on the borders of the Scythian Husbandmen, where they adjoin upon the Alazonians; and the place where it rises is called in the Scythic tongue Exampaeus, which means in our language, the Sacred Ways. The spring itself bears the same name. The Tyras and the Hypanis approach each other in the country of the Alazonians, but afterwards separate, and leave a wide space between their streams.

53. The fourth of the Scythian rivers is the Borysthenes. Next to the Ister, it is the greatest of them all; and, in my judgment, it is the most productive river, not merely in Scythia, but in the whole world, excepting only the Nile, with which no stream can possibly compare. It has upon its banks the loveliest and most excellent pasturages for cattle; it contains abundance of the most delicious fish; its water is most pleasant to the taste; its stream is limpid, while all the other rivers near it are muddy; the richest harvests spring up along its course, and where the ground is not sown, the heaviest crops of grass; while salt forms in great plenty about its mouth without human aid,[20] and large fish are taken in it of the sort called sturgeon, without any prickly bones, and good for pickling. Nor are these the whole of its marvels. As far inland as the place named Gerrhus, which is distant forty days' voyage from the sea,[21] its course is known, and its direction is from north to south; but above this no one has traced it, so as to say through what countries it flows. It enters the territory of the Scythian Husbandmen after running for some time across a desert region, and continues for ten days' navigation to pass through the land which they inhabit. It is the only river besides the Nile the sources of which are unknown to me, as they are also (I believe) to all the other Greeks. Not long before it reaches the sea, the Borysthenes is joined by the Hypanis, which pours its waters into the same lake. The land that lies between them, a narrow point like the beak of a ship, is called Cape Hippolaus. Here is a temple dedicated to Demeter, and opposite the temple upon the Hypanis is the dwelling-place of the Borysthenites. But enough has been said of these streams.

54. Next in succession comes the fifth river, called the Panticapes, which has, like the Borysthenes, a course from north to south, and rises from a lake. The space between this river and the Borysthenes is occupied by the Scythians who are engaged in husbandry. After watering their country, the Panticapes flows through the Woodland, and empties itself into the Borysthenes.

55. The sixth stream is the Hypacyris, a river rising from a lake, and running directly through the middle of the Nomadic Scythians. It falls into the sea near the city of Carcinitis, leaving the Woodland and the Race-course of Achilles to the right.

56. The seventh river is the Gerrhus, which is a branch thrown out by the Borysthenes at the point where the course of that stream first begins to be known, the region called by the same name as the stream itself, Gerrhus. This river on its passage towards the sea divides

[20] The salt of Kinburn is still of the greatest importance to Russia.

[21] The Dnieper is navigable for barges all the way from Smolensk to its mouth, a distance of not less than 1,500 miles.

the country of the Nomadic from that of the Royal Scyths. It runs into the Hypacyris.

57. The eighth river is the Tanais,[22] a stream which has its source, far up the country, in a lake of vast size, and which empties itself into another still larger lake, the Palus Maeotis, whereby the country of the Royal Scythians is divided from that of the Sauromatae. The Tanais receives the waters of a tributary stream, called the Hyrgis.

58. Such then are the rivers of chief note in Scythia. The grass which the land produces is more apt to generate gall in the beasts that feed on it than any other grass which is known to us, as plainly appears on the opening of their carcases.

59. Thus abundantly are the Scythians provided with the most important necessaries. Their manners and customs come now to be described. They worship only the following gods, namely, Hestia, whom they reverence beyond all the rest, Zeus and Earth, whom they consider to be the wife of Zeus; and after these Apollo, Celestial Aphrodite, Heracles, and Ares. These gods are worshipped by the whole nation: the Royal Scythians offer sacrifice likewise to Poseidon. In the Scythic tongue Hestia is called *Tabiti,* Zeus (very properly, in my judgment) *Papaeus,* Earth *Apia,* Apollo *Oetosyrus,* Celestial Aphrodite *Artimpasa,* and Poseidon *Thamimasadas.* They use no images, altars, or temples, except in the worship of Ares; but in his worship they do use them.

60. The manner of their sacrifices is everywhere and in every case the same; the victim stands with its two fore-feet bound together by a cord, and the person who is about to offer, taking his station behind the victim, gives the rope a pull, and thereby throws the animal down; as it falls he invokes the god to whom he is offering; after which he puts a noose round the animal's neck, and, inserting a small stick, twists it round, and so strangles him. No fire is lighted, there is no consecration, and no pouring out of drink-offerings; but directly that the beast is strangled the sacrificer flays him, and then sets to work to boil the flesh.

61. As Scythia, however, is utterly barren of firewood, a plan has had to be contrived for boiling the flesh, which is the following. After flaying the beasts, they take out all the bones, and (if they possess such gear) put the flesh into boilers made in the country, which are very like the cauldrons of the Lesbians, except that they are of a much larger size; then, placing the bones of the animals beneath the cauldron, they set them alight, and so boil the meat. If they do not happen to possess a cauldron, they make the animal's paunch hold the flesh, and pouring in at the same time a little water, lay the bones under and light them. The bones burn beautifully, and the paunch easily contains all the flesh when it is stripped from the bones, so that by this plan the ox is made to boil himself, and other victims also to do the like. When the meat is all cooked, the sacrificer offers a portion of the flesh and of the entrails, by casting it on the ground before him. They sacrifice all sorts of cattle, but most commonly horses.

62. Such are the victims offered to the other gods, and such is the mode in which they are sacrificed; but the rites paid to Ares are different. In every district, at the seat of government, there stands a temple of this god, whereof the following is a description. It is a pile of brushwood, made of a vast quantity of faggots, in length and breadth 600 yards; in height somewhat less, having a square platform upon the top, three sides of which are precipitous, while the fourth slopes so that men may walk up it. Each year 150 waggon-loads of brushwood are added to the pile, which sinks continually by reason of the rains. An antique iron sword is planted on the top of every such mound, and serves as the image of Ares; yearly sacrifices of cattle and of horses are made to it, and more victims are offered thus than to all the rest of their gods. When prisoners are taken in war, out of every hundred men they sacrifice one, not however with same rites as the cattle, but with different. Libations of wine are first poured upon their heads, after which they are slaughtered over a vessel; the vessel is then carried up to the top of the pile, and the blood poured upon the scimitar. While this takes place at the top of the mound, below, by the side of the temple, the right hands and arms of the slaughtered prisoners are cut off, and tossed on high into the air. Then the other victims are slain, and those who have offered the sacrifice depart, leaving the hands and arms where they may chance to have fallen, and the bodies also, separate.

63. Such are the observances of the Scythians with respect to sacrifice. They never use swine for the purpose, nor indeed is it their wont to breed them in any part of their country.

64. In what concerns war, their customs are the following. The Scythian soldier drinks the blood of the first man he overthrows in battle. Whatever number he slays, he cuts off all their heads, and carries them to the king; since he is thus entitled to a share of the booty, whereto

22 The modern Don.

he forfeits all claim if he does not produce a head. In order to strip the skull of its covering, he makes a cut round the head above the ears, and, laying hold of the scalp, shakes the skull out; then with the rib of an ox he scrapes the scalp clean of flesh, and softening it by rubbing between the hands, uses it thenceforth as a napkin. The Scyth is proud of these scalps, and hangs them from his bridle-rein; the greater the number of such napkins that a man can show, the more highly is he esteemed among them. Many make themselves cloaks, like the sheepskins of our peasants, by sewing a quantity of these scalps together. Others flay the right arms of their dead enemies, and make of the skin, which is stripped off with the nails hanging to it, a covering for their quivers. Now the skin of a man is thick and glossy, and would in whiteness surpass almost all other hides. Some even flay the entire body of their enemy, and, stretching it upon a frame, carry it about with them wherever they ride. Such are the Scythian customs with respect to scalps and skins.

65. The skulls of their enemies, not indeed of all, but of those whom they most detest, they treat as follows. Having sawn off the portion below the eyebrows, and cleaned out the inside, they cover the outside with leather. When a man is poor, this is all that he does; but if he is rich, he also lines the inside with gold: in either case the skull is used as a drinking cup. They do the same with the skulls of their own kith and kin if they have been at feud with them, and have vanquished them in the presence of the king. When strangers whom they deem of any account come to visit them, these skulls are handed round, and the host tells how that these were his relations who made war upon him, and how that he got the better of them; all this being looked upon as proof of bravery.

66. Once a year the governor of each district, at a set place in his own province, mingles a bowl of wine, of which all Scythians have a right to drink by whom foes have been slain; while they who have slain no enemy are not allowed to taste of the bowl, but sit aloof in disgrace. No greater shame than this can happen to them. Such as have slain a very large number of foes, have two cups instead of one, and drink from both.

67. Scythia has an abundance of soothsayers, who foretell the future by means of a number of willow wands. A large bundle of these wands is brought and laid on the ground. The soothsayer unties the bundle, and places each wand by itself, at the same time uttering his prophecy: then, while he is still speaking, he gathers the rods together again, and makes them up once more into a bundle. This mode of divination is of home growth in Scythia. The Enarees, or womanlike men, have an-

other method, which they say Aphrodite taught them. It is done with the inner bark of the linden-tree. They take a piece of this bark, and, splitting it into three strips, keep twining the strips about their fingers, and untwining them, while they prophesy.

68. Whenever the Scythian king falls sick, he sends for the three soothsayers of most renown at the time, who come and make trial of their art in the mode above described. Generally they say that the king is ill, because such or such a person, mentioning his name, has sworn falsely by the royal hearth. This is the usual oath among the Scythians, when they wish to swear with very great solemnity. Then the man accused of having forsworn himself is arrested and brought before the king. The soothsayers tell him that by their art it is clear he has sworn a false oath by the royal hearth, and so caused the illness of the king—he denies the charge, protests that he has sworn no false oath, and loudly complains of the wrong done to him. Upon this the king sends for six new soothsayers, who try the matter by soothsaying. If they too find the man guilty of the offence, straitway he is beheaded by those who first accused him, and his goods are parted among them: if, on the contrary, they acquit him, other soothsayers, and again others, are sent for, to try the case. Should the greater number decide in favour of the man's innocence, then they who first accused him forfeit their lives.

69. The mode of their execution is the following: a waggon is loaded with brushwood, and oxen are harnessed to it; the soothsayers, with their feet tied together, their hands bound behind their backs, and their mouths gagged, are thrust into the midst of the brushwood; finally the wood is set alight, and the oxen, being startled, are made to rush off with the waggon. It often happens that the oxen and the soothsayers are both consumed together, but sometimes the pole of the waggon is burnt through, and the oxen escape with a scorching. Diviners —lying diviners, they call them—are burnt in the way described, for other causes besides the one here spoken of. When the king puts one of them to death, he takes care not to let any of his sons survive: all the male offspring are slain with the father, only the females being allowed to live.

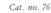
Cat. no. 76

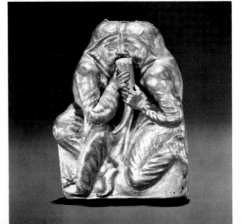

70. Oaths among the Scyths are accompanied with the following ceremonies: a large earthen bowl is filled with wine, and the parties to the oath, wounding themselves slightly with a knife or an awl, drop some of their blood into the wine; then they plunge into the mixture a scimitar, some arrows, a battle-axe, and a javelin, all the while repeating prayers; lastly the two contracting parties drink each a draught from the bowl, as do also the chief men among their followers.

71. The tombs of their kings are in the land of the Gerrhi, who dwell at the point where the Borysthenes is first navigable. Here, when the king dies, they dig a grave, which is square in shape, and of great size. When it is ready, they take the king's corpse, and, having opened the belly, and cleaned out the inside, fill the cavity with a preparation of chopped cypress, frankincense, parsley-seed, and anise-seed, after which they sew up the opening, enclose the body in wax, and, placing it on a waggon, carry it about through all the different tribes. On this procession each tribe, when it receives the corpse, imitates the example which is first set by the Royal Scythians; every man chops off a piece of his ear, crops his hair close, makes a cut all round his arm, lacerates his forehead and his nose, and thrusts an arrow through his left hand. Then they who have the care of the corpse carry it with them to another of the tribes which are under the Scythian rule, followed by those whom they first visited. On completing the circuit of all the tribes under their sway, they find themselves in the country of the Gerrhi, who are the most remote of all, and so they come to the tombs of the kings. There the body of the dead king is laid in the grave prepared for it, stretched upon a mattress; spears are fixed in the ground on either side of the corpse, and beams stretched across above it to form a roof, which is covered with a thatching of twigs. In the open space around the body of the king they bury one of his concubines, first killing her by strangling, and also his cup-bearer, his cook, his groom, his lackey, his messenger, some of his horses, firstlings of all his other possessions, and some golden cups; for they use neither silver nor brass. After this they set to work, and raise a vast mound above the grave, all of them vying with each other and seeking to make it as tall as possible.

72. When a year is gone by, further ceremonies take place. Fifty of the best of the late king's attendants are taken, all native Scythians—for, as bought slaves are unknown in the country, the Scythian kings choose any of their subjects that they like, to wait on them—fifty of these are taken and strangled, with fifty of the most beautiful horses. When they are dead, their bowels are taken out, and the cavity cleaned, filled full of chaff, and straightway sewn up again. This done, a number of posts are driven into the ground, in sets of two pairs each, and on every pair half the felly of a wheel is placed archwise; then strong stakes are run lengthways through the bodies of the horses from tail to neck, and they are mounted upon the fellies, so that the felly in front supports the shoulders of the horse, while that behind sustains the belly and quarters, the legs dangling in midair; each horse is furnished with a bit and bridle, which latter is stretched out in front of the horse, and fastened to a peg. The fifty strangled youths are then mounted severally on the fifty horses. To effect this, a second stake is passed through their bodies along the course of the spine to the neck; the lower end of which projects from the body, and is fixed into a socket, made in the stake that runs lengthwise down the horse. The fifty riders are thus ranged in a circle round the tomb, and so left.

73. Such, then, is the mode in which the kings are buried: as for the people, when any one dies, his nearest of kin lay him upon a waggon and take him round to all his friends in succession: each receives them in turn and entertains them with a banquet, whereat the dead man is served with a portion of all that is set before the others; this is done for forty days, at the end of which time the burial takes place. After the burial, those engaged in it have to purify themselves, which they do in the following way. First they well soap and wash their heads; then, in order to cleanse their bodies, they act as follows: they make a booth by fixing in the ground three sticks inclined towards one another, and stretching around them woollen felts, which they arrange so as to fit as close as possible: inside the booth a dish is placed upon the ground, into which they put a number of red-hot stones, and then add some hemp-seed.

74. Hemp grows in Scythia: it is very like flax; only that it is a much coarser and taller plant: some grows wild about the country, some is produced by cultivation: the Thracians make garments of it which closely resemble linen; so much so, indeed, that if a person has never seen hemp he is sure to think they are linen, and if he has, unless he is very experienced in such matters, he will not know of which material they are.

75. The Scythians, as I said, take some of this hempseed, and, creeping under the felt coverings, throw it upon the red-hot stones; immediately it smokes, and gives out such a vapour as no Grecian vapour-bath can exceed; the Scyths, delighted, shout for joy, and this vapour serves them instead of a waterbath;[23] for they never by any chance wash their bodies with water. Their women make a mixture of cypress, cedar, and frankincense wood,

which they pound into a paste upon a rough piece of stone, adding a little water to it. With this substance, which is of a thick consistency, they plaster their faces all over, and indeed their whole bodies. A sweet odour is thereby imparted to them, and when they take off the plaster on the day following, their skin is clean and glossy.

76. The Scythians have an extreme hatred of all foreign customs, particularly of those in use among the Greeks, as the instances of Anacharsis, and, more lately, of Scylas, have fully shown. The former, after he had travelled over a great portion of the world, and displayed wherever he went many proofs of wisdom, as he sailed through the Hellespont on his return to Scythia, touched at Cyzicus. There he found the inhabitants celebrating with much pomp and magnificence a festival to the Mother of the gods,[24] and was himself induced to make a vow to the goddess, whereby he engaged, if he got back safe and sound to his home, that he would give her a festival and a night-procession in all respects like those which he had seen in Cyzicus. When, therefore, he arrived in Scythia, he betook himself to the district called the Woodland, which lies opposite the Race-course of Achilles, and is covered with trees of all manner of different kinds, and there went through all the sacred rites with the tambourine in his hand, and the images tied to him. While thus employed, he was noticed by one of the Scythians, who went and told king Saulius what he had seen. Then king Saulius came in person, and when he perceived what Anacharsis was about, he shot at him with an arrow and killed him. To this day, if you ask the Scyths about Anacharsis, they pretend ignorance of him, because of his Grecian travels and adoption of the customs of foreigners. I learnt, however, from Tymnes, the steward of Ariapeithes, that Anacharsis was paternal uncle to the Scythian king Idanthyrsus, being the son of Gnurus, who was the son of Lycus and the grandson of Spargapeithes. If Anacharsis were really of this house, it must have been by his own brother that he was slain, for Idanthyrsus was a son of the Saulius who put Anacharsis to death.

[23] Herodotus appears in this instance to have confounded together two things in reality quite distinct, intoxication from the fumes of hemp-seed or hashish, and indulgence in the vapour-bath.

[24] Cybele or Rhea, whose worship passed from the Phrygians to the Ionian Greeks.

77. I have heard, however, another tale, very different from this, which is told by the Peloponnesians: they say, that Anacharsis was sent by the king of the Scyths to make acquaintance with Greece—that he went, and on his return home reported, that the Greeks were all occupied in the pursuit of every kind of knowledge, except the Lacedaemonians; who, however, alone knew how to converse sensibly. A silly tale, this, which the Greeks have invented for their amusement! There is no doubt that Anacharsis suffered death in the mode already related, on account of his attachment to foreign customs, and the intercourse which he held with the Greeks.

78. Scylas, likewise, the son of Ariapeithes, many years later, met with almost the very same fate. Ariapeithes, the Scythian king, had several sons, among them this Scylas, who was the child, not of a native Scyth, but of a woman of Istria. Bred up by her, Scylas gained an acquaintance with the Greek language and letters. Some time afterwards, Ariapeithes was treacherously slain by Spargapeithes, king of the Agathyrsi; whereupon Scylas succeeded to the throne, and married one of his father's wives, a woman named Opoea. This Opoea was a Scythian by birth, and had brought Ariapeithes a son called Oricus. Now when Scylas found himself king of Scythia, as he disliked the Scythic mode of life, and was attached, by his bringing up, to the manners of the Greeks, he made it his usual practice, whenever he came with his army to the town of the Borysthenites, who, according to their own account, are colonists of the Milesians,—he made it his practice, I say, to leave the army before the city, and, having entered within the walls by himself, and carefully closed the gates, to exchange his Scythian dress for Grecian garments, and in this attire to walk about the marketplace, without guards or retinue. The Borysthenites kept watch at the gates, that no Scythian might see the king thus apparelled. Scylas, meanwhile, lived exactly as the Greeks, and even offered sacrifices to the gods according to the Grecian rites. In this way he would pass a month, or more, with the Borysthenites, after which he would clothe himself again in his Scythian dress, and so take his departure. This he did repeatedly, and even built himself a house in Borysthenes, and married a wife there who was a native of the place.

79. But when the time came that was ordained to bring him woe, the occasion of his ruin was the following. He wanted to be initiated in the rites of the Bacchic Dionysus, and was on the point of obtaining admission to the rites, when a most strange prodigy occurred to him. The house which he possessed, as I mentioned a short time back, in the city of the Borysthenites, a building of great extent and erected at a vast cost, round which there

stood a number of sphinxes and griffins carved in white marble, was struck by lightning from on high, and burnt to the ground. Scylas, nevertheless, went on, and received the initiation. Now the Scythians are wont to reproach the Greeks with their Bacchanal rage, and to say that it is not reasonable to imagine there is a god who impels men to madness. No sooner, therefore, was Scylas initiated in the Bacchic mysteries than one of the Borysthenites went and carried the news to the Scythians. "You Scyths laugh at us," he said, "because we rave when the god seizes us. But now our god has seized upon your king, who raves like us, and is maddened by the influence. If you think I do not tell you true, come with me, and I will show him to you." The chiefs of the Scythians went with the man accordingly, and the Borysthenite, conducting them into the city, placed them secretly on one of the towers. Presently Scylas passed by with the band of revellers, raving like the rest, and was seen by the watchers. Regarding the matter as a very great misfortune, they instantly departed, and came and told the army what they had witnessed.

80. When, therefore, Scylas, after leaving Borysthenes, was about returning home, the Scythians broke out into revolt. They put at their head Octamasadas, grandson (on the mother's side) of Teres. Then Scylas, when he learned the danger with which he was threatened, and the reason of the disturbance, made his escape to Thrace. Octamasadas, discovering whither he had fled, marched after him, and had reached the Ister, when he was met by the forces of the Thracians. The two armies were about to engage, but before they joined battle, Sitalces[25] sent a message to Octamasadas to this effect, "Why should there be trial of arms between us? You are my own sister's son, and you have in your keeping my brother. Surrender him into my hands, and I will give Scylas back to you. So neither you nor I will risk our armies." Sitalces sent this message to Octamasadas by a herald, and Octamasadas, with whom a brother of Sitalces had formerly taken refuge, accepted the terms. He surrendered his own uncle to Sitalces, and obtained in exchange his brother Scylas. Sitalces took his brother with him and withdrew; but Octamasadas beheaded Scylas upon the spot. Thus rigidly do the Scythians maintain their own customs, and thus severely do they punish such as adopt foreign usages.

81. What the population of Scythia is, I was not able to learn with certainty; the accounts which I received varied from one another. I heard from some that they were very numerous indeed; others made their numbers but scanty for such a nation as the Scyths. Thus much,

however, I witnessed with my own eyes. There is a tract called Exampaeus between the Borysthenes and the Hypanis. I made some mention of it in a former place, where I spoke of the bitter stream which rising there flows into the Hypanis, and renders the water of that river undrinkable. Here then stands a brazen bowl, six times as big as that at the entrance of the Euxine, which Pausanias, the son of Cleombrotus, set up.[26] Such as have never seen that vessel may understand me better if I say that the Scythian bowl holds with ease six hundred amphorae,[27] and is of the thickness of six fingers' breadth. The natives gave me the following account of the manner in which it was made. One of their kings, by name Ariantas, wishing to know the number of his subjects, ordered them all to bring him, on pain of death, the point off one of their arrows. They obeyed, and he collected thereby a vast heap of arrow-heads, which he resolved to form into a memorial that might go down to posterity. Accordingly he made of them this bowl, and dedicated it at Exampaeus. This was all that I could learn concerning the number of the Scythians.

82. The country has no marvels except its rivers, which are larger and more numerous than those of any other land. These, and the vastness of the great plain, are worthy of note, and one thing besides, which I am about to mention. They show a footmark of Heracles, impressed on a rock, in shape like the print of a man's foot, but three feet in length. It is in the neighbourhood of the Tyras. Having described this, I return to the subject on which I originally proposed to discourse.

83. The preparations of Darius against the Scythians had begun, messengers has been dispatched on all sides with the king's commands, some being required to furnish troops, others to supply ships, others again to bridge the Thracian Bosporus, when Artabanus, son of Hystaspes and brother of Darius, entreated the king to desist from his expedition, urging on him the great difficulty of attacking Scythia. Good, however, as the advice of Artabanus was, it failed to persuade Darius. He therefore ceased his reasonings, and Darius, when his preparations were complete, led his army forth from Susa.

84. It was then that a certain Persian, by name Oeobazus, the father of three sons, all of whom were to accompany the army, came and prayed the king that he would

[25] Sitalces was contemporary with Herodotus. He died 424 B.C.

[26] Pausanias set up this bowl at the time that he was besieging Byzantium, 477 B.C.

[27] About 5,400 gallons.

allow one of his sons to remain with him. Darius made answer, as if he regarded him in the light of a friend who had urged a moderate request, that he would allow them all to remain. Oeobazus was overjoyed, expecting that all his children would be excused from serving; the king however bade his attendants take the three sons of Oeobazus and forthwith put them to death. Thus they were all left behind, but not till they had been deprived of life.

85. When Darius, on his march from Susa, reached the territory of Calchedon on the shores of the Bosporus, where the bridge had been made, he took ship and sailed thence to the Cyanean islands, which, according to the Greeks, once floated. He took his seat also in the temple and surveyed the Pontus, which is indeed well worthy of consideration. There is not in the world any other sea so wonderful: it extends in length 1,280 miles, and its breadth, at the widest part, is 380 miles.[28] The mouth is but one-half mile wide, and this strait, called the Bosporus, and across which the bridge of Darius had been thrown, is fourteen miles in length,[29] reaching from the Euxine to the Propontis. The Propontis is sixty miles across, and 160 miles long.[30] Its waters flow into the Hellespont, the length of which is fifty miles, and the width no more than 1,400 yards.[31] The Hellespont opens into the wide sea called the Aegean.

86. The mode in which these distances have been measured is the following. In a long day a vessel generally accomplishes about 70,000 fathoms, in the night 60,000. Now from the mouth of the Pontus to the river Phasis, which is the extreme length of this sea, is a voyage of nine days and eight nights, which makes the distance 1,110,000 fathoms, or 11,100 furlongs.[32] Again, from Sindica to Themiscyra on the river Thermodon, where the Pontus is wider than at any other place, is a sail of three days and two nights; which makes 330,000 fathoms, or 3,300 furlongs. Such is the plan on which I have measured the Pontus, the Bosporus, and the Hellespont, and such is the account which I have to give of them. The Pontus has also a lake belonging to it, not very

much inferior to itself in size.[33] The waters of this lake run into the Pontus; it is called the Maeotis, and also the mother of the Pontus.

87. Darius, after he had finished his survey, sailed back to the bridge, which had been constructed for him by Mandrocles a Samian. He likewise surveyed the Bosporus, and erected upon its shores two pillars of white marble, whereupon he inscribed the names of all the nations which formed his army—on the one pillar in Greek, on the other in Assyrian characters. Now his army was drawn from all the nations under his sway, and the whole amount, without reckoning the naval forces, was 700,000 men, including cavalry. The fleet consisted of 600 ships. Some time afterwards the Byzantines removed these pillars to their own city, and used them for an altar which they erected to Orthosian Artemis. One block remained behind: it lay near the temple of Dionysus at Byzantium, and was covered with Assyrian writing. The spot where Darius bridged the Bosporus was, I think but I speak only from conjecture, half-way between the city of Byzantium and the temple at the mouth of the strait.

88. Darius was so pleased with the bridge thrown across the strait by the Samian Mandrocles, that he not only bestowed upon him all the customary presents, but gave him ten of every kind. Mandrocles, by way of offering firstfruits from these presents, caused a picture to be painted which showed the whole of the bridge, with King Darius sitting in a seat of honour, and his army engaged in the passage. This painting he dedicated in the temple of Hera at Samos, attaching to it the inscription following:

The fish-fraught Bosporus bridged, to Hera's fane
 Did Mandrocles this proud memorial bring;
When for himself a crown he'd skill to gain,
 For Samos praise, contenting the Great King.

Such was the memorial of his work which was left by the architect of the bridge.

89. Darius, after rewarding Mandrocles, passed into Europe, while he ordered the Ionians to enter the Pontus, and sail to the mouth of the Ister. There he bade them throw a bridge across the stream and await his coming. The Ionians, Aeolians, and Hellespontians were the nations which furnished the chief strength of his navy. So the fleet, threading the Cyanean Isles, proceeded straight to the Ister, and, mounting the river to the point where its channels separate, a distance of two days' voyage from

[28] These measurements are extremely incorrect. The distance from the mouth of the Bosporus to the Phasis is little more than 630 miles. Again, the distance across from the Thermodon to the Sindic peninsula is about 270 miles.

[29] This is under the true length, which is about sixteen miles.

[30] The Propontis is nearer forty-three miles across and 110 miles long.

[31] The length is about forty miles; Herodotus' width is correct.

[32] These figures are given in miles in the preceding chapter. It will be noted that Herodotus regularly overestimates ships' speeds.

[33] It is commonly supposed that Herodotus fell here into a very gross mistake, since the Sea of Azov is not now much more than one-twelfth of the size of the Euxine; but it is possible that Lake Maeotis may have been very greatly larger in the time of Herodotus than it is at present.

the sea, yoked the neck of the stream. Meantime Darius, who had crossed the Bosporus by the bridge over it, marched through Thrace; and happening upon the sources of the Tearus, pitched his camp and made a stay of three days.

90. Now the Tearus is said by those who dwell near it, to be the most healthful of all streams, and to cure, among other diseases, the scab either in man or beast. Its sources, which are thirty-eight in number, all flowing from the same rock, are in part cold, in part hot. They lie at an equal distance from the town of Heraeum near Perinthus, and Apollonia on the Euxine, a two days' journey from each. This river, the Tearus, is a tributary of the Contadesdus, which runs into the Agrianes, and that into the Hebrus. The Hebrus empties itself into the sea near the city of Aenus.

91. Here then, on the banks of the Tearus, Darius stopped and pitched his camp. The river charmed him so, that he caused a pillar to be erected in this place also, with an inscription to the following effect, "The fountains of the Tearus afford the best and most beautiful water of all rivers: they were visited, on his march into Scythia, by the best and most beautiful of men, Darius, son of Hystaspes, king of the Persians, and of the whole continent." Such was the inscription which he set up at this place.

92. Marching thence, he came to a second river, called the Artiscus, which flows through the country of the Odrysians. Here he fixed upon a certain spot, where every one of his soldiers should throw a stone as he passed by. When his orders were obeyed, Darius continued his march, leaving behind him great hills formed of the stones cast by his troops.

93. Before arriving at the Ister, the first people whom he subdued were the Getae, who believe in their immortality. The Thracians of Salmydessus, and those who dwelt above the cities of Apollonia and Mesembria—the Scyrmiadae and Nipsaeans, as they are called—gave themselves up to Darius without a struggle; but the Getae obstinately defending themselves, were forthwith enslaved, notwithstanding that they are the noblest as well as the most just of all the Thracian tribes.

97. When Darius, with his land forces, reached the Ister, he made his troops cross the stream, and after all were gone over gave orders to the Ionians to break the bridge, and follow him with the whole naval force in his land march. They were about to obey his command, when the general of the Mytilenaeans, Coes son of Erxander, having first asked whether it was agreeable to the king to listen to one who wished to speak his mind, addressed him in the words following, "You are about, Sire, to

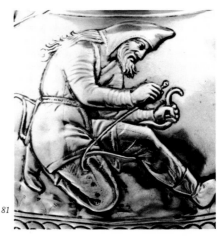

Cat. no. 81

attack a country no part of which is cultivated, and wherein there is not a single inhabited city. Keep this bridge, then, as it is, and leave those who built it, to watch over it. So if we come up with the Scythians and succeed against them as we could wish, we may return by this route; or if we fail of finding them, our retreat will still be secure. For I have no fear lest the Scythians defeat us in battle, but my dread is lest we be unable to discover them, and suffer loss while we wander about their territory. And now, mayhap, it will be said I advise you thus in the hope of being myself allowed to remain behind; but in truth I have no other design than to recommend the course which seems to me the best; nor will I consent to be among those left behind, but my resolve is, in any case, to follow you." The advice of Coes pleased Darius highly, who thus replied to him: "Dear Lesbian, when I am safe home again in my palace, be sure to come to me, and with good deeds will I recompense your good words of today."

98. Having so said, the king took a leathern thong, and tying sixty knots in it, called together the Ionian tyrants, and spoke thus to them, "Men of Ionia, my former commands to you concerning the bridge are now withdrawn. See, here is a thong; take it, and observe my bidding with respect to it. From the time that I leave you to march forward into Scythia, untie every day one of the knots. If I do not return before the last day to which the knots will hold out, then leave your station, and sail to your several homes. Meanwhile, understand that my resolve is changed, and that you are to guard the bridge with all care, and watch over its safety and preservation. By so doing you will oblige me greatly." When Darius had thus spoken, he set out on his march with all speed.

99. Before you come to Scythia, on the sea coast, lies Thrace. The land here makes a sweep, and then Scythia begins, the Ister falling into the sea at this point with its mouth facing the east. Starting from the Ister I shall now describe the measurements of the sea-shore of Scythia.

Immediately that the Ister is crossed, Old Scythia begins, and continues as far as the city called Carcinitis, fronting towards the south wind and the midday. Here upon the same sea, there lies a mountainous tract[34] projecting into the Pontus, which is inhabited by the Tauri, as far as what is called the Rugged Chersonese, which runs out into the sea upon the east. For the boundaries of Scythia extend on two sides to two different seas, one upon the south, and the other towards the east, as is also the case with Attica. And the Tauri occupy a position in Scythia like that which a people would hold in Attica, who, being foreigners and not Athenians, should inhabit the highland of Sunium, from Thoricus to the township of Anaphlystus, if this tract projected into the sea somewhat further than it does. Such, to compare great things with small, is the Tauric territory. For the sake of those who may not have made the voyage round these parts of Attica, I will illustrate in another way. It is as if in Iapygia a line were drawn from Port Brundusium to Tarentum, and a people different from the Iapygians inhabited the promontory.[35] These two instances may suggest a number of others, where the shape of the land closely resembles that of Taurica.

100. Beyond this tract, we find the Scythians again in possession of the country above the Tauri and the parts bordering on the eastern sea, as also of the whole district lying west of the Cimmerian Bosporus and Lake Maeotis, as far as the river Tanais, which empties itself into that lake at its upper end. As for the inland boundaries of Scythia, if we start from the Ister, we find it enclosed by the following tribes, first the Agathyrsi, next the Neuri, then the Man-eaters, and last of all, the Black-cloaks.

101. Scythia then, which is square in shape, and has two of its sides reaching down to the sea, extends inland to the same distance that it stretches along the coast, and is equal every way. For it is a ten days' journey from the Ister to the Borysthenes, and ten more from the Borysthenes to Lake Maeotis while the distance from the coast inland to the country of the Black-cloaks, who dwell above Scythia, is a journey of twenty days. I reckon the day's journey at twenty-five miles. Thus the two sides which run straight inland are 500 miles each, and the transverse sides at right angles to these are also of the same length, which gives the full size of Scythia.

102. The Scythians, reflecting on their situation, perceived that they were not strong enough by themselves to contend with the army of Darius in open fight. They, therefore, sent envoys to the neighbouring nations, whose kings had already met, and were in consultation upon the advance of so vast a host. Now they who had come together were the kings of the Tauri, the Agathyrsi, the Neuri, the Man-eaters, the Black-cloaks, the Geloni, the Budini, and the Sauromatae.

103. The Tauri have the following customs. They offer in sacrifice to the virgin goddess all shipwrecked persons, and all Greeks compelled to put into their ports by stress of weather. The mode of sacrifice is this. After the preparatory ceremonies, they strike the victim on the head with a club. Then, according to some accounts, they hurl the trunk from the precipice whereon the temple stands, and nail the head to a cross. Others grant that the head is treated in this way, but deny that the body is thrown down the cliff—on the contrary, they say, it is buried. The goddess to whom these sacrifices are offered the Tauri themselves declare to be Iphigenia[36] the daughter of Agamemnon. When they take prisoners in war they treat them in the following way. The man who has taken a captive cuts off his head, and carrying it to his home, fixes it upon a tall pole, which he elevates above his house, most commonly over the chimney. The reason that the heads are set up so high, is (it is said) in order that the whole house may be under their protection. These people live entirely by war and plundering.

104. The Agathyrsi are a race of men very luxurious, and very fond of wearing gold on their persons. They have intercourse promiscuously, that so they may be all brothers,[37] and, as members of one family, may neither envy nor hate one another. In other respects their customs approach nearly to those of the Thracians.

105. The Neurian customs are like the Scythian. One generation before the attack of Darius they were driven from their land by a huge multitude of serpents which invaded them. Of these some were produced in their own country, while others, and those by far the greater number, came in from the deserts on the north. Suffering grievously beneath this scourge, they quitted their homes, and took refuge with the Budini. It seems that these people are conjurers: for both the Scythians and the Greeks who dwell in Scythia say, that every Neurian once a year becomes a wolf[38] for a few days, at the end

[34] The mountains lie only along the southern coast of the Crimea. All the rest of the peninsula belongs to the steppes.

[35] This passage was evidently written for the benefit of readers in Magna Graecia. Herodotus at Thurii would have Iapygia before his eyes, as it were. Writing from Ionia, or even from Greece Proper, he would never have thought of such an illustration.

[36] The virgin goddess of the Tauri was more generally identified by the Greeks with their own Artemis.

[37] This anticipation of the theory of Plato (*Rep.* v.) is curious.

[38] This is the earliest reference to the widespread superstition as to werewolves.

of which time he is restored to his proper shape.[39] Not that I believe this, but they constantly affirm it to be true, and are even ready to back their assertion with an oath.

106. The manners of the Man-eaters are more savage than those of any other race. They neither observe justice, nor are governed by any laws. They are nomads, and their dress is Scythian; but the language which they speak is peculiar to themselves. Unlike any other nation in these parts, they are cannibals.

107. The Black-cloaks wear, all of them, black cloaks, and from this derive the name which they bear. Their customs are Scythic.

108. The Budini are a large and powerful nation: they have all deep blue eyes, and bright red hair. There is a city in their territory, called Gelonus, which is surrounded with a lofty wall, four miles each way, built entirely of wood. All the houses in the place and all the temples are of the same material. Here are temples built in honour of the Grecian gods, and adorned after the Greek fashion with images, altars, and shrines, all in wood. There is even a festival, held every third year, in honour of Dionysus, at which the natives fall into the Bacchic fury. For the fact is that the Geloni were anciently Greeks, who, being driven out of the trading-ports along the coast, fled to the Budini and took up their abode with them. They still speak a language half Greek, half Scythian.

109. The Budini, however, do not speak the same language as the Geloni, nor is their mode of life the same. They are the aboriginal people of the country, and are nomads; unlike any of the neighbouring races, they eat lice.[40] The Geloni, on the contrary, are tillers of the soil, eat bread, have gardens, and both in shape and complexion are quite different from the Budini. The Greeks notwithstanding call these latter Geloni, but it is a mistake to give them the name. Their country is thickly planted with trees of all manner of kinds. In the very woodiest part is a broad deep lake, surrounded by marshy ground with reeds growing on it. Here otters are caught, and beavers, with another sort of animal which has a square face. With the skins of this last the natives border their leather cloaks: and their testicles provide a remedy, for diseases of the womb.

110. It is reported of the Sauromatae, that when the Greeks fought with the Amazons, whom the Scythians call Oiorpata or man-slayers, as it may be rendered, *Oior* being Scythic for man, and *pata* for to slay—it is reported, I say, that the Greeks after gaining the battle of the

Thermodon, put to sea, taking with them on board three of their vessels all the Amazons whom they had made prisoners; and that these women upon the voyage rose up against the crews, and massacred them to a man. As however they were quite strange to ships, and did not know how to use either rudder, sails, or oars, they were carried, after the death of the men, where the winds and the waves listed. At last they reached the shores of Lake Maeotis and came to a place called Cremni or the Cliffs, which is in the country of the free Scythians. Here they went ashore, and proceeded by land towards the inhabited regions; the first herd of horses which they fell in with they seized, and mounting upon their backs, fell to plundering the Scythian territory.

111. The Scyths could not tell what to make of the attack upon them—the dress, the language, the nation itself, were alike unknown—whence the enemy had come even, was a marvel. Imagining, however, that they were all men of about the same age, they went out against them, and fought a battle. Some of the bodies of the slain fell into their hands, whereby they discovered the truth. Hereupon they deliberated, and made a resolve to kill no more of them, but to send against them a detachment of their youngest men, as near as they could guess equal to the women in number, with orders to encamp in their neighbourhood, and do as they saw them do—when the Amazons advanced against them, they were to retire, and avoid a fight—when they halted, the young men were to approach and pitch their camp near the camp of the enemy. All this they did on account of their strong desire to obtain children from so notable a race.

112. So the youth departed, and obeyed the orders which they had been given. The Amazons soon found out that they had not come to do them any harm, and so they on their part ceased to offer the Scythians any molestation. And now day after day the camps approached nearer to one another; both parties led the same life, neither having anything but their arms and horses, so that they were forced to support themselves by hunting and pillage.

113. The Amazons scattered by ones and twos at noon, wandering off to relieve themselves. The Scythians noticed this and did likewise; one of them attacked an Amazon who was alone; she did not resist but let him have his way. Then she bade him by signs (for they did not understand each other's language) to bring a friend the next day to the spot where they had met—promising on her part to bring with her another woman. He did so, and the woman kept her word. When the rest of the youths heard what had taken place, they had intercourse with the other Amazons.

[39] As Herodotus recedes from the sea his accounts become more mythic, and less trustworthy.

[40] Photius defines the same word as fir-cone.

114. The two camps were then joined in one, each Scythian having the Amazon with whom he first had intercourse as his wife. The men were unable to learn the tongue of the women, but the women soon caught up the tongue of the men. When they could thus understand one another, the Scyths addressed the Amazons in these words, "We have parents, and properties, let us therefore give up this mode of life, and return to our nation, and live with them. You shall be our wives there no less than here, and we promise you to have no others." But the Amazons said, "We could not live with your women—our customs are quite different from theirs. To draw the bow, to hurl the javelin, to bestride the horse, these are our arts—of womanly employments we know nothing. Your women, on the contrary, do none of these things; but stay at home in their waggons, engaged in womanish tasks, and never go out to hunt, or to do anything. We should never agree together. But if you truly wish to keep us as your wives, and would conduct yourselves with strict justice towards us, go you home to your parents, bid them give you your inheritance, and then come back to us, and let us and you live together by ourselves."

115. The youths approved of the advice, and followed it. They went and got the portion of goods which fell to them, returned with it, and rejoined their wives, who then addressed them in these words following, "We are ashamed, and afraid to live in the country where we now are. Not only have we stolen you from your fathers, but we have done great damage to Scythia by our ravages. As you like us for wives, grant the request we make of you. Let us leave this country together, and go and dwell beyond the Tanais." Again the youths complied.

116. Crossing the Tanais they journeyed eastward a distance of three days' march from that stream, and again northward a distance of three days' march from Lake Maeotis. Here they came to the country where they now live, and took up their abode in it. The women of the Sauromatae have continued from that day to the present, to observe their ancient customs, frequently hunting on horseback with their husbands, sometimes even unaccompanied; in war taking the field; and wearing the very same dress as the men.

117. The Sauromatae speak the language of Scythia, but have never talked it correctly, because the Amazons learned it imperfectly at the first. Their marriage-law lays it down, that no girl shall wed till she has killed a man in battle. Sometimes it happens that a woman dies unmarried at an advanced age, having never been able in her whole lifetime to fulfil the condition.

118. The envoys of the Scythians, on being introduced into the presence of the kings of these nations, who were assembled to deliberate, made it known to them, that the Persian, after subduing the whole of the other continent, had thrown a bridge over the strait of the Bosporus, and crossed into the continent of Europe, where he had reduced the Thracians, and was now making a bridge over the Ister, his aim being to bring under his sway all Europe also. "Stand not aloof then from this contest," they went on to say, "look not on tamely while we are perishing—but make common cause with us, and together let us meet the enemy. If you refuse, we must yield to the pressure, and either quit our country, or make terms with the invaders. For what else is left for us to do, if your aid be withheld from us? The blow, be sure, will not light on you more gently upon this account. The Persian comes against you no less than against us: and will not be content, after we are conquered, to leave you in peace. We can bring strong proof of what we here advance. Had the Persian leader indeed come to avenge the wrongs which he suffered at our hands when we enslaved his people, and to war on us only, he would have been bound to march straight upon Scythia, without molesting any nation by the way. Then it would have been plain to all, that Scythia alone was aimed at. But now, what has his conduct been? From the moment of his entrance into Europe, he has subjugated without exception every nation that lay in his path. All the tribes of the Thracians have been brought under his sway, and among them even our next neighbours, the Getae."

119. The assembled princes of the nations, after hearing all that the Scythians had to say, deliberated. At the end opinion was divided—the kings of the Geloni, Budini, and Sauromatae were of accord, and pledged themselves to give assistance to the Scythians; but the Agathyrsian and Neurian princes, together with the sovereigns of the Man-eaters, the Black-cloaks, and the Tauri, replied to their request as follows, "If you had not been the first to wrong the Persians, and begin the war, we should have thought the request you make just; we should then have complied with your wishes, and joined our arms with yours. Now, however, the case stands thus—you, independently of us, invaded the land of the Persians, and so long as God gave you the power, lorded it over them: raised up now by the same God, they are come to do to you the like. We, on our part, did no wrong to these men in the former war, and will not be the first to commit wrong now. If they invade our land, and begin aggressions upon us, we will not suffer them; but, till we see this come to pass, we will remain at home. For we believe that the Persians are not

come to attack us, but to punish those who are guilty of first injuring them."

120. When this reply reached the Scythians, they resolved, as the neighbouring nations refused their alliance, that they would not openly venture on any pitched battle with the enemy, but would retire before them, driving off their herds, choking up all the wells and springs as they retreated, and leaving the whole country bare of forage. They divided themselves into three bands, one of which, namely that commanded by Scopasis, it was agreed should be joined by the Sauromatae, and if the Persians advanced in the direction of the Tanais, should retreat along the shores of Lake Maeotis and make for that river; while if the Persians retired, they should at once pursue and harass them. The two other divisions, the principal one under the command of Idanthyrsus, and the third, of which Taxacis was king, were to unite in one, and, joined by the detachments of the Geloni and Budini, were, like the others, to keep at the distance of a day's march from the Persians, falling back as they advanced, and doing the same as the others. At first, they were to take the direction of the nations which had refused to join the alliance, and were to draw the war upon them: that so, if they would not of their own free will engage in the contest, they might by these means be forced into it. Afterwards, it was agreed that they should retire into their own land, and, should it on deliberation appear to them expedient, join battle with the enemy.

121. When these measures had been determined on, the Scythians went out to meet the army of Darius, sending on in front as scouts the fleetest of their horsemen. Their waggons, wherein their women and their children lived, and all their cattle, except such a number as was wanted for food, which they kept with them, were made to precede them in their retreat, and departed, with orders to keep marching, without change of course, to the north.

122. The scouts of the Scythians found the Persian host advanced three days' march from the Ister, and immediately took the lead of them at the distance of a day's march, encamping from time to time, and destroying all that grew on the ground. The Persians no sooner caught sight of the Scythian horse than they pursued upon their track, while the enemy retired before them. The pursuit of the Persians was directed towards the single division of the Scythian army, and thus their line of march was eastward towards the Tanais. The Scyths crossed the river, and the Persians after them, still in pursuit. In this way they passed through the country of the Sauromatae, and entered that of the Budini.

123. As long as the march of the Persian army lay through the countries of the Scythians and Sauromatae, there was nothing which they could damage, the land being waste and barren; but on entering the territories of the Budini, they came upon the wooden fortress above mentioned, which was deserted by its inhabitants and left quite empty of everything. This place they burnt to the ground; and having so done, again pressed forward on the track of the retreating Scythians, till, having passed through the entire country of the Budini, they reached the desert, which has no inhabitants, and extends a distance of seven days' journey above the Budinian territory. Beyond this desert dwell the Thyssagetae, out of whose land four great streams flow. These rivers all traverse the country of the Maeotians, and fall into Lake Maeotis. Their names are the Lycus, the Oarus, the Tanais, and the Syrgis.

124. When Darius reached the desert, he paused from his pursuit, and halted his army upon the Oarus. Here he built eight large forts, at an equal distance from one another, eight miles apart or thereabouts, the ruins of which were still remaining in my day.[41] During the time that he was so occupied, the Scythians whom he had been following, made a circuit by the higher regions, and re-entered Scythia. On their complete disappearance, Darius, seeing nothing more of them, left his forts half finished, and returned towards the west. He imagined that the Scythians whom he had seen were the entire nation, and that they had fled in that direction.

125. He now quickened his march, and entering Scythia, fell in with the two combined divisions of the Scythian army, and instantly gave them chase. They kept to their plan of retreating before him at the distance of a day's march; and, he still following them hotly, they led him, as had been previously settled, into the territories of the nations that had refused to become their allies, and first of all into the country of the Black-cloaks. Great disturbance was caused among this people by the invasion of the Scyths first, and then of the Persians. So, having harassed them after this sort, the Scythians led the way into the land of the Man-eaters, with the same result as before; and thence passed onwards into Neuris, where their coming likewise spread dismay among the inhabitants. Still retreating they approached the Agathyrsi; but this people, which had witnessed the flight and terror of their neighbours, did not wait for the Scyths to invade them, but sent a herald to forbid them to cross their borders, and to forewarn them, that, if they made the

[41] The conjecture is probable that these supposed "forts" were ruined barrows. Herodotus would hear of them from the Greek traders. His words do not necessarily imply that he had himself seen them.

attempt, it would be resisted by force of arms. The Agathyrsi then proceeded to the frontier, to defend their country against the invaders. As for the other nations, the Black-cloaks, the Man-eaters, and the Neuri, instead of defending themselves, when the Scyths and Persians overran their lands, they forgot their threats, and fled away in confusion to the deserts lying towards the north. The Scythians, when the Agathyrsi forbade them to enter their country, refrained; and led the Persians back from the Neurian district into their own land.

126. This had gone on so long, and seemed so interminable, that Darius at last sent a horseman to Idanthyrsus, the Scythian king, with the following message, "Strange man, why do you keep on flying before me, when there are two things you might do so easily? If you deem yourself able to resist my arms, cease your wanderings and come, let us engage in battle. Or if you are conscious that my strength is greater than yours—even so you should cease to run away—you have but to bring your lord earth and water, and to come at once to a conference."

127. To this message Idanthyrsus, the Scythian king, replied, "This is my way, Persian. I never fear men or fly from them. I have not done so in times past, nor do I now fly from you. There is nothing new or strange in what I do; I only follow my common mode of life in peaceful years. Now I will tell you why I do not at once join battle with you. We Scythians have neither towns nor cultivated lands, which might induce us, through fear of their being taken or ravaged, to be in any hurry to fight with you. If, however, you must needs come to blows with us speedily, look you now, there are our fathers' tombs—seek them out, and attempt to meddle with them—then you shall see whether or no we will fight with you. Till you do this, be sure we shall not join battle, unless it pleases us. This is my answer to the challenge to fight. As for lords, I acknowledge only Zeus my ancestor, and Hestia, the Scythian queen. Earth and water, the tribute you ask, I do not send, but you shall soon receive more suitable gifts. Last of all, in return for calling yourself my lord, I say to you, 'Go howl.'" (This is what men mean by the Scythian mode of speech.) So the herald departed, bearing this message to Darius.

128. When the Scythian kings heard the name of slavery they were filled with rage, and despatched the division under Scopasis to which the Sauromatae were joined, with orders that they should seek a conference with the Ionians, who had been left at the Ister to guard the bridge. Meanwhile the Scythians who remained behind resolved no longer to lead the Persians hither and thither about their country, but to fall upon them whenever they should be at their meals. So they waited till such times, and then did as they had determined. In these combats the Scythian horse always put to flight the horse of the enemy; these last, however, when routed, fell back upon their foot, who never failed to afford them support; while the Scythians, on their side, as soon as they had driven the horse in, retired again, for fear of the foot. By night too the Scythians made many similar attacks.

129. There was one very strange thing which greatly aided the Persians, and was of equal disservice to the Scyths, in these assaults on the Persian camp. This was the braying of the asses and the appearance of the mules. For, as I observed before, the land of the Scythians produces neither ass nor mule, and contains no single specimen of either animal, by reason of the cold. So, when the asses brayed, they frightened the Scythian cavalry; and often, in the middle of a charge, the horses, hearing the noise made by the asses, would take fright and wheel round, pricking up their ears, and showing astonishment. This was owing to their having never heard the noise, or seen the form, of the animal before: and it was not without some little influence on the progress of the war.

130. The Scythians, when they perceived signs that the Persians were becoming alarmed, took steps to induce them not to quit Scythia, in the hope, if they stayed, of inflicting on them the greater injury, when their supplies should altogether fail. To effect this, they would leave some of their cattle exposed with the herdsmen, while they themselves moved away to a distance: the Persians would make a foray, and take the beasts, whereupon they would be highly elated.

131. This they did several times, until at last Darius was at his wits' end; hereon the Scythian princes, understanding how matters stood, despatched a herald to the Persian camp with presents for the king: these were, a bird, a mouse, a frog, and five arrows. The Persians asked the bearer to tell them what these gifts might mean, but he made answer that he had no orders except to deliver them, and return again with all speed. If the Persians were wise, he added, they would find out the meaning for themselves. So when they heard this, they held a council to consider the matter.

132. Darius gave it as his opinion, that the Scyths intended a surrender of themselves and their country, both land and water, into his hands. This he conceived to be the meaning of the gifts, because the mouse is an inhabitant of the earth, and eats the same food as man,

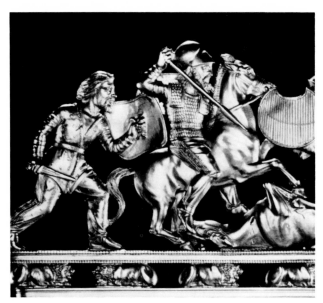

Cat. no. 71

while the frog passes his life in the water; the bird bears a great resemblance to the horse, and the arrows might signify the surrender of all their power. To the explanation of Darius, Gobryas, one of the seven conspirators against the Magus, opposed another which was as follows, "Unless, Persians, you can turn into birds and fly up into the sky, or become mice and burrow under the ground, or make yourselves frogs, and take refuge in the fens, you will never make escape from this land, but die pierced by our arrows." Such were the meanings which the Persians assigned to the gifts.

133. The single division of the Scyths, which in the early part of the war had been appointed to keep guard about Lake Maeotis, and had now been sent to get speech of the Ionians stationed at the Ister, addressed them, on reaching the bridge, in these words, "Men of Ionia, we bring you freedom, if you will only do as we recommend. Darius, we understand, enjoined you to keep your guard here at this bridge just sixty days; then, if he did not appear, you were to return home. Now, therefore, act so as to be free from blame, alike in his sight, and in ours. Tarry here the appointed time, and at the end go your ways." Having said this, and received a promise from the Ionians to do as they desired, the Scythians hastened back with all possible speed.

134. After the sending of the gifts to Darius, the part of the Scythian army, which had not marched to the Ister, drew out in battle array horse and foot[42] against the

[42] We now hear for the first time of the Scythians having infantry. It is scarcely possible that they really possessed any such force. If they had had a force of foot-soldiers, Darius might have compelled them to a general engagement.

Persians, and seemed about to come to an engagement. But as they stood in battle array, it chanced that a hare started up between them and the Persians, and set to running; when immediately all the Scyths who saw it, rushed off in pursuit, with great confusion, and loud cries and shouts. Darius, hearing the noise, inquired the cause of it, and was told that the Scythians were all engaged in hunting a hare. On this he turned to those with whom he was wont to converse, and said, "These men do indeed despise us utterly: and now I see that Gobryas was right about the Scythian gifts. As, therefore, his opinion is now mine likewise, it is time we form some wise plan, whereby we may secure ourselves a safe return to our homes." "Sire," Gobryas rejoined, "I was almost sure, before I came here, that this was an impracticable race—since our coming I am yet more convinced of it, especially now that I see them making game of us. My advice is, therefore, that, when night falls, we light our fires as we do at other times, and leaving behind us on some pretext that portion of our army which is weak and unequal to hardship, taking care also to leave our asses tethered, retreat from Scythia, before our foes march forward to the Ister and destroy the bridge, or the Ionians come to any resolution which may lead to our ruin."

135. So Gobryas advised; and when night came, Darius followed his counsel, and leaving his sick soldiers, and those whose loss would be of least account, with the asses also tethered about the camp, marched away. The asses were left that their noise might be heard: the men, really because they were sick and useless, but under the pretense, that he was about to fall upon the Scythians with the flower of his troops, and that they meanwhile were to guard his camp for him. Having thus declared his plans to the men whom he was deserting, and having caused the fires to be lighted, Darius set forth, and marched hastily towards the Ister. The asses, aware of the departure of the host, brayed louder than ever; and the Scythians, hearing the sound, entertained no doubt of the Persians being still in the same place.

136. When day dawned, the men who had been left behind, perceiving that they were betrayed by Darius, stretched out their hands towards the Scythians, and spoke as befitted their situation. The enemy no sooner heard, than they quickly joined all their troops in one, and both portions of the Scythian army—alike that which consisted of a single division, and that made up of two, accompanied by all their allies, the Sauromatae, the Budini, and the Geloni, set off in pursuit, and made straight for the Ister. As, however, the Persian army was chiefly foot, and had no knowledge of the routes, which are not cut out in Scythia; while the Scyths were all

horsemen and well acquainted with the shortest way; it so happened that the two armies missed one another, and the Scythians, getting far ahead of their adversaries, came first to the bridge. Finding that the Persians were not yet arrived, they addressed the Ionians, who were aboard their ships, in these words, "Men of Ionia, the number of your days is out, and you do wrong to remain. Fear doubtless has kept you here hitherto: now, however, you may safely break the bridge, and hasten back to your homes, rejoicing that you are free, and thanking for it the gods and the Scythians. Your former lord and master we undertake so to handle, that he will never again make war upon any one."

137. The Ionians now held a council. Miltiades the Athenian who was king of the Chersonesites upon the Hellespont,[43] and their commander at the Ister, recommended the other generals to do as the Scythians wished, and restore freedom to Ionia. But Histiaeus the Milesian opposed this advice. "It is through Darius," he said, "that we enjoy our thrones in our several states. If his power be overturned, I cannot continue lord of Miletus, nor you of your cities. For there is not one of them which will not prefer democracy to kingly rule." Then the other captains, who, till Histiaeus spoke, were about to vote with Miltiades, changed their minds, and declared in favour of the last speaker.

138. The following were the voters on this occasion, all men who stood high in the esteem of the Persian king: the tyrants of the Hellespont—Daphnis of Abydos, Hippoclus of Lampsacus, Herophantus of Parium, Metrodorus of Proconnesus, Aristagoras of Cyzicus, and Ariston of Byzantium; the Ionian princes—Strattis of Chios, Aeaces of Samos, Laodamas of Phocaea, and Histiaeus of Miletus, the man who had opposed Miltiades. Only one Aeolian of note was present, to wit, Aristagoras of Cyme.[44]

139. Having resolved to follow the advice of Histiaeus, the Greek leaders further determined to speak and act as follows. In order to appear to the Scythians to be doing something, when in fact they were doing nothing of consequence, and likewise to prevent them from forcing a passage across the Ister by the bridge, they resolved to break up the part of the bridge which abutted on

43 Concerning this sovereignty of Miltiades see Book vi. 34-36.

44 One cannot but suspect that the list of Herodotus is imperfect, and that more contingents were present than he names. It may be conjectured that the list came from a Hellespontine source (from the family of Miltiades, most probably); and thus, while the catalogue of the Hellespontine cities is tolerably complete, there being no important omission but that of Calchedon, only those Ionian and Aeolian leaders who were of particular repute obtained any mention.

Scythia, to the distance of a bowshot from the river bank; and to assure the Scythians, while the demolition was proceeding, that there was nothing which they would not do to pleasure them. Such were the additions made to the resolution of Histiaeus; and then Histiaeus himself stood forth and made answer to the Scyths in the name of all the Greeks, "Good is the advice which you have brought us, Scythians, and well have you done to come here with such speed. Your efforts have now put us into the right path, and our efforts shall not be wanting to advance your cause. Your own eyes see that we are engaged in breaking the bridge, and, believe us, we will work zealously to procure our own freedom. Meantime, while we labour here at our task, be it your business to seek them out, and, when found, for our sakes, as well as your own, to visit them with the vengeance which they so well deserve."

140. Again the Scyths put faith in the promises of the Ionian chiefs, and retraced their steps, hoping to fall in with the Persians. They missed, however, the enemy's whole line of march; their own former acts being to blame for it. Had they not ravaged all the pasturages of that region, and filled in all the wells, they would have easily found the Persians whenever they chose. But, as it turned out, the measures which seemed to them so wisely planned were exactly what caused their failure. They took a route where water was to be found and fodder could be got for their horses, and on this track sought their adversaries, expecting that they too would retreat through regions where these things were to be obtained. The Persians, however, kept strictly to the line of their former march, never for a moment departing from it; and even so gained the bridge with difficulty. It was night when they arrived, and their terror, when they found the bridge broken up, was great; for they thought that perhaps the Ionians had deserted them.

141. Now there was in the army of Darius a certain man, an Egyptian, who had a louder voice than any other man in the world. This person was bid by Darius to stand at the water's edge, and call Histiaeus the Milesian. The fellow did as he was bid; and Histiaeus, hearing him at the very first summons, brought the fleet to assist in conveying the army across, and once more made good the bridge.

142. By these means the Persians escaped from Scythia, while the Scyths sought for them in vain, again missing their track. And hence the Scythians are accustomed to say of the Ionians, by way of reproach, that, if they be looked upon as free-men, they are the basest and most dastardly of all mankind—but if they be considered as under servitude, they are the faithfulest of slaves, and the most fondly attached to their lords.

The Dawn of Chivalry

Helmut Nickel

Curator, Arms and Armor, The Metropolitan Museum of Art

The horseman, mastering a beautiful animal and towering over the man walking on his own feet, had a traditional sense of superiority and felt little more than contempt for the digger of the soil. In primitive societies, when the horseman was a herder, the two life styles—that of nomadic herdsman and peasant behind his plough—were considered mutually exclusive. This age-old antagonism showed itself even as late as the range wars of the American West, when cowhands fought homesteaders.

On the more romantic side, the dashing horseman made a deep impression on those outside of his culture. The centaur, the Amazon warrior-maiden, the Hun, the Tartar of the Golden Horde, the medieval knight in shining armor, the Saracen, the dazzling Napoleonic hussar and cuirassier, the Plains Indian and the cowboy under the "big blue sky," all were looked upon with a mixture of awe and a delicious shudder that became greater the more remote they became in time and distance.

The horsemen *par excellence* of classical antiquity were the Scythians, who lived on the plains north of the Black Sea beyond the borders of Greek civilization. Roaming the steppes east of the Scythians, were tribes that Herodotus called the Sauromatae, who were thought to be the offspring of Scythians and Amazons. Later, in Roman times, called the Sarmatians, they showed up in

the west—as the first heavy armored cavalry (*cataphractarii*) in Europe. When the Huns came from Central Asia and in A.D. 375 shattered the Ostrogothic Empire that had been established in the former lands of the Scythians, agricultural Germanic tribes—Goths, Burgundians, and the much-maligned Vandals—as well as nomadic tribes from the steppes, such as the Alans, cousins of the Scythians and Sarmatians, were driven from their eastern homes and set adrift westward. The uprooted Germanic warriors successfully adopted the nomads' cavalry equipment, and from the blending of the two cultures emerged what became a fundamental concept of the medieval world, chivalry.

In 378 the Gothic-Alanic cavalry wiped out a Roman army at Adrianople, a victory that heralded the dominance of the heavy armored horseman on the medieval battlefield. Groups of Alans set themselves up as local aristocracies in northern Spain (Catalonia: Goth-Alania) and northern France (Alençon). Chivalry developed into its final form when another wave of Germanic warriors, the Normans, came to northern France and took up the horsemanship of the Alanic gentry. (The Battle of Hastings, in 1066, was decided by the time-honored nomad tactic of feigned retreat, executed by the left wing of the Norman cavalry commanded by the

1. *Sarmatian chief clad in scale armor. Fluttering behind him is the distinctive Sarmatian battle standard, a dragon made like a windsock. Fragments of a funeral stele from the Roman camp at Chester, England. Chester Museum. Photo: Chester Archaeological Society. From* The Sarmatians *(New York, 1970), pl. 46.*

Count of Brittany, who had the telltale name Alan the Red.)

By the first century the Sarmatians had moved from their homeland between the Black and Caspian seas to the banks of the Danube, where they clashed with outposts of the Roman Empire. In 175 the emperor Marcus Aurelius made a treaty with the westernmost Sarmatian tribe, the Iazyges, who occupied Pannonia, today's Hungary, and hired 8,000 of them to serve in the Roman army. Fifty-five hundred Iazyges cavalrymen were sent to northern Britain to fight the troublesome Picts. After their twenty-year term of service expired, they were not permitted to return home but were settled in Bremetennacum, the modern Ribchester in Lancashire, where their descendants were still listed in the fifth century as "the troop of Sarmatian veterans" (see Figure 1).

As the first heavy armored cavalry in western Europe, the Sarmatians wore segmented helmets and scale body armor; even their horses were protected by scale covers and bronze-studded leather chanfrons. For their distinctive battle standard, Sarmatian troops carried a dragon made like a windsock on a pole; it had a metal head and a red fabric body that writhed when the wind blew through its jaws. They worshiped their tribal god in the form of a sword stuck upright into a small stone plat-

form. These details may resemble uncannily some of the more familiar motifs from the stories surrounding King Arthur, and it is interesting to note further that the commander (*praefectus*) of the Legio VI Victrix, to which the Sarmatian auxiliaries in Britain were assigned, was a certain Lucius Artorius Castus, who had served in Pannonia. The Sarmatians undoubtedly welcomed a commander familiar with their homeland, perhaps even their customs and language; possibly they turned his name, Artorius, into a title—the way Caesar became Kaiser and Tsar. During the fifth century, when the "historical" Arthur is supposed to have lived, this title might have been used by a great British chieftain. In addition, the earliest source that mentions Arthur, the *Historia Britonum* of Nennius shortly before 800, gives three city names in a list of twelve battles won by Arthur, and all three (one of which seems to be an abbreviated form of Bremetennacum) were garrisons of Sarmatians or heavy armored cavalry in Roman times.

An integral part of chivalry was chivalrous literature, especially the Arthurian legends. Judging from nomads in historical and modern times, it can be assumed that the early Scythians, Sarmatians, Alans, and Huns possessed a highly developed epic tradition (since it was oral, the term "literature" is not quite fitting). In fact,

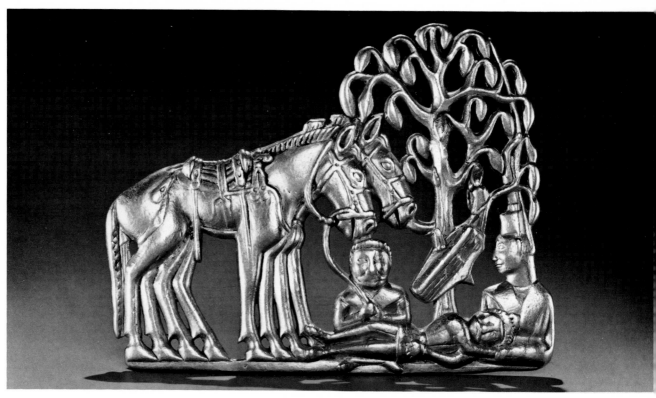

2. Warrior resting (probably a scene from a legend), plaque. Gold, length 16.2 cm. (6⅜ in.). Siberian collection of Peter I. Hermitage, Si 1727, 1/161. (Cat. no. 95, color plate 21).

the great western European epics, the Nibelungen and Dietrich cycles and the Arthurian legends, were composed around heroes who lived during the fifth century, the period of the greatest influx of steppe nomads into western Europe.

Among the gold plaques from the Siberian collection of Peter the Great are two pairs with human representations. One pair shows a rider pursuing a boar; the other (Figure 2) a woman sitting under a tree with a man stretched out resting his head in her lap, while two horses and a groom stand by. This idyllic scene has been recognized as a distinctive motif appearing in the medieval legend of St. Ladislav of Hungary, in the Hungarian folk ballad *Ana Molnár,* and in the ancient Turkish epic about the hero Targhyn (whose name has the same root as Pen*dragon*). In western Europe this motif is featured in Ekkehard of St. Gall's epic poem *Waltharius* (about 940), in Wolfram von Eschenbach's *Parzival* (about 1200), and in Sir Thomas Malory's *Sir Balin and Sir Balan* (about 1470, after French sources of about 1250). Waltharius, fleeing from the Huns who had held him hostage, is armed "in the manner of the Pannonians" with two swords (which might explain why these gold plaques, originally scabbard mounts, are in pairs), and both Arthurian heroes, Parzival and Sir Balin, carry two swords. (After Sir Balin's death one of his swords is

stuck into a marble block by Merlin.) Furthermore, Parzival and Sir Balin are heroes connected with the quest for the Holy Grail, the sacred vessel that inspired visions of bliss, and it is intriguing that the Scythians—and the Siberian nomads, as we have learned from their frozen tombs—used special cauldrons to burn hashish on hot stones and inhaled the fumes, according to Herodotus, "shouting for joy." The other scene on the gold plaques, the boar hunt, brings to mind Arthur's earliest supernatural adventure, reported by Nennius, the hunt for the boar Trwch Troynt.

Finally, the story of the sword Excalibur (which at Arthur's death is thrown into the water after the knight entrusted with this task had hesitated twice to do so) has direct parallels in the epic of the death of Batradz, the tribal hero of the Ossetians of the Caucasus, and in the episode of the death of Krabat, included in a folk tale of the Sorbs of eastern Germany. The Ossetians are the last surviving group of Sarmatian-speaking people, and the Sorbs, though now speaking a Slavic language, are an isolated group still bearing a Sarmatian tribal name. "Excalibur," incidentally, in its earliest form "Caliburnus," is clearly derived from the Latin word for steel, *chalybs,* which comes from a Greek word derived from the name of the Sarmatian Kalybes, a tribe of smiths in the Caucasus.

The Vettersfelde Find

Dietrich von Bothmer

Chairman, Greek and Roman Art, The Metropolitan Museum of Art

Draining his fields in the village of Vettersfelde on October 5, 1882, a farmer dug up a buried treasure consisting of weapons and jewelry. What distinguished this find at once from other prehistoric discoveries made in northern Germany was the big decorated fish (Figure 1) made of electrum (an alloy of gold and silver). The immediate recognition of its great artistic importance led to the prompt acquisition of the find by the Berlin museum in 1883. A. Furtwängler, who published it the same year, recognized at once that the objects were Scythian works of art, made by Greeks for Scythians or by Scythian craftsmen imitating Greek (more specifically Ionian) workmanship. The find is dated on stylistic grounds to the beginning of the fifth century B.C.

When and how these objects reached the small village of Vettersfelde, about fifty miles southeast of Berlin, will remain a mystery for a long time to come. Unlike Greek art, Scythian art was not widely exported, although Scythian finds in Hungary give a hint of migrations probably following the period of the Persian Wars.

Another question concerns the original function of the find—human burial or buried hoard. There is a report that the plough brought to the surface sherds of a big round pot that may have contained the treasure. An excavation on the site conducted by the ethnographic department of the Berlin museums in the summer of 1883 yielded more fragments of the urn but no bones, a fact that favors the interpretation of the find as a hoard or treasure hastily buried for safekeeping.

The Vettersfelde find, except for seven smaller pieces, is in the Staatliche Museen, Preussischer Kulturbesitz, Antikenabteilung in Berlin and is included in A. Greifenhagen's monumental catalogue *Schmuckarbeiten in Edelmetall* I (Berlin, 1970), from which the following descriptions are adapted.

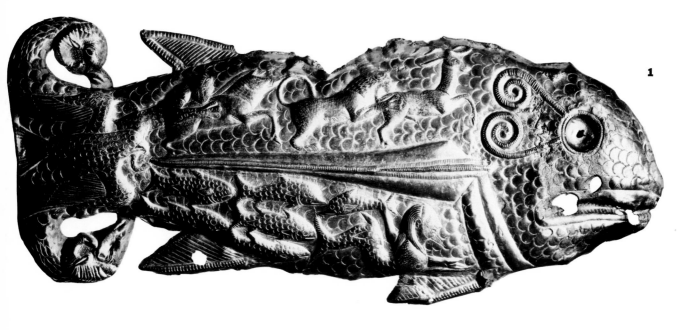

1

1 (previous page)

Fish, raised from a sheet of electrum. The dorsal fin is missing, as is the eye, which must have been inlaid in glass or stone. The highly stylized fish, of a species that cannot be determined, is decorated with animals and a merman that are organized along the anatomical divisions. The tail is ornamented with an eagle, and its curving points are in the shape of rams' heads and necks. The back shows a panther attacking a boar and a lion seizing a fallow deer; the belly is given over to a school of six fish led by a merman who wields a seventh fish in his right hand. The movement of all animals is from left to right, and the direction follows that of the fish which they embellish.

On the underside of the fish four staples are still in place, proving that the object was once fastened to another surface—probably a shield or cuirass made of a different material.

Though the conceit of covering the surface of one animal with other animals is not known in Greek art, the style of the merman, small fish, eagle, rams' heads, and felines and their prey bears a strong resemblance to East Greek

(Ionian) art and thus, indirectly, to Etruscan art, which borrowed so freely from it. Hence it has even been claimed that the Vettersfelde fish is Etruscan, an assumption already rejected by Furtwängler, who saw at once the stylistic affinity of the Vettersfelde fish to the stag from the Kul Oba tumulus at Kerch (illustrated here as color plate 15, cat. no. 77). There, too, the anatomical divisions of the animal were employed as background for other animals superposed as it were, and one of the points of the antlers terminates in a ram's head and neck, quite analogous to the tips of the tail on the Vettersfelde fish. Moreover Greifenhagen has pointed out that the rope contour of the fins recurs on the Scythian stag in Budapest from Zöldhalompuszta. These two parallels suffice to assign the Vettersfelde find firmly to the realm of Scythian art.

Length 41 cm. (16⅛ in.); preserved height 15 cm. (5⅞ in.); weight 608.5 gr.

2

Electrum ornament in the shape of four disks grouped around a smaller central disk. Each disk once bore a separately worked boss in the center (three are lost). The outer disks are decorated with animals: (1) lion chasing fallow deer; hound coursing after hare; (2) lion attacking bull; leopard attacking boar; (3) lynx confronting ibex; two heraldic rams; (4) four leopards, in two heraldic groups.

Several holes in the disks indicate that the ornament was once attached to something else, and it may have been a decoration (phalera) for the breastplate of a horse. The animals on the roundels are not quite so fine as on the fish and may stem from another workshop.

Height and width, each 17 cm. (6 11/16 in.); weight 282.5 gr.

3

Iron sword and sheath; the scabbard and the sword's hilt and pommel are covered with sheet electrum. The shape of the sword is unmistakably that of an *akinakes*, the typical Scythian sword known from finds in the Dnieper region and Poltava; the hilt bears plain decorations in the shape of four soldered

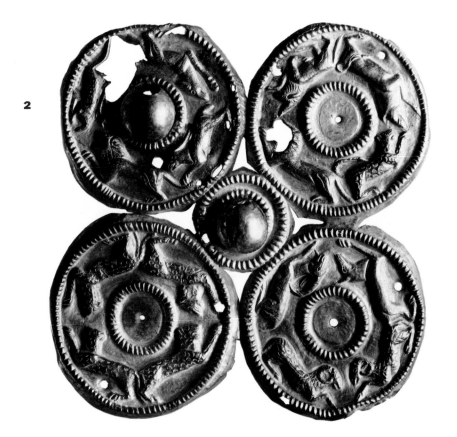

2

4

7

staples on each side. The lower half of the sheath, now lost, had an ornamental band of soldered gold wire, braided and beaded, that bordered double spirals; below this band was a pendent row of leaf-shaped loops. The upper part of the sheath is divided into four areas. The top has a nose and two cut-out eyes; the rounded bulge is decorated with a lion and a star rosette; the long narrow part is divided by a ridge into two fields; above, a leopard pursuing a boar, followed by a fish; below, a lion attacking a fallow deer, again followed by a fish. These animals resemble those on the big fish very closely.

Length of hilt and blade, as preserved, 15 cm. (5⅞ in.); length of scabbard 19 cm. (7½ in.); combined length, as restored, about 50 cm. (19¹¹⁄₁₆ in.); weight (including the iron core of the pommel) 507.5 gr.

4

Electrum earring. The three capsules that form the middle zone are now empty and may have contained colored stones. On the bottom, four leaves and a small sphere. The upper and lower hemispheres are decorated with wire loops.

Height 7.7 cm. (3 in.); weight 17.5 gr.

5

Electrum pendant in the shape of a lozenge. A loop above served for suspension on a chain. Similar in technique to the lower part of the sheath and the earring, the ornaments consist of wire loops that are soldered on. Here they form a rosette.

Height 6.9 cm. (2 11/16 in.); weight 23.7 gr.

6

Wedge-shaped stone pendant, its upper two thirds covered with sheet electrum and furnished with a broad loop for suspension. Its front is decorated with wire loops in the shape of a rosette and bounded below by a beaded line.

Height 4 cm. (1 9/16 in.).

7

Whetstone covered above by sheet electrum and perforated for suspension. A similar whetstone has been found at Chertomlyk on the Dnieper.

Length 16 cm. (6 5/16 in.).

8

Small bronze cover, once attached to an iron utensil, as shown by traces of iron oxide on the inside.

Width 2.5 cm. (1 in.).

9

Massive electrum bracelet with snakes'-head finials (one finial deformed through melting). The scales and eyes are incised.

Diameter 7 cm. (2¾ in.); weight 48.9 gr.

10

Braided electrum chain. At one end there is a small cylinder with beaded borders and a tiny wire loop. A similar chain was found with the stag of Zöldhalompuszta in Hungary, mentioned above under no. 1.

Length 71 cm. (27 15/16 in.); weight 212 gr.

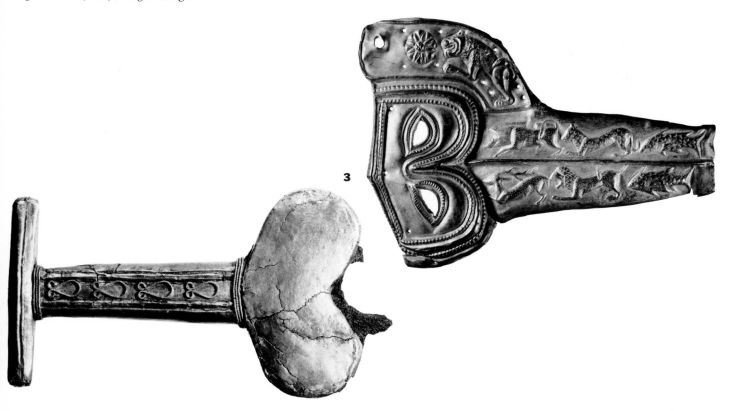

3

"The Maikop Treasure"

Prudence Oliver Harper, Curator, Ancient Near Eastern Art, The Metropolitan Museum of Art

The material remains of the Scythians, particularly the gold and silver from the Royal tombs, have been found largely by accident. Nevertheless, the various persons who explored and excavated these incredibly rich burial mounds during the eighteenth, nineteenth, and early twentieth centuries made some record of their discoveries. Frequently there are general lists of the finds according to provenance; more rarely, drawings or diagrams accompany these notes to illustrate the original placement of the objects in the tomb and their relationship to the human and animal skeletons. There were, however, some regrettable occasions when the works of art, especially those made of gold, silver, and semi-precious stones, passed into the hands of private collectors and dealers with no factual evidence aside from their appearance to indicate the region from which they came or the period of their manufacture. This is the situation with the objects from the so-called Maikop Treasure, allegedly from the Kuban river region, northwest of the Caucasus mountains. Early in the twentieth century this "treasure" was acquired from three separate sources by three museums, the Berliner Museen; The University Museum, University of Pennsylvania, Philadelphia; and The Metropolitan Museum of Art, New York. Some of the Maikop pieces in the three museums are identical. There are also unique objects in all three collections supposedly belonging to the same "Maikop" find.

The largest number of pieces and the finest examples from this "treasure" are at present in the Antikenabteilung of the Staatliche Museen, Preussischer Kulturbesitz, West Berlin, and have been published by Adolf Greifenhagen in the first volume of his catalogue of the gold and silver in Berlin. There he dates the Berlin pieces in the middle of the fifth century B.C. and accepts Rostovtzeff's conclusion that the objects come from the Kuban region, probably Maikop. This date is in accordance with the evidence provided by a Greek vessel and vase fragment included among the Philadelphia "Maikop" objects that can be firmly dated in the fifth century (see Figures 11, 12.) It is therefore possible that many of the pieces in Berlin and Philadelphia, as well as objects in New York, were made during the fifth century, but there is no proof that all are from the same site or burial. It is certainly unlikely that this is the complete inventory of a Royal Scythian tomb as there are no large-scale works in precious metal such as weapons.

By the time "hoards" or "treasures" reach museums from the antiquities market, it often happens that miscellaneous objects varying in date and style have become attached to the original group. Some such pieces are in the "Maikop" collections purchased by Philadelphia and Berlin. Those in Philadelphia include works as late as the second half of the first millennium A.D. in date. Although these cannot be assigned to a Royal Scythian burial, their original provenance may have been the Black Sea region. Therefore their inclusion in a Scythian "find" when it appeared on the market would not be surprising.

The material shown here, allegedly from Maikop, is most accurately described as an assortment of objects from the Black Sea region. Among them are many pieces that may have come from one Scythian tomb of the fifth century B.C., although it cannot be proven. Others must be from graves of a different date but quite probably from the same region. As is to be expected in lands occupied by nomads, local products are supplemented by those of foreign manufacture, notably imports from workshops in Greece and the Near East. The varied objects included in this "treasure" illustrate the uncertain archaeological history of the Pontic region as well as the styles developed by many peoples—Scythians, Sarmatians, Huns, and Turks—who passed through or settled on the borders of the Black Sea in the period from the mid-first millennium B.C. to the end of the first millennium A.D.

Staatliche Museen, West Berlin

A large number of silver, gold, and bronze objects was acquired in 1913 from an Armenian dealer, who claimed that their provenance was the region north of the Black Sea between the Dnieper and Dniester rivers. M. Rostovtzeff, in 1931, reattributed this group to the region of the Kuban river valley farther east, where similar works had been found. A portion of this collection was published by Greifenhagen in 1970 as coming from the "Kuban region (Maikop)"; included under this heading are a variety of gold and silver pieces, probably all of a mid- or late 5th-century date. Greifenhagen does not believe that the bronzes (now in East Berlin) acquired with the gold and silver necessarily come from the same burial. He finds no certain proof that they are immediately connected with the so-called Maikop find.

M. Rostovtzeff, *Skythien und der Bosporus* (Berlin, 1931), p. 367f; A. Greifenhagen, *Schmuckarbeiten in Edelmetall* 1 (Berlin, 1970), pp. 55-60, pls. 29-37, figs. 9-53.

1

This silver bowl, a *phiale,* is undoubtedly a Greek work. The zone around the omphalos is decorated with a feather pattern. The engraved detail of the head of a bird of prey on the interior is unusual, and was probably added to suit the taste of the Scythian owner.

Diameter 16.2 cm. (6⅜ in.). Acc. no. 30221 a.

2

It is uncertain how the 14 long gold chains with rams'-head pendants (one pendant is missing) were used, but they are unquestionably Greek in style. Possibly slightly later in date than the chains with rams' heads are the 3 with small flower-shaped bells, examples of which are also in Philadelphia.

Chains with rams' heads: lengths 15.7 cm. (6⅜ in.). Chains with flower-shaped bells: lengths 26 cm. (10¼ in.). Acc. nos. 30221 q, p.

3

This gold pectoral, inlaid with blue and green glass paste, may have been sewn below the neck of a garment. Such ornaments are known in Assyrian, Urartean, and Iranian art of the 1st millennium B.C.

Length 23 cm. (9¹⁄₁₆ in.). Acc. no. 30221 e.

4

These gold stag and griffin plaques have tiny loops on the back so that they could be attached to fabric. Stags and griffins of the same type are in New York and Philadelphia.

Griffins (10): heights 2.5 cm. (1 in.). Stags (14): heights 3 cm. (1³⁄₁₆ in.). Acc. nos. 30221 r, s.

5

It has been suggested that these gold plaques—birds of prey holding fish, heads of birds of prey and panthers, and stags' and boars' legs—were originally attached to a leather backing or wooden vessel, as there are pins still preserved on many of the examples. Some of these pieces illustrate the abstract and unnaturalistic style typical of Scythian art. A boar's leg and panther's head are in Philadelphia.

Birds of prey holding fish (2): heights 11.2 cm. (4⅜ in.). Panthers' heads (3): heights 5 cm. (2 in.). Birds' heads (5): lengths 5.6 cm. (2³⁄₁₆ in.). Stags' legs (4): heights 13.4 cm. (5¼ in.). Boars' legs (3): heights 7.7 cm. (3 in.). Acc. nos. 30221 e, f, g, d.

6

Only in Berlin are there fragments of drinking horns associated with the Maikop finds. The two pieces of gold plating and a lion's-head finial would have decorated a vessel made of some other material, possibly horn or wood.

Gold plating. Lion's-head finial: length 3 cm. (1³⁄₁₆ in.). Acc. nos. 30221 h, i.

1

2

3

4

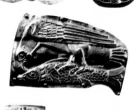

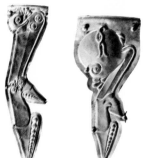

5

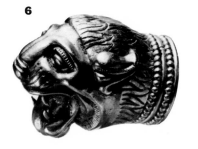

6

The University Museum, Philadelphia

The "Maikop" material was purchased for this museum by a private collector at an auction of the Ercole Canessa Collection held in New York in 1930. The lot acquired, number 120, "The Maikop Treasure," included gold, silver, bronze, and pottery objects ranging in date from the early 5th century B.C. to the 8th or 9th centuries A.D. These pieces were described in an earlier Canessa catalogue (1915) as being from various Scythian tombs in "the province of Kuban," not simply from Maikop. They had been seen in Paris by John Marshall in 1913, the same year that Berlin acquired its "Maikop" objects.

It is possible to assign a number of the gold pieces as well as some of the bronze and pottery ones to the 5th century B.C. This constitutes the bulk of the Philadelphia collection and includes all the works of typical Scythian form and style. Among these objects are exact duplicates of some of the gold plaques and jewelry in Berlin and New York. Parallels for the bronzes exist among those purchased by Berlin in 1913 with the silver and gold.

Y. I. Smirnov, *Vostochnoe Serebro (Argenterie Orientale)* (St. Petersburg, 1909), pl. CVII; Panama-Pacific International Exposition, *Catalogue: Canessa's Collection* (San Francisco, 1915), pp. 9-11, no. 2; American Art Association, Anderson Galleries Inc., N.Y., *The Ercole Canessa Collection,* Mar. 29, 1930; M. Rostovtzeff in *Seminarium Kondakovianum* 6 (Prague, 1933), pp. 168-169.

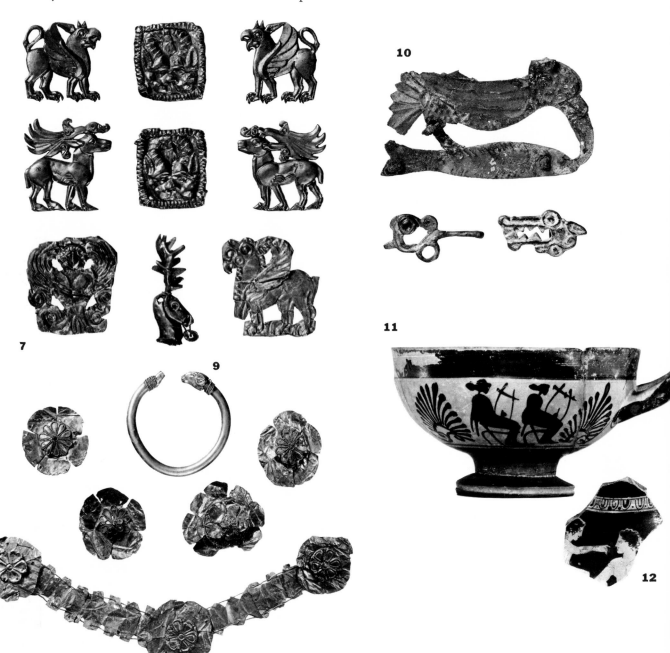

7

8

9

10

11

12

158

7

The flat gold plaques from Maikop in Philadelphia include a number of different types. The openwork stags and griffins in the upper two rows have precisely defined body surfaces. Small loops are attached to their backs. In typical Scythian fashion the stags incorporate small birds' heads within the tremendous antlers. Both types of plaques are in Berlin and New York.

Of Greek workmanship are the two thin gold plaques in the center of the upper rows: on these appear heads of horned lion-griffins within beaded frames. Other examples of these plaques are in Berlin.

In the bottom row the crudely worked plaques reflect both Greek and Scythian designs. The siren on the left is derived from a Greek motif, while the griffin on the right is more typically Scythian. A complete griffin plaque in Philadelphia has a small bird's head at the end of the tail.

In the center of the bottom row is a tiny hollow stag's head with a small pendant hanging from the mouth. Greifenhagen has suggested that almost identical pieces in Berlin and Leningrad (Hermitage) may once have decorated diadems.

Griffins: heights 2.5 cm. (1 in.). Stags: heights 3 cm. (1³⁄₁₆ in.). Horned lion-griffins: heights 2.5 cm. (1 in.). Siren. Stag's head: height 3.5 cm. (1⅜ in.). Griffin: height 3.2 cm. (1¼ in.). Acc. nos. 30.33-1, 13, 14.

8

The presence of these fragmentary gold diadems in the Maikop group in Philadelphia supports the theory that the 5th-century objects from this "treasure" may be part of the inventory of a Royal Scythian tomb. Such diadems were worn only by persons of the highest rank.

Length of lower diadem 25 cm. (9¹³⁄₁₆ in.). Acc. nos. 30.33-5, 6.

9

This gold bracelet is Greek, of the 5th century B.C.; one of the rams'-head finials is missing. The modeling of the ram's head closely resembles that of the heads serving as finials on the chains from Maikop in Berlin.

Diameter 7 cm. (2¾ in.). Acc. no. 30.33-9.

10

The large bird of prey grasping a fish in its beak and talons repeats in bronze a design more skillfully rendered on gold plaques among the Maikop pieces in Berlin (see Figure 5). The bird with its head turned backward and the wolf's head have characteristically Scythian curvilinear outlines and exaggerated circular eyes. Both bronzes have parallels among the bronzes in Berlin originally purchased with the Maikop gold and silver.

Bird grasping a fish: length 11.5 cm. (4½ in.). Bird's head: length 4.5 cm. (1¾ in.). Wolf's head: length 5 cm. (2 in.). Acc. nos. 30.33-118, 102, 104.

11

This black-figured skyphos (one handle is missing) is of a special shape in which the base is pinched in and the lip is offset. It has been attributed by Sir John Beazley to the Lancút Group that is "connected with late members of the Haimon Group," hence datable about 470 B.C. Black-figure is now in its decline, and here the artist no longer enlivens his silhouettes with incised lines and added colors. The hairdos indicate that the lyre players are women.

Other skyphoi of this group have been found in Olynthos, a city in northern Greece; this one may have been exported to Maikop from a Greek city or settlement in northern Greece or the Black Sea area.

Diameter 17.5 cm. (6⅞ in.); height 9.8 cm. (3¹⁵⁄₁₆ in.). Acc. no. 30.33-130.

12

This fragment of a red-figured pelike has been attributed by Dietrich von Bothmer to the Painter of Louvre G 539, a minor Attic painter of the late 5th century B.C.

The Peloponnesian war, which ended in the defeat of Athens, ruined the traditional markets for Athenian wares in the west, and this commercial decline was accompanied by an artistic one. A generation later, a new impetus was given to Attic vase painting by the increased export to the Greek colonies in South Russia and beyond.

Height 7.5 cm. (2¹⁵⁄₁₆ in.); width 6.5 cm. (2⁹⁄₁₆ in.). Acc. no. 30.33-131.

13

This rather bizarre bronze pin, sheathed in gold foil, is in the shape of a victorious warrior grasping the head of a slain enemy. Because of the extreme simplification of the forms it is difficult to date this piece precisely, although it cannot be earlier than the beginning of the 1st millennium A.D.

Length 8 cm. (3⅛ in.). Acc. no. 30.33-31.

14

Among the latest Maikop objects in Philadelphia are a silver bowl and 10 small silver-plated bronze clasps (probably from a jacket or a suit of armor). Similar bowls found in the Kuban region are in the Hermitage Museum, confirming the fact that the present vessel may have been found in the Maikop area. The plant designs, the form of the lion, and the minute punched dots on the background suggest an 8th- or 9th-century A.D. date for the bowl and clasps in The University Museum. By this time Turkic peoples had moved into the Pontic region, and much of their art shows the influence of the Islamic Near East and Central Asia.

Clasps (10): lengths 6.4 cm. (2⅛ in.). Bowl: diameter 14.2 cm. (5⁹⁄₁₆ in.). Acc. nos. 30.33-55, 132.

13

14

The Metropolitan Museum of Art, New York

Thirty-two ornaments were acquired in 1924 from John Marshall, who had bought them that year from Merle de Massoneau (Yalta, Crimea), whose collection contained mostly South Russian antiquities. All the pieces in New York except for two small plaques in the form of a winged lion and bird-headed lion have exact parallels in the Philadelphia and Berlin Maikop collections. Bird-headed lion plaques from Maikop were purchased by the Russian Imperial Archaeological Commission in 1908. They were published in 1909 as being in the collection of the commission in St. Petersburg. A silver bowl, a pedestal base, and a few other small pieces were found with the plaques.

Y. I. Smirnov, *Vostochnoe Serebro (Argenterie Orientale)* (St. Petersburg, 1909), pl. CXIX, fig. 43; *Archäologischer Anzeiger (Jahrbuch des archäologischen Instituts XXIV)* (1909), no. 2, cols. 148-149, fig. 10; Christine Alexander in *The Metropolitan Museum of Art Bulletin* (July 1925), p. 180f., fig. 7; M. S. Dimand, H. E. McAllister, *Near Eastern Jewelry*, Metropolitan Museum of Art picture book (New York, 1944), cover, fig. 2.

15

The stag, griffin, volute, and geometric ornaments are quite different in appearance from the two lions—one with a bird's head and the other with wings. These two pieces are pierced for attachment to fabric, while the others have loops on the back.

Griffins (4): heights 2.5 cm. (1 in.) Stags (4): heights 3 cm. (1 3/16 in.). Winged lion: height 3 cm. (1 3/16 in.). Bird-headed lion: height 3 cm. (1 3/16 in.). Square geometric ornaments (10): widths .8 cm. (3/8 in.). Volutes (12): widths 1.6 cm. (5/8 in.). Fletcher Fund, 24.97.48-79.

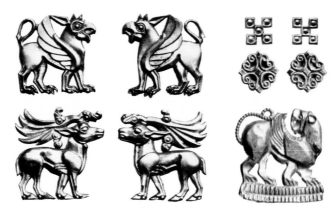

15